WE SHOT THE WAR

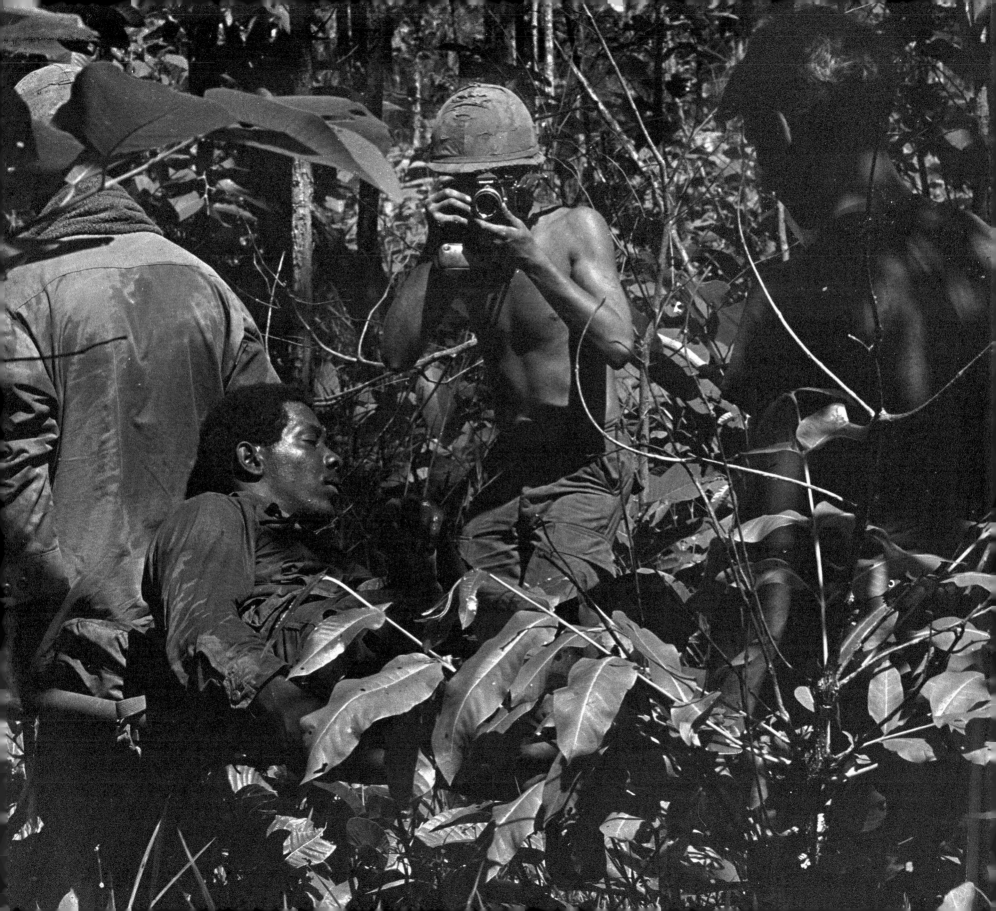

WE SHOT THE WAR

OVERSEAS WEEKLY IN VIETNAM

EDITED BY
Lisa Nguyen

FOREWORD BY
Eric Wakin

CONTRIBUTIONS BY
Cynthia Copple
Art Greenspon
Don Hirst
Brent Procter

www.hoover.org

Hoover Institution Press Publication No. 690

Hoover Institution at Leland Stanford Junior University,
 Stanford, California 94305-6003

First printing 2018
24 23 22 21 20 19 18 9 8 7 6 5 4 3 2 1

Printed and bound by Friesens Corporation in Canada

The paper used in this publication meets the minimum requirements of the American
National Standard for Information Sciences—Permanence of Paper for Printed Library
Materials, ANSI/NISO Z39.48-1992. ∞

Cataloging-in-Publication Data is available from the Library of Congress.

ISBN: 978-0-8179-2164-4 (cloth)
ISBN: 978-0-8179-2166-8 (epub)
ISBN: 978-0-8179-2167-5 (mobi)
ISBN: 978-0-8179-2168-2 (PDF)

Design and layout by Mary Ann Casler.

TABLE OF CONTENTS

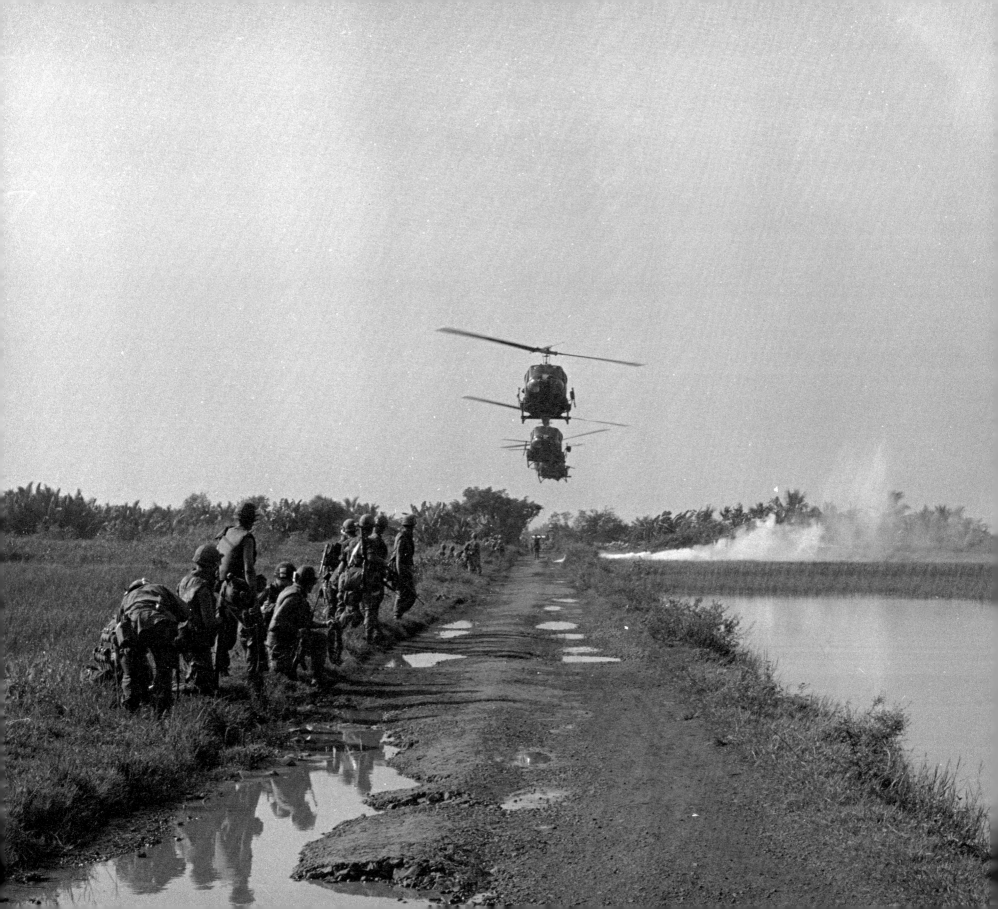

FOREWORD

IT IS WITH GREAT PLEASURE that the Hoover Institution Library & Archives presents this volume of photographs from its *Overseas Weekly* collection, one of the most significant acquisitions the institution has made in recent years. Begun in 1950 in Frankfurt, Germany, the *Overseas Weekly* was a landmark venture in wartime reporting and served as an alternative to US Defense Department papers like *Stars and Stripes*. Its Pacific edition began publication in 1966 and covered controversial topics more intently than the official papers did, including courts-martial, racial discrimination, drug use, and opposition to command, while also publishing raw photographs of life in the field and in billets. The photographs in the collection represent some of the most intimate and moving portraits of American GIs and Vietnamese civilians taken between 1966 and 1972; their specific purpose was to document the daily life of individuals caught in what was then the world's most grueling conflict—one that would ultimately kill over fifty-eight thousand Americans and one million Vietnamese.

The Hoover Institution Library & Archives acquired the collection of over twenty thousand photographs and two hundred contact sheets in 2014, understanding that this incredible record of the political, social, and cultural upheaval of the Vietnam era would be a significant contribution to the institution's mission to document war, revolution, and peace across the globe. Since its founding in 1919, the Hoover Library & Archives has collected, preserved, and made available the most important material on social, economic, and political change from the early twentieth century,

through World War I, to the present day. The *Overseas Weekly* collection complements the institution's other significant holdings on Vietnam, from the papers of Edward Lansdale to the manuscript of Ron Kovic's *Born on the Fourth of July* and the records of Sybil Stockdale, coordinator of the National League of Families of American Prisoners in Southeast Asia and the wife of Vice Admiral James Bond Stockdale, who was held as a prisoner of war in North Vietnam from 1965 to 1973. Since acquiring the *Overseas Weekly* collection, we have sought to enhance and encourage access to its content. This year, we digitized and made available over nine hundred images from the collection through our digital collections portal, and in the spring of 2018 the Herbert Hoover Memorial Exhibit Pavilion will feature the exhibition *We Shot the War: Overseas Weekly in Vietnam*, organized by the curator for Digital Scholarship and Asian Initiatives Lisa Nguyễn, for which this publication is a companion volume.

In addition to the significance of its photographs, the *Overseas Weekly* has a strong connection to Stanford University. Its publisher, Marion von Rospach, was the former editor in chief of the *Stanford Daily*. After graduating from Stanford in the midst of World War II, von Rospach worked briefly for the US military's official newspaper, *Stars and Stripes*, leaving after becoming disenchanted with what she considered the paper's bias toward brass hat opinion. Along with her husband (also a Stanford graduate) and three servicemen, von Rospach started the European edition of the *Overseas Weekly* with a printing press borrowed from

Stars and Stripes—and quickly became embroiled in controversy when the racy content of the *Overseas Weekly* caused the US State Department to ban it from newsstands. Marion von Rospach fought back—her own mother reported to the *Stanford Daily*, "I know she will give them a bad time. . . . She's a fighter"—and won.

The paper continued to thrive, and when US involvement in the Vietnam War escalated in the 1960s, von Rospach decided to expand the paper's circulation by launching a Pacific edition based in Hong Kong and Saigon. The government and mainstream media continued to criticize the tabloid they dubbed the *Oversexed Weekly*. In 1967 *Time* magazine cited the paper as "the least popular publication at the Pentagon"; in 1970 the *New York Times* referred to the *Overseas Weekly* as the "GI's friend" and therefore one of the US Army's "major gadflies"; and in 1971 *Rolling Stone* dismissed it as a "rabble-rousing newspaper for GIs." Regardless of reproach by the establishment, circulation of the Pacific edition continued to rise. During the height of the conflict in Vietnam, the *Overseas Weekly* had a readership of approximately sixty thousand and had attracted a highly talented staff of photographers and reporters, including Ann Bryan, Art Greenspon, Richard Boyle, Don Hirst, and Brent Procter, among others. As can be seen from the outstanding photographs featured in this book, von Rospach's fearless tenacity in the face of authority yielded one of the most historically significant collections of wartime documentation from the Vietnam era.

The *Overseas Weekly* collection, therefore, offers much to researchers on the Vietnam War and the art and technique of war correspondence. The great Magnum photographer Robert Capa—who was killed by a land mine in French Indochina in 1954, camera in hand—once warned fellow journalists, "If your photographs aren't good enough, you're not close enough." The photographs that readers find collected in this volume are the incredible work of a group of journalists who indeed were "close enough"—dangerously close—to the physical, mental, and emotional demands on soldiers and civilians in Vietnam from 1966 to 1972. Unlike photographers working for major media outlets, the *Overseas Weekly* photographers found that their subject was also their audience: they took photographs that were never intended for a civilian viewership. What divide, then, do we see between photographs taken for the *Overseas Weekly* and those that appeared on broadcast television or in popular magazines?

The Vietnam War has often been called the first "living room war" due to the proliferation of television sets in American homes in the 1960s and 1970s and advances in film and photography, which allowed journalists to carry lightweight cameras through jungles and rice paddies, on helicopters, and through the streets of Saigon. The term, however, is somewhat misleading, as it imparts the idea of civilians' intimate and immediate viewing of events in Vietnam as somehow yielding more honest, uncensored reportage than that which they previously consumed (during World War II and the Korean War, for example) through newspapers and newsreels. Mainstream journalists covering the conflict often found that, though they enjoyed advanced camera equipment and enhanced access to combat zones, the information they received from official government outlets was, as in previous wars, often

hazy or unhelpful. Early in the conflict, mainstream journalists went as far as to dub government news briefings for official war correspondents the "Five O'Clock Follies" because of their belief that much of the information released by the authorities was inaccurate or purposefully misleading.

As in many previous conflicts, soldiers often resented the sometimes sanitized news being reported at home or in officially sanctioned newspapers, and the *Overseas Weekly* offered relief from bowdlerization and a forum for frank discussion. In addition to articles and comics, for example, the *Overseas Weekly* ran a weekly column called "Man on the Street," in which reporters would ask soldiers' opinions on such subjects as race, class, and the legitimacy of the war. The photographs and responses of the GIs interviewed—many of which are reproduced in this volume—provide some of the rawest and rarest glimpses into the lives and minds of those in service in Vietnam between 1966 and 1972. The fact that the vast majority of the photographs featured in this volume have never before been published will no doubt encourage critical inquiry and comparisons between the mainstream and independent, underground media coverage of the conflict in Vietnam.

The historian Stanley Karnow, Pulitzer Prize–winning author of the landmark work *Vietnam: A History*, whose papers are housed at Hoover Archives, referred to the conflict in Vietnam as "the war nobody won." We have seen his sentiment—that of the unresolved nature of the war's purpose and influence—grappled with through increased public and scholarly interest in the war, resulting in the production of books, films, and exhibitions that look for the meaning of the conflict in the eyes of those on all sides who experienced it firsthand.

The intimate photographs of the *Overseas Weekly* have been a part of recent Vietnam related projects, reinforcing the fact that the weekly tabloid provided a unique viewpoint of the war and the culture enveloping the American soldiers fighting in it. The scenes and faces found in the *Overseas Weekly* photographs stand testament to the wide-ranging hardships that the conflict brought to soldiers and civilians. Though the origin of the Vietnam War is complex and its legacy still to be determined, these photographs help viewers remember that war is not just epic tragedy but a collection of individual experiences—and that the sorrows, joys, fears, and valor of soldiers must be given voice. Within the pages of this volume readers will find images of graphic wartime violence beside those of tranquility that emerged from the chaos. As the famous Vietnam photographer Eddie Adams once put it: "You have the whole world in the viewfinder."

Eric Wakin

Deputy Director, Robert H. Malott Director of Library & Archives, and Research Fellow Hoover Institution, Stanford University

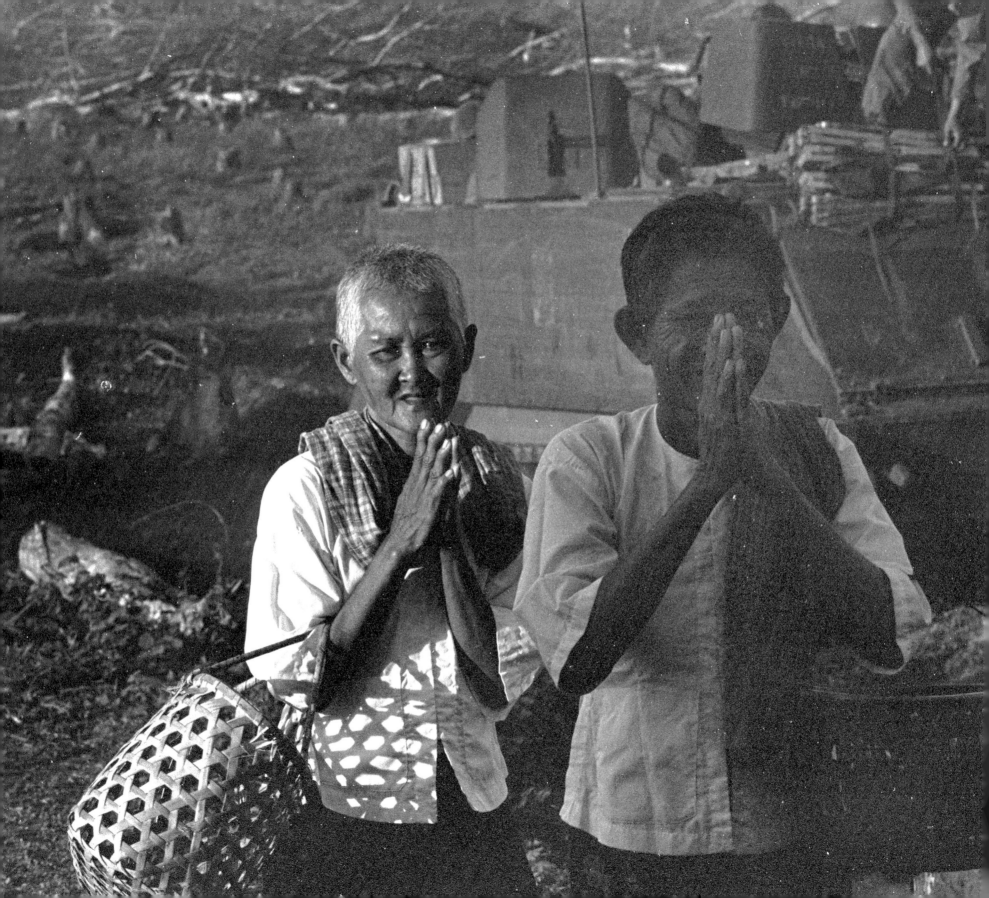

ACKNOWLEDGMENTS

THE HOOVER INSTITUTION LIBRARY & Archives is honored to provide expanded opportunity for researchers to experience the richness of the *Overseas Weekly* photograph collection through this publication, *We Shot the War:* Overseas Weekly *in Vietnam.* This catalog would not have been possible without the inspiration and support of many individuals. First and foremost, the *Overseas Weekly* reporters, photographers, freelancers, associates, and relatives who readily and generously shared their time and memories of their journalistic careers in Southeast Asia. Among them are Cynthia Copple, Don Hirst, Art Greenspon, Peter McDowell, Brent Procter, Tony Mariano, Bob McKay, Kate Steffens, Bob Stokes, and Chuq von Rospach. Furthermore, without the foresight and care of Ann Bryan Mariano McKay, Calle Hesslefors, and Mark Goldsworthy, an important piece of US photographic history might have been lost forever.

For research, I obtained extensive assistance from Elizabeth Engel, the deft and extraordinary senior archivist from the State Historical Society of Missouri. Her deep knowledge of the content within the Ann Bryan Mariano McKay Papers, which she meticulously processed, served as an invaluable resource. Gawain Weaver and his team of photograph conservation specialists produced the quality images seen in this volume. Veronica Oliva, permissions editor, assisted in investigating copyright status of the photographs.

At the Hoover Institution, I appreciate the encouragement and copious support of Eric Wakin, Robert H. Malott Director of Library & Archives to pursue this project. I am humbled and grateful to all my diligent Library & Archives colleagues who wrested themselves from competing priorities to help breathe life into this catalog. Among them are Laura Bedford, James Fayne, Rayan Ghazal, and Kurtis Kekkonen (Preservation); Rachel Bauer and Stephanie Stewart (Visual Materials); Danielle Scott (Curator); Samira Bozorgi, Jean Cannon, Bronweyn Coleman, and Marissa Rhee (Exhibitions, Outreach, and Programs); Sally DeBauche, Fiore Irving, Daniel Jarvis, and Lisa Miller (Digital Materials); Sang-Suk Shon (Microfilm); Irena Czernichowska and David Sun (Administration and Finance). At the amazing Hoover Press, Barbara Arellano, Scott Harrison, Jennifer Navarrette, Laura Somers and, especially, Alison Petersen, who shepherded this process with professionalism, patience, and humor. Judith Riotto, copyeditor, delivered valuable and constructive feedback on the catalog's essays.

Finally, I could not have maintained the focus and energy required to complete this project without the support of my family. I extend my deep gratitude to my parents, Phu and Thu, daughter, Hannah, and husband, Don. Special thanks to my extended family who lived through the horrors of the Vietnam War but were fortunate enough to survive and reconstruct their shattered lives in the United States to become an infinitely stronger family unit. *Xin cảm tạ.*

Thu Phương Lisa H. Nguyễn
CURATOR, DIGITAL SCHOLARSHIP
AND ASIAN INITIATIVES

INTRODUCTION

THE VIETNAM WAR has been memorialized as a period of dramatic political, social, and cultural upheaval. The harrowing images that emerged from this era have shaped public opinion, have left indelible imprints on the American psyche, and continue to rivet viewers today. *We Shot the War:* Overseas Weekly *in Vietnam* explores the interrelationship between artistic technique and journalistic content through the photographs submitted to the *Overseas Weekly*'s Pacific edition, a military tabloid at once beloved by troops and reviled by the Pentagon for its muckraking content. The striking pictures and personal essays published in this catalog aim to bring viewers behind the viewfinders of photojournalists who covered the conflict in Southeast Asia for the *Overseas Weekly* between 1966 and 1972.

The *Overseas Weekly* was the bestselling privately owned newspaper published in Europe and Asia for members of the US armed forces between 1950 and 1974. With the tagline "a touch of home away from home," this publication served up an eclectic farrago of military exposés, pinups, and comic strips. Its editorial content was constructively controversial. It readily tackled issues of racial friction and integration, drug abuse, and the justice system in the military service. In 1966 the *Wall Street Journal* described the *Overseas Weekly* as "a journalistic court of last resort for the ordinary GI. . . . It publishes hardhitting and accurate exposés of abuses of military authority. . . . When it talks, the brass listens—like it or not. And the GIs snap it up." At the helm of this landmark publication were two highly respected women: Stanford-educated Marion von Rospach, founder and owner of the Overseas Media Corporation, and Ann Bryan, the editor in chief of the *Overseas Weekly*'s Saigon office.

For more than forty years, the elusive photo morgue of the *Overseas Weekly*'s Pacific edition lay moribund in a Nordic cellar until it was bequeathed to Mark Goldsworthy, a Swedish graphic designer, by former *Overseas Weekly* photographer Calle Hesslefors. What resurfaced was an enormous cache of more than twenty thousand photo negatives. Each 35mm film strip was carefully enwrapped in translucent glassine and weathered green and white envelopes that marked the location where it was processed: Photo Perfect at 22 Ngô Đức Kế in Saigon. The negatives were warped, fusty, and deteriorating. Some envelopes contained faded pencil-written notations and typed dopesheets that yielded important clues about the photographers, locations, dates, subjects, and purpose for which the images were taken. A vast majority of the negatives were undescribed and unattributed. When the collection arrived at Hoover Institution Library & Archives at Stanford University in 2014, preservation and curatorial staff advanced Goldsworthy's previous endeavors to research the historical background of the paper, preserve the negatives, and make digital contact sheets and descriptive information available online. As the collection was cataloged and processed, several questions arose: What was this publication, and where were the extant copies? Who was its target audience? Who created content for the paper, and where are they now?

At the time, online information about publication was fragmentary so Hoover staff turned to traditional research methods, combing through

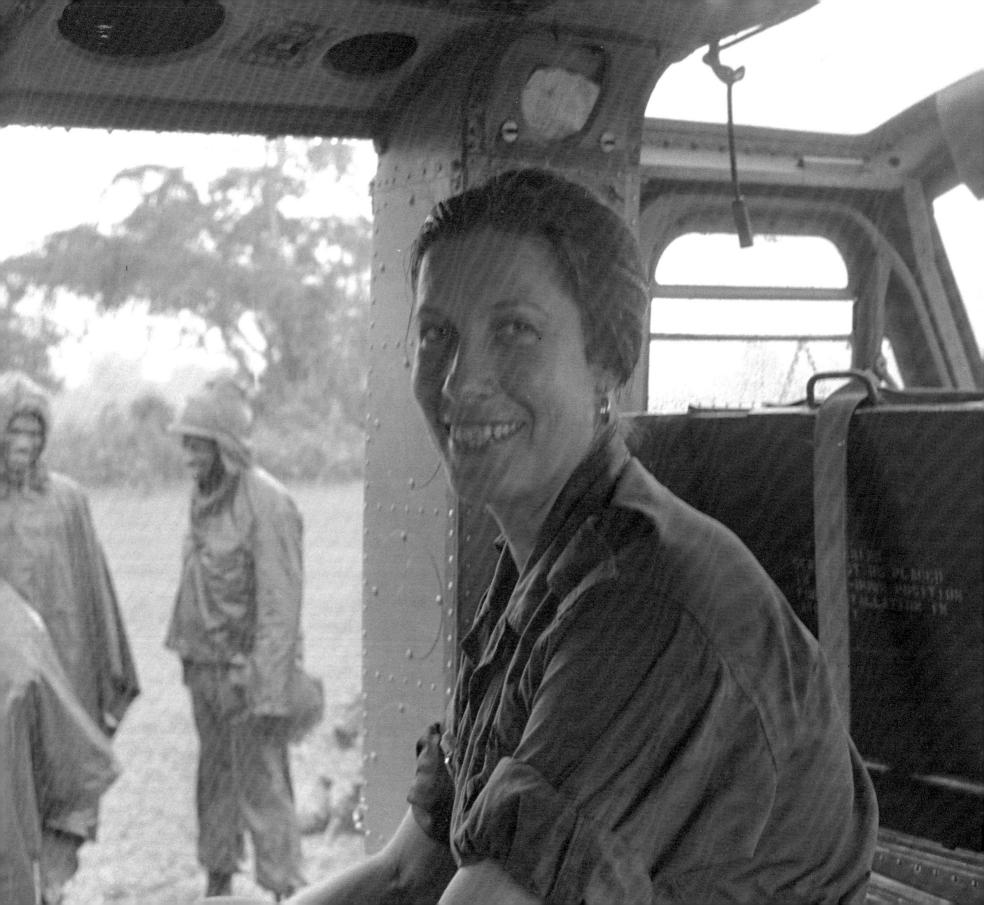

▲ Negative film envelopes from
Photo Perfect, a film processing
lab in Saigon.
1969 | South Vietnam

microfilm reels of historical newspapers, tracing primary sources at peer archival institutions, and connecting to human networks. Elizabeth Engel, senior archivist of the State Historical Society of Missouri, where Ann Bryan's papers are housed, played a pivotal role in piecing together this intriguing puzzle. Vietnam Old Hacks, a community of journalists who reported on the war, also provided valuable linkages. From these connections, principal figures whose names appeared in the collection were finally brought to light. After a series of introductions, emails, and phone calls, the photographs were reconnected with their creators, who had presumed that their life's work had been destroyed and permanently lost. The unexpected reunion elicited varied responses, from elation to distress. For some, the photographs brought back nostalgic recollections of their time with the *Overseas Weekly*. For others, the images conjured startling memories of the war and compelled them to confront a painful past they were not entirely prepared to face.

It soon became apparent that the newly available photographs of the *Overseas Weekly*—many of which had never been published—deserved to be seen by a wider audience. Thousands of pictures were methodically and subjectively examined for digitization, exhibition, and publication. The process of elimination proved to be a challenging task—there were far too many exceptional images. The final selection—representing a miniscule percentage of the entire corpus—was based on the physical condition of the negatives, visual impact, emotional resonance, and balanced representation of topical themes covered by the *Overseas Weekly*. The captions, derived from descriptive text gleaned from the dopesheets and photo envelopes, give context to the visual imagery.

We Shot the War: Overseas Weekly in Vietnam—a companion piece to a physical exhibition held at Hoover in 2018—is presented in four parts. Part one, "Marion and Ann Enter the Pacific," describes the journey and adverse conditions von Rospach and Bryan faced while managing operations of this roaring publication. For these two journalists, the war in Vietnam extended beyond the battlefields and reached into the courtroom, where they fought for the right of women to report in combat zones and argued against media censorship.

Part two, "Photographers in Focus," brings together the personal recollections of surviving photojournalists of the *Overseas Weekly*'s Saigon bureau: Cynthia Copple, Art Greenspon, Don Hirst, and Brent Procter. These individuals offer their professional take on combat photography and recount the circumstances that led them to Vietnam in the 1960s. Their mission to tell a vital story, from the GIs' point of view, led them dangerously and intimately close to the action and people fighting the war. Copple, a UC–Berkeley English graduate who had participated in Vietnam teach-ins in 1965, arrived in South Vietnam in 1967 on impulse and with a desire to filter the hysterical arguments of both pro- and anti-war protesters and to seek the

truth of war. Hirst, an enlisted Army soldier who served in Vietnam for two tours of duty in 1964–65 and 1967–68, was trained in combat photography. He returned to Vietnam and soon became Bryan's main reporter and confidant. In addition to combat reporting, Hirst also covered human-interest stories like Johnny Cash, June Carter, and Carl Perkins's 1971 performance for exuberant US troops at the Long Bình military base in Vietnam—an experience that was later recounted in Cash's hit song "Singin' in Vietnam Talkin' Blues." Greenspon, perhaps best known for his photograph "Help from Above," which inspired the movie poster for Oliver Stone's *Platoon*, captured striking action shots of emotion-laden soldiers during a terrifying Viet Cong attack in Huế during the spring of 1968, a pivotal turning point in the war. Procter, a New Zealander who was drafted for the war, found himself stationed in South Vietnam, not as an army grunt but as a war correspondent. He later succeeded Bryan as the *Overseas Weekly*'s Saigon bureau chief, serving in that post from 1970 to 1972.

Part three, "Selected Photographs of the *Overseas Weekly*, Pacific Edition," showcases a provocative mix of photographs of American soldiers in Vietnam making the best of an unfamiliar situation. The *Overseas Weekly* photojournalists accompanied service members on their missions to the central highlands of Pleiku, the citadels of Huế, the rice paddies of the Mekong River Delta, the coastal areas of Đà Nẵng, and the border regions of Laos and Cambodia. In this section, readers will find

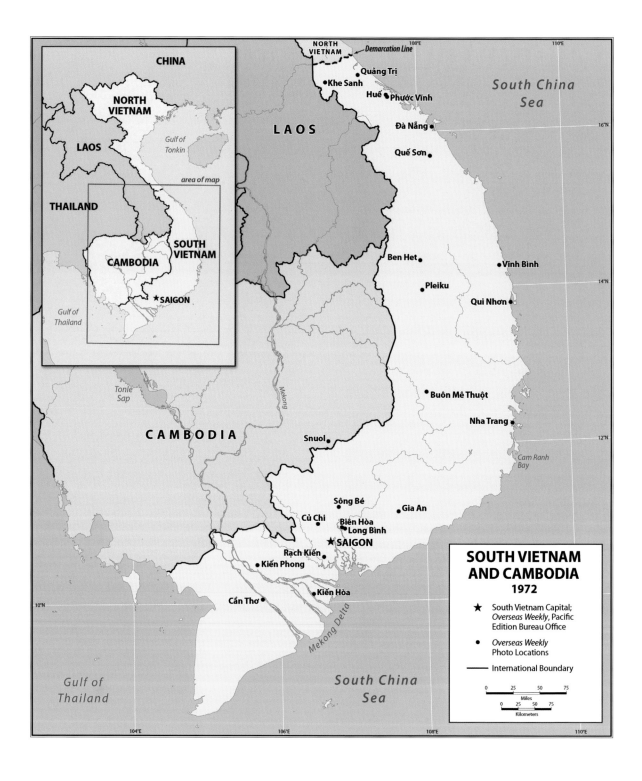

The Overseas Weekly

A TOUCH OF HOME ... AWAY FROM HOME

Vol. 21, No. 42 25 U.S. Cents Pacific Edition Oct. 23, 1966

Hell With Red Tape — OW Enters Pacific

— Page 4

Check Comics Inside!

Petty Gripes Trigger GI To Slay Sgt in Vietnam

— Page 24 — Page 5

Off-Beat Gear Outlawed For Airmen in Vietnam

SAIGON — He's a strange-looking airman deuce — decked out in Army jungle fatigues and a battered Aussie "go to hell" bush hat tilted at a rakish angle.

But A/2C Earl L. Morrison, an aircraft mechanic on the Tan Son Nhut AB flightline, will have to stick his unusual duds in mothballs next time an AP or a gung ho officer spots him.

Because Mickey Mouse has struck 7th AF, which recently clamped down on unauthorized uniforms and zeroed in on off-beat headgear. Specifically outlawed were the Aussie bush hats —nicknamed "go-to-hell" hats— and bright colored baseball caps with or without homemade unit insignias.

"For years, the Air Force has been strong on keeping the uniform simple and clean," primly explained a Tan Son Nhut lieutenant. "This all started with people coming up with slight alterations of the uniform, just to be different. Then it went from bad to worse."

Ticked-off flyboys don't see things that way.

"Who's there to impress with sharp uniforms — Vietnamese cabbies and bar girls?" griped an airman third.

At Tan Son Nhut, grease monkey Morrison is one of the last independent troopers who are bucking the crackdown by continuing to wear their go-to-hell hats.

Time was—just a few weeks ago, in fact — when dozens of guys roamed the big base and the streets of Saigon with the distinctive headgear.

Sometimes they rolled up the brims on one side, sometimes on both sides. The hats were usually OD or camouflage and guys sewed on patches, available in many local shops, with the names of their outfits.

Most popular patch was one that defiantly proclaimed, "Go to hell," and eventually all the bush hats became known by that name.

COs figured a man who drew a Vietnam tour deserved to break a couple of little regulations, looked the other way. Some leaders went their men one better, authorizing individual unit patches for hats and uniforms to beef up esprit de corps.

Unauthorized baseball caps, decorated with the name of the squadron or detachment in bright letters, were very popular. Troopers tacked on little brass rank insignia—also against the regs.

Writing in an Air Force newspaper, A/1C Patrick Baker of Da Nang AB reported that in baseball caps "color is predominant with each squadron vying for the brightest combinations."

Other units, especially at the big bases, adopted flashy berets with equally unusual colors.

But now all those bizarre bonnets are rapidly vanishing after the head shed ruled that you WILL cover your head in the authorized manner, flyboy.

If the Air Force is getting picky, can the Army be far behind? Surprisingly, the usually stricter ground-pounders aren't getting any static about headgear, according to officials.

Morrison faces Mickey Mouse.

"We don't have a regulation on hats," said a USARV spokesman, "because we don't have a problem."

Although rules are understandably rigid about when GIs have to wear steel pots for their own protection, most combat COs don't much care about what their men use at other times.

At the 25th Inf Div soldiers can sport sweatbands made of camouflage material and topped with a Tropic Lightning Division patch. Other outfits allow GIs to enscribe hats and uniforms with mottos or nicknames.

So at least when it comes to how you can clothe your skull, this man's Army obviously offers a lot more bennies than the blue-nosed Air Force.

photographs that capture the many faces, scenes, and facets of war, from the gritty realism of combat to the sanguine moments of hope and humanity. Also portrayed are the Vietnamese, Montagnards, and Cambodians who suffered immeasurable sorrow and loss during the protracted war. There are Boyle's photographs of North Vietnamese army defectors like the gold-toothed Trần Văn Hai who, exhaused from the virulent destruction of war, desired a peaceful future for his country. There are Procter's photographs of unnamed men of the Army of the Republic of Vietnam (ARVN) preparing for an unknown future post-Vietnamization. In one photo, taken during a jump school training session, the carnival-like environment and light-hearted expressions of the soldiers appear to contradict the gravity of the situation. And then there are Hirst's photographs of smoldering landscapes and of individuals like Võ Thị Phương and countless other anguished mothers, bewildered children, and terrorized Vietnamese families.

Part four, "Man on the Street," features close-up portraits and selected quotations by US soldiers that form a representative sample of opinion on the interview topics so often covered by the *Overseas Weekly*, such as racial prejudice in the service.

Though Vietnam War's complex and polarizing history has yet to be reconciled, there are still lessons to be learned, people to be remembered, and hearts to be healed. The *Overseas Weekly* photograph collection—now publicly accessible at the

◀ First issue of the *Overseas Weekly*, Pacific Edition. October 23, 1966. Image courtesy of the State Historical Society of Missouri.

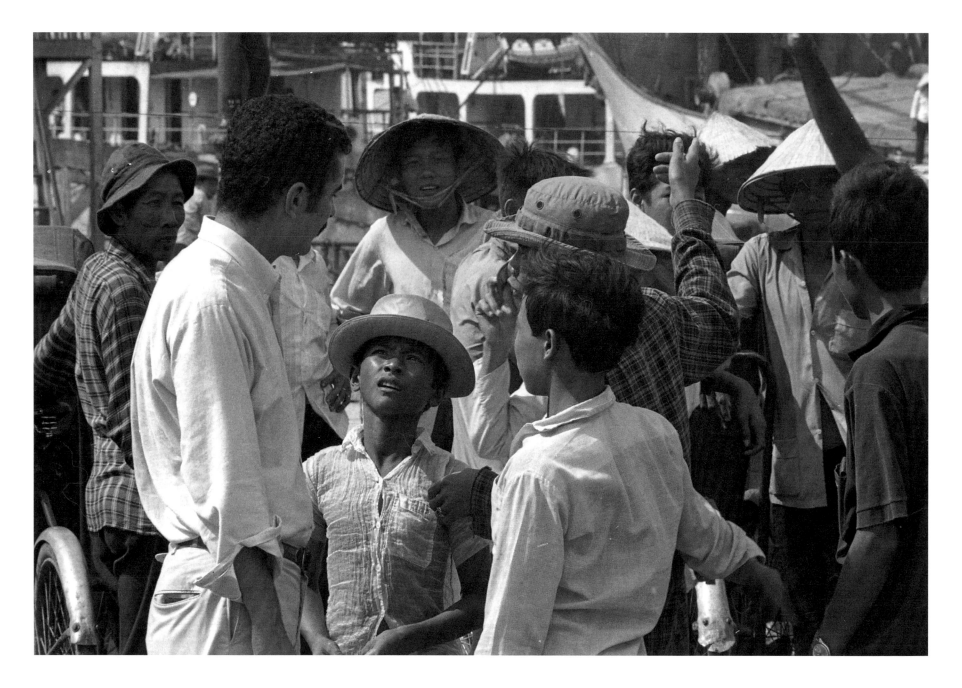

▲ **OW** STAFFER

Overseas Weekly reporter Richard Boyle conducts
interviews on the drug problem in Vietnam.
August 9, 1969 | South Vietnam

Hoover Institution Library & Archives, whose mission is to collect, preserve, and make available the most important materials about global political, social, and economic change in the twentieth and twenty-first centuries—offers a new generation of researchers an opportunity to reflect on, reexamine, and remember the grave sacrifices made by soldiers, journalists, and civilians in pursuit of democracy, a free press, and peace.

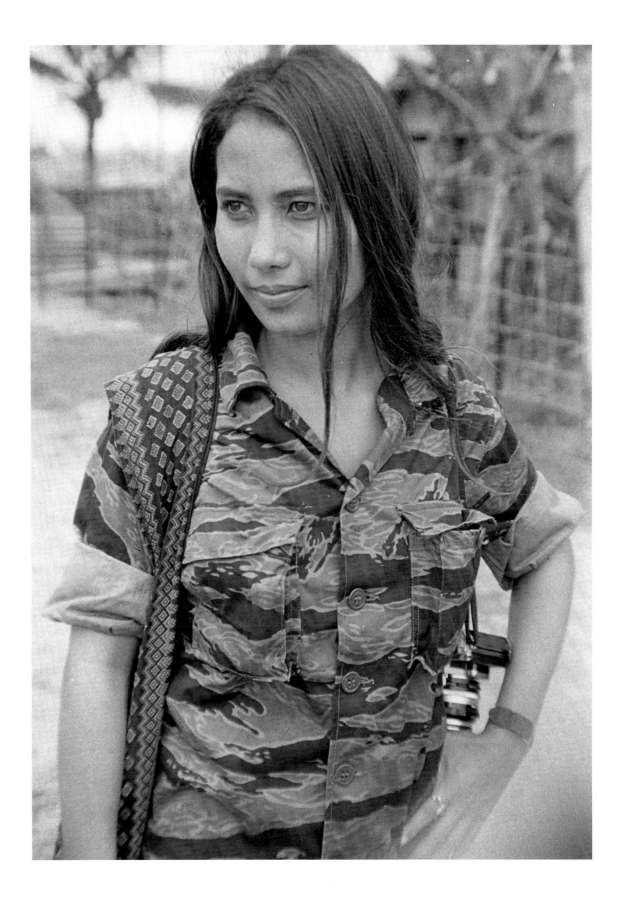

▶ **DON HIRST**
Overseas Weekly staff member Jacqueline Desdame.

August 3, 1969 | South Vietnam

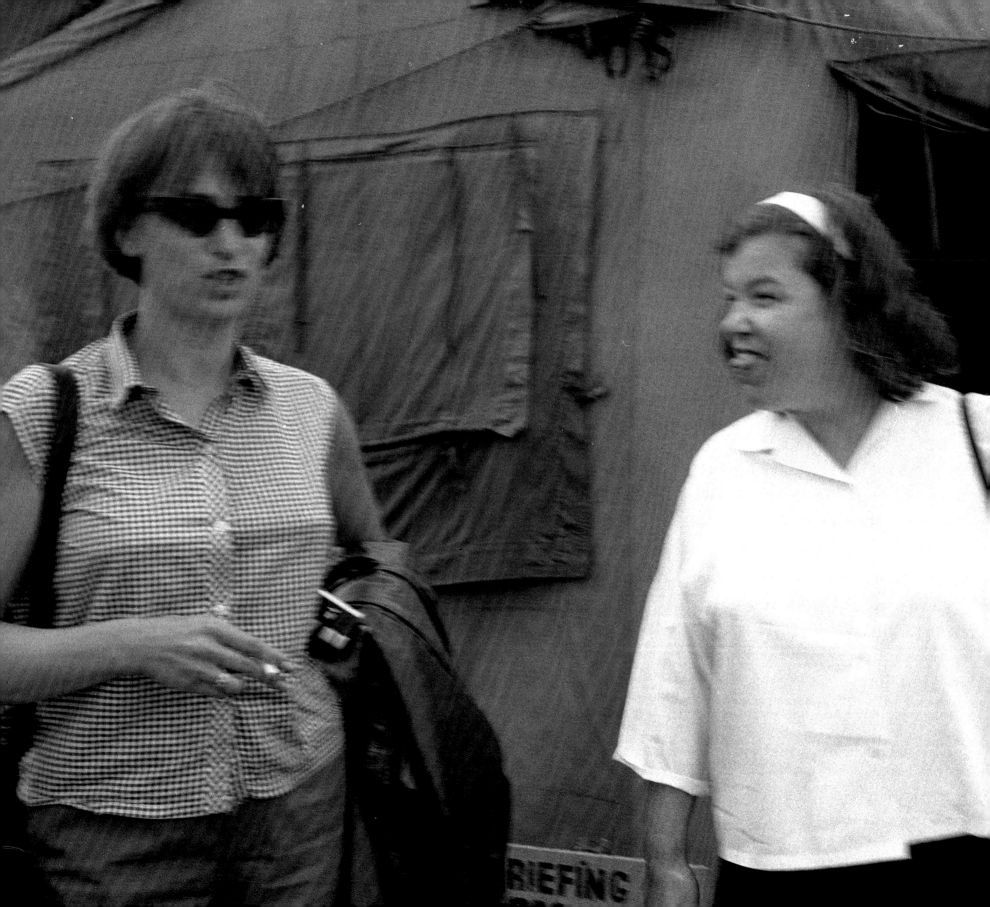

MARION AND ANN ENTER THE PACIFIC

WHAT THE HELL IS A WOMAN DOING HERE?

DURING THE 1960s, as war intensified in Southeast Asia, news agencies and journalists worldwide descended on Saigon in droves. Shielded, for the most part, from the brutality of guerilla warfare, the capital city of the Republic of South Vietnam pulsated to cacophonous rhythms of rock 'n' roll, buzzing mopeds, warbling street hawkers, and periodically the crackle of rifle fire. Here, the new bureau office of the *Overseas Weekly*'s Pacific edition, nestled in "Soul Alley" of the Khánh Hội district, swayed to its own distinct beat. The *Overseas Weekly*, an English-language military tabloid, represented an alternative subculture within the news industry. Working in concert with the *Overseas Weekly*, American GIs were given a platform to call attention not only to the brave acts but also the questionable conduct of their superiors and fellow soldiers.

With an initial investment of $3,300, the *Overseas Weekly* was founded in Frankfurt, West Germany, by two Stanford University graduates, Cecil and Marion von Rospach (who met while working for the student paper, the *Stanford Daily*), and three servicemen, Captain Charles Garnett, Captain Jim Ziccarelli, and Sergeant Joe Oswald.[1] Its first issue was published on May 14, 1950. The *Overseas Weekly* served as a counterpoint to US Department of Defense–sanctioned newspapers such as *Stars and Stripes*. As an independent, citizen-run paper, it sought to give the American troops abroad a voice by exposing often obscured truths about conflict, war, and the military establishment. At the time, the paper was disdainfully dismissed for being nothing more than a sensational tabloid peppered with schlocky content (and thus nicknamed the *Oversexed Weekly*).[2]

Following the outbreak of the Korean War and divorce from her husband, twenty-five-year-old Marion von Rospach took over as president and majority stockholder of the Overseas Media Corporation, the parent company that not only put out the *Overseas Weekly*'s various editions but also distributed other American periodicals in West Germany, operated a color film–processing plant, and published books. In the early years, her operations were conducted on a shoestring budget out of the trunk of a worn Studebaker.[3] Von Rospach, a supercharged dynamo of a businesswoman, was usually found with her sleeves rolled up, hair disheveled, and clothes wrinkled.[4] To GIs, the *Overseas Weekly* was described as a cross between a parrot and a lion and von Rospach as a cross between Ike and Bob Hope.[5]

The *Overseas Weekly* conducted its business without political interference until it printed a series of articles on the sex-reassignment surgery of a transgendered World War II veteran, Christine (née George) Jorgensen; the ill treatment of American soldiers in Turkey; and the underground activities of the American Nazi Party within the US military ranks.[6] As a result, von Rospach was ordered to stop printing and distributing the *Overseas Weekly* following a storm of protest from commanders in the field and others concerned with the moral welfare of dependent military personnel. The ban was lifted after intercession by several US congressmen and with the public support of the Hearst Corporation and the American Civil Liberties Union. In 1961, tensions flared again when the *Overseas Weekly* brought to light the alarming details of Major General Edwin A. Walker and the indoctrination of US troops by the John Birch Society, a far-right political

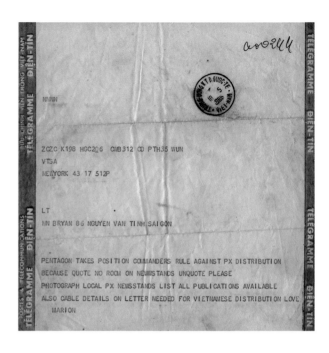

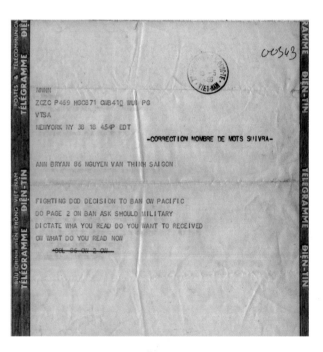

organization.[7] Within days of the exposé, General Walker was released from duty. For this reporting, the *Overseas Weekly* earned nominations for the Pulitzer Prize and the Heywood Broun Award of the American Newspaper Guild. The paper's hard-nosed reporting garnered praise for its candor and for conveying the "real, as opposed to the official picture of war as it affected American GIs."[8]

When US involvement in the Vietnam War escalated in the 1960s, Marion von Rospach seized the opportunity to set up local coverage and expand circulation to the Pacific region. She entrusted the endeavor to a promising young reporter named Ann Bryan, a spirited redhead from Texas "who did not sacrifice femininity when going into the fields under fire" and had five years of experience as editor of the *Overseas Weekly*'s family edition.[9] Now she was ready to take the helm as the only female editor in chief in Southeast Asia. In the beginning, Bryan ran a one-woman show from her second-floor apartment above the Guillaume Tell Restaurant on Trình Minh Thế Street. She single-handedly ful-filled the roles of reporter, photographer, editor, cir-culation manager, public relations specialist, copy boy, and putzfrau.[10] Her mission was clear: give the American troops a voice without fear of repercus-sions; write for soldiers in their own language.

The *Overseas Weekly*'s foray into Asia was not without challenges. In the beginning, Bryan's physi-cal strength was tested by oppressive heat and trop-ical illnesses. Her presence in combat zones was sometimes questioned by officers who antagonized her with scornful remarks like "What the hell is a woman doing here?"[11] However, the most daunt-ing task she confronted was navigating the murky waters of import licenses, government censors, printers, and distributors. Bryan was given the runaround, and she sensed that American military officials connived with Vietnamese officials to spike her distribution efforts. Left to her own devices, she attempted to connect with General William C. Westmoreland to plead her case. For this, she was chided by Lieutenant Colonel Dan Biondi (Chief of Public Information, Military Assistance Command, Vietnam) for mixing reporting and business. "The reporters from *Time* and *Newsweek* would never talk to the general about circulation," he told her.[12]

She turned to the Defense Department, through Assistant Secretary Thomas D. Morris, to request for the *Overseas Weekly* a *sine qua non* "no objec-tion letter" to enable the publication and distribu-tion of newspapers in Asia without falling afoul of the ban or obstruction of the foreign governments involved. This request, together with a renewed request for post exchange (PX) distribution rights, was denied. Bryan felt demoralized.

> Frankly, I'm depressed, if you will pardon my indulging in some complaining. Not depressed enough to give up by any means, or I will tell you. Who would have thought publishing a fairly simple and straightforward newspaper could be so much trouble? I don't mind a fight, but I don't really understand the Vietnamese rules and I think the Americans are hitting below the belt.[13]

Throughout her travails, Bryan found support in like-minded women at the *Overseas Weekly* (Dagmar Rios and Jane Bobba), as well as fellow female correspondents from rival news organi-zations, such as Kate Webb of United Press Inter-national, Anne Morrissy Merick of ABC-TV, and

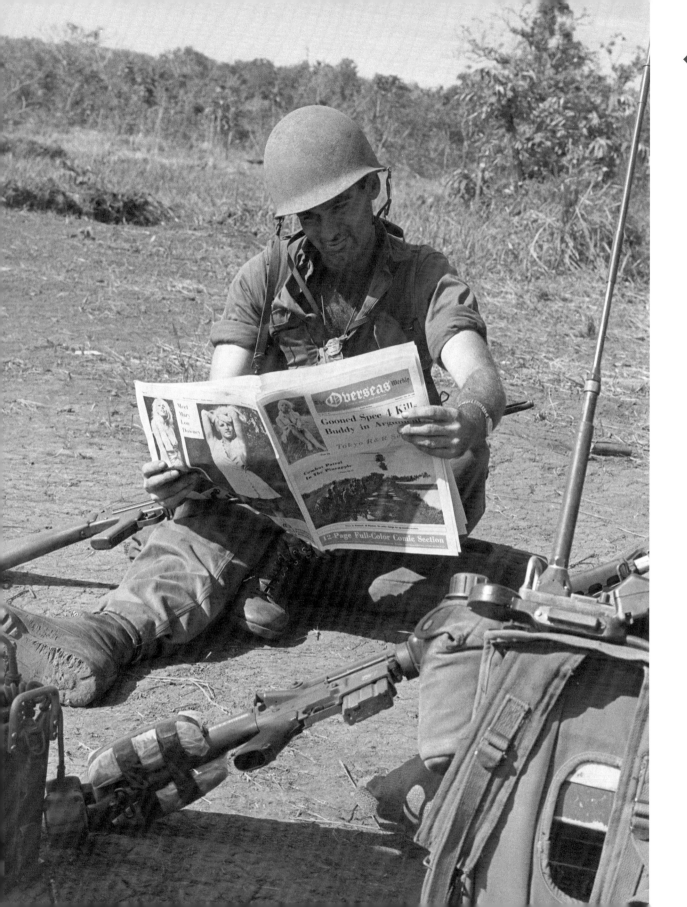

◄ **OW STAFFER**
Unidentified Australian soldier reading the *Overseas Weekly*.
February 1, 1969 | South Vietnam

Denby Fawcett of KGMB, the Honolulu CBS affiliate.[14] Together, they even led a protest against General Westmoreland's 1967 edict that banned women from reporting in combat zones. "I paid my dues and earned my place in the field, but even so, as women, we still had to assert our right to cover the war in Southeast Asia."[15] Von Rospach had absolute faith in Bryan's modus operandi and offered words of encouragement from eight thousand kilometers away.

> I can understand that you must feel discouraged often because it is not the red, white and blue package one was taught in grammar school. I must say however, Ann, that the fight we are waging has a value beyond the *Overseas Weekly* and I think, as you have always thought, that we should take pride in doing it. As a matter of fact, as I look at the pictures of those poor boys on the front line I wonder if maybe ours isn't a better battle.[16]

Without the benefit of competitive access to the military newsstands, the determined Bryan charged forward. Five hundred copies of a special edition of the paper were replated by the main *Overseas Weekly* office in Frankfurt and commercially airlifted to Saigon. The paper made its official debut on October 23, 1966. In bold letters, the front page blazoned "TO HELL WITH THE RED TAPE—THE *OVERSEAS WEEKLY* ENTERS THE PACIFIC." Bryan's first editorial blared, "With this issue, The *Overseas Weekly* launches regular publication of its Pacific Edition. . . . The battle rages—and will continue as long as Constitutional guarantees of freedom of the press exist in America—and as long as readers desire to read an independent, uncensored,

newspaper such as The *Overseas Weekly*."[17] Within twenty-four hours the paper, hawked by the trẻ bụi đời ("young dust of life") newsboys on Tự Do Street at twenty-five piasters a piece, sold out.[18]

Subsequent issues, printed by the Dai Nippon Printing Company in Hong Kong, were banned in Thailand, Okinawa, Korea, Japan, Philippines, Guam, and Taiwan for unstated reasons. The copies that filtered through commercial channels into South Vietnam were heavily censored. Despite being one of the bestselling publications for soldiers in Europe, it was the only newspaper that was barred from distribution on US military PX newsstands in the Pacific, not on grounds of content, but because of the lack of shelf space.

Bryan felt that "no space" was a poor excuse for preventing the *Overseas Weekly* from being sold at any military post exchanges in Asia—a decision, in her opinion, that amounted to censorship and retaliation for the General Walker reporting. Undeterred by institutions that lambasted the paper as "personally repulsive," she, along with the entire *Overseas Weekly* editorial team, fought back and waged a yearlong battle against Secretary of Defense Robert S. McNamara.[19] For this, the *Overseas Weekly* earned a new moniker: "the least popular publication at the Pentagon."[20]

On October 3, 1967, the *Overseas Weekly* won a plea for trial against the Pentagon when the US Court of Appeals for the District of Columbia Circuit unanimously reversed a decision made by the US District Court and ruled, "It is impossible to say at this time that the necessities of military operations justified the ban on The *Overseas Weekly*." Once again, the *Overseas Weekly* emerged victorious against the military establishment's efforts to

stifle its voice. Bryan expressed the significance of the verdict by stating it was a fine moment for the First Amendment to the US Constitution.[21]

The *Overseas Weekly*'s readership base increased to sixty thousand. As Bryan's skeletal staff grew, she moved into larger quarters at the *Newsweek* villa at 10 Duy Tân Street, where the staff shared two-thirds of an office with the *Washington Post*, a luxurious upgrade that included two desks, a filing cabinet, and access to a telephone with the number 2 21 51.[22] Bryan recruited a colorful assortment of writers and freelancers armed with nothing more than an intrepid spirit, writing tools, and cameras. Among them were Anne Allen, Richard Boyle, Cynthia Copple, Jacqueline Desdame, Cathy Domke, Art Greenspon, Bob Handy, Don Hirst, Phil Jordan, Saul Lockhart, Tom Marlowe, Brent Procter, Terry Reynolds, John Roemer, Dennis Rutherford, Charles Ryan, and Bob Stokes.

In October 1969, the *Overseas Weekly* was dealt a new blow when von Rospach died unexpectedly in her New York City home at the age of forty-three. The publication's heyday reached its denouement with the sale of the *Overseas Weekly* to Joseph Kroesen, a mail order diamond merchant from Oakland, California, and his business partner, Bud Koch from Walnut Creek, California.[23] Ann Bryan remained at her post until November 14, 1970. She had married Frank Mariano of ABC-TV, and her heart guided her toward new aspirations: refugee relief work and finding homes for Vietnamese orphans in the United States. Brent Procter carried forward as Saigon bureau chief until August 1971.

In September 1972, Don Hirst left Saigon and went to Okinawa to open the *Overseas Weekly* Pacific edition's last foreign bureau. By 1974, the *Overseas Weekly*'s Pacific and European bureaus abruptly shut down their offices, and the staff dispersed. The trailblazing publication faded into silence.

Despite the malaise of war and ardent struggles to establish the *Overseas Weekly* in Frankfurt and in Saigon, von Rospach and Bryan's fierce conviction to give voice to the US troops propelled them to directly confront societal notions of a woman's role in reporting "a men's war." In the age of a well-read GI, their peculiar tabloid exerted just enough influence to unsettle the US military paradigm and ultimately shift the way the Cold War–era narrative would be recounted by soldiers on the front lines.[24] These two avant-garde newswomen staunchly defended against corrosive attacks on the press and left a legacy of persistence and commitment to the American principle of freedom of expression.

—— Here to Serve You ——

The Editor's Notebook
Battle Rages But We're Starting

WITH this issue **The Overseas Weekly** launches regular publication of its Pacific edition.

The **Weekly** began serving American servicemen in Europe in 1950 and has been regularly distributed ever since through facilities of the military newsstand system there.

Over the past year and a half, as military friends moved from Europe to the Pacific to bolster American strength, **OW** received an increasing number of requests to set up local coverage.

We never dreamed the U.S. Government could make such an effort so difficult. By stalling, evasion, misrepresentation and even lying, petty bureaucrats left no doubt in anybody's mind that they found the idea of a genuine GI newspaper in the Pacific too tough to take.

The battle rages—and will continue as long as Constitutional guarantees of freedom of the press exist in America—and as long as readers desire to read an independent, uncensored newspaper such as **The Overseas Weekly**.

We've been asked why some people in the Government are opposed to **OW**. It certainly isn't for the reason given—"there's no space on the newsstands." (Have you looked at **your** newsstand lately?)

It is because **OW** prints hard facts, and not even our worst enemy has questioned the paper's accuracy. It steps on toes. It never has been and never will be bought by pressure groups. It fights. It backs the little guy against the impersonal machine.

A newspaper is a living entity with responsibilities and rights. The only people who should judge it are the readers — not timid officials. How can one defend fighting for democratic ideals as we are the world over while denying them to our own citizens?

Let us speak plainly. The exclusion of a publication which for 16 years has been the largest selling weekly for American servicemen in Europe; which has never been charged with any act harmful to the U.S.; which has never even lost a libel suit; which can prove demand among its readers . . . this IS censorship.

We ask no favors. We ask only the same right given every other American publisher—to be sold side by side with other publications and let the reader decide.

We'll keep fighting. In the meantime, we're going to do our best to get our newspaper to you through whatever means we can find. But if you have trouble finding us in the beginning, it ain't because we're not trying!

Let us know what you honestly think of us. We appreciate suggestions and benefit from criticism.

We're here to serve you.

▲ Ann Bryan's first editorial for the *Overseas Weekly*, Pacific Edition. October 3, 1966. Image courtesy of the State Historical Society of Missouri.

▲ *OW* STAFFER
US Marine Corps at Cửa Việt Base
March 1969 | Near Quảng Trị

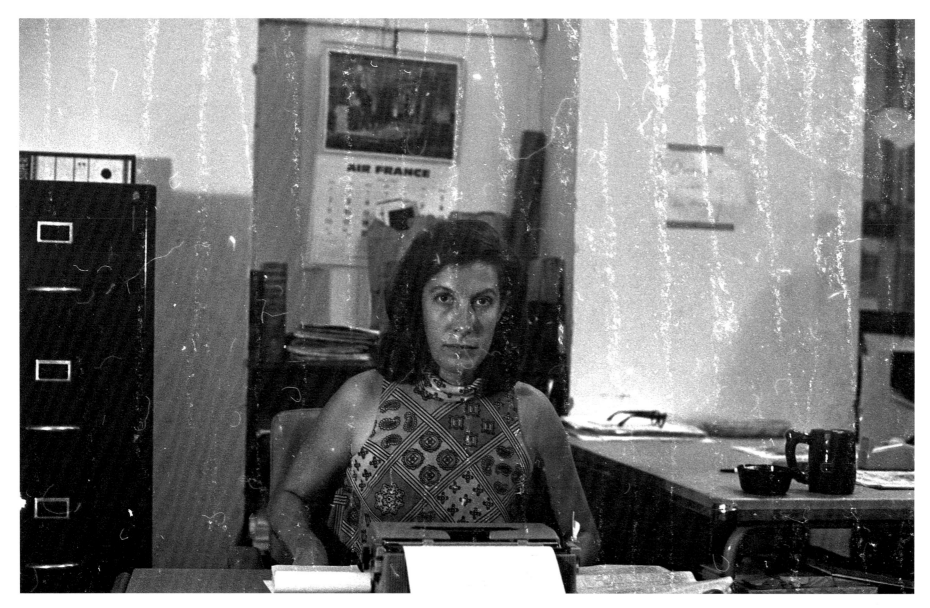

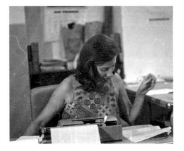 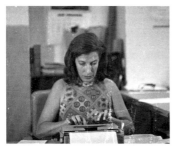

◀ *OW* STAFFER

Overseas Weekly Pacific Edition, editor
in chief Ann Bryan (1966–70) at the Duy
Tân Street office.

1969 | South Vietnam

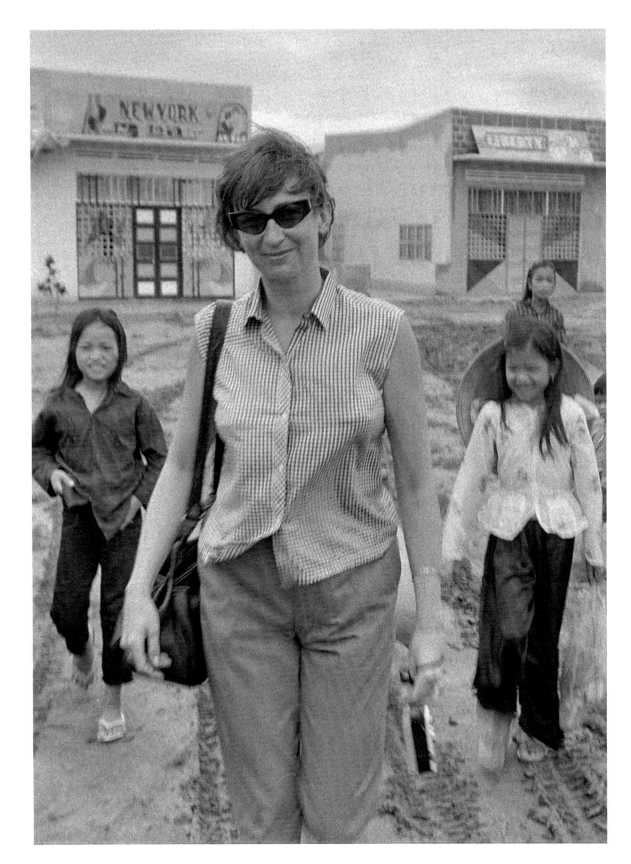

▶ Ann Bryan
1967 | South Vietnam

PHOTOGRAPHERS IN FOCUS

HAPPINESS IS BEING EXPOSED BY THE OVERSEAS WEEKLY.

CYNTHIA COPPLE

I ARRIVED AT TÂN SƠN NHỨT AIRPORT on the outskirts of Saigon on January 30, 1969. The airport was rundown and empty, with a few young American soldiers in bedraggled uniforms with M16s. I asked one if he knew of a good hotel and where to get a taxi.

"Why are you here? Don't you know there's a war going on? Last year at Tết this airport was overrun by Viet Cong, and Tết is in two days!" He shouted at me as if he had never seen a twenty-two-year-old blonde woman with a suitcase and portable typewriter before. Maybe he thought I was a spy. Mata Hari as a blonde UC–Berkeley graduate traveler!

After I settled in at the "safe" hotel recommended by the soldier in the airport, I started walking around, looking for the war. It turned out that the war was not in Saigon, although it was not safe there either, with exploding hand grenades being tossed into cyclos in the busy streets. (Cyclos were motorcycles with passenger seats in the front.) The rat-a-tat of machine guns interrupted our sleep nightly.

When I had attended a Vietnam teach-in as a student at UC Berkeley (I graduated in 1966), I was disappointed to hear both pro- and anti-war sides making hysterical arguments that were hard to believe. I was anti-war, and yet I wondered why we were really at war. That curiosity had taken me on a circuitous route to Saigon.

At JUSPAO, the military's PR office, I was told that I needed to get outside Saigon to find out firsthand what was happening in the war. For that I needed press credentials. A credentialed journalist could travel anywhere in the country for free on military aircraft with the rank equivalent of major. With press credentials, I could get a visa extension, which was important since my tourist visa was expiring.

I visited the media bureaus in Saigon and found out that Ann Bryan, bureau chief of a publication called the *Overseas Weekly*, was looking for a writer. I had taken courses for an MA in English literature at San Francisco State College, including a creative writing course, but I had not published anything yet.

I rode to the *OW* office in a cyclo. The office was at 10 Duy Tân, up the street from the Continental Hotel in downtown Saigon. Outside the door were two small, easy-to-miss signs: "*Overseas Weekly*" and "Duy Tân Color Lab."

Opening the door, I walked into a front room and found an empty desk with a sign on it ("Film Drop Off") next to an empty cardboard box for film to be developed.

"Is this the *Overseas Weekly*?" I called out. Through an open door into the next room I saw a tall, red-headed woman maybe ten years older than myself. Ann Bryan had a soft voice, but she was very bright and fully in charge. She invited me in and told me about herself and the publication. She was the only female bureau chief in Saigon. I wanted to write for her!

She sat behind a big, battered metal desk piled with carbon copies of articles and eight-by-ten

▶ **OW STAFFER**
Overseas Weekly freelancer Cynthia Copple sits with a Montagnard family inside a newly built longhouse in Chu Kuk hamlet.
May 16, 1969 | Pleiku

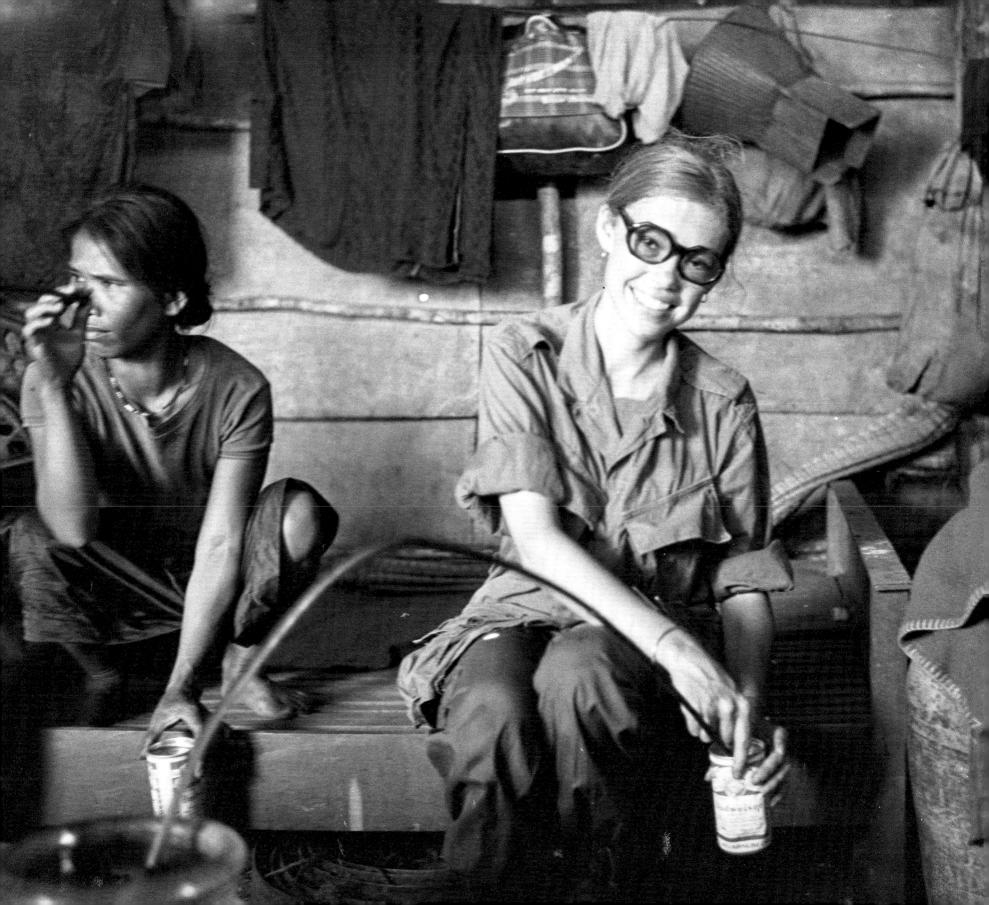

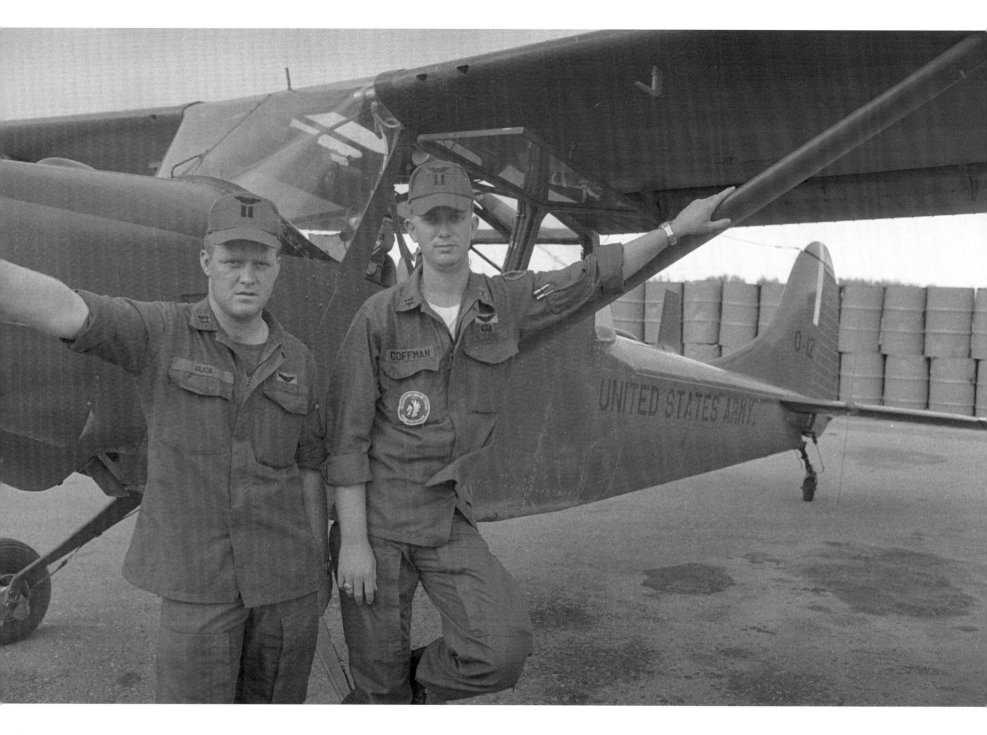

▲ **CYNTHIA COPPLE**
Captain Blick (*left*) and Captain Coffman.
June 6, 1969 | Kiến Hòa

black-and-white glossy photographs. The small office had two or three desks, and later I saw that Jacqueline Desdame, the Vietnamese-French office assistant, and Don Hirst, Ann's main writer, seemed to be using the desks.

Ann told me she had just lost a journalist (I was never sure if he had been killed on the job or had gone back home) and needed someone to do man-on-the-street interviews, cover courts-martial, and write feature stories. She gave me one story idea to start with and said we'd see how it goes.

That first article was about the Psyops group—the Army's Psychological Operations. They were located just on the outskirts of Saigon. They were responsible for "winning the hearts and minds" of the Viet Cong (VC). Among other things, they flew planes that dropped leaflets encouraging the VC to surrender. They didn't understand the Vietnamese minds at all, and their efforts were comical in retrospect. *Playboy* centerfolds were awaiting them if they surrendered. Not their culture at all! (I flew on a leaflet-dropping biplane later.)

At Psyops I met the information officer, who briefed me on the group's activities. I asked to speak to some enlisted men Ann had told me the *Overseas Weekly* focused on the enlisted man's point of view and told me to be sure to speak to some. The Army's publication, the *Stars and Stripes*, printed the official view of the service and wars. The *OW* was designed to counter the official point of view.

I took notes during the interviews in a spiral steno notebook, then returned to my hotel room and my Olivetti portable typewriter. I had bought it in Hong Kong, where I had spent my spare time trying to write dialogue when I wasn't writing poems. Now I had to write an article, my first ever.

I stayed up all night writing, typing and whiting out, rewriting, scotch-taping sections together, and drinking coffee to stay awake.

On the day of the deadline, exhausted and scared that my article wasn't good enough, I took a cyclo to the *OW* office. Ann offered a friendly greeting from behind her desk. She asked me to put my article on top of a pile on her desk. She was busy putting together the next issue and was up against a deadline. The newspaper was shipped to Okinawa, Japan, where it was printed and shipped back to Vietnam and circulated in that country and at military bases in Asia.

After a few days I went to the office again. After exchanging greetings, Ann asked me what other story ideas I had. I was surprised. "Was the Psyops article okay?" I asked.

"Oh, sure, it was fine. Now you have to come up with story ideas and run them by me. And here's an old Nikon with a broken light meter. You'll need to take pictures for the man-on-the-street interviews and other articles too."

I was in! I was elated to see my first article in print. It was hard to believe that I was in Vietnam during the war and had published an article.

One of my jobs was to do the man-on-the-street interviews. I would go to the PX in downtown Saigon and stand on the sidewalk outside, asking approachable-looking soldiers as they walked toward the entry door, "Can I do a man-on-the-street interview with you for my newspaper, the *Overseas Weekly*?" Sometimes they'd ask what the question was first, or they'd say no or yes. Sometimes they'd ask, "What's the *Overseas Weekly*?"

When they said yes, we'd go inside and find a table. They'd get a Coke or coffee or food, and I'd set

up my Sony TC-100 portable tape recorder, which was lightweight and top-of-the-line for journalists at the time. And I'd get my pen and steno pad out.

I remember a few questions I asked: Is there prejudice in the armed services? (Blacks said yes. Whites said no.) Do you believe the number of enemy dead being reported? (Most said no. Some said they were at a battle and never saw that many dead.)

My whole war experience was like a dream: intense emotions, unexpected events, fear of failure as a journalist (but no fear of dying). Vietnam was like a poem: very intense emotions, laughter and horror feeling much the same. Laughing at gunshots—because one intense feeling felt like the next. Life, death—it was a matter of luck. Live for the moment, intensely. I interviewed many soldiers who were addicted to that intensity and later found life in the United States to be dull, so they re-upped. Journalists too.

I met Richard Boyle when he was hired by Ann at *OW* to write a few articles. I think he had showed up at her office much as I had. He had rented a small car and offered to drive me home. He had wild, bloodshot eyes, talked a mile a minute, and flirted like mad, so I was a bit hesitant but finally agreed. That was the most dangerous ride I have ever been on. He careened around the corners, honking the horn, laughing hysterically, talking nonstop. I was sure we were going to crash and burn. I kept screaming, "Slow down! Stop! I want to get out!" and he kept going. My knees were shaking when I arrived at my apartment (moving from the hotel to an apartment was another story), and I never rode with him after that.

Richard took the riskier articles I didn't want to cover—pot smoking among the troops, the fact that the United States was in Cambodia even though the US government was denying it. Years later he wrote the book *Salvador*, about being a war correspondent in El Salvador. He was always looking for the next war to cover.

I wrote human-interest stories, interviewing the soldiers, flying on medevac missions, covering courts-martial. To cover the courts-martial, I took a military bus for the half hour trip from Saigon to Long Bình, an Army complex. One soldier up before the jury had returned from three months in the jungle and on a Friday night was partying in the barracks with his buddies. He got into a drunken argument with his best friend from home, with whom he had enlisted. To win the argument, he went into the other room, unlocked his weapon, and shot his friend dead. In the courtroom he was sorry, sad, upset, regretful—but his friend was dead. His life was changed forever.

A few other courts-martial stories I covered involved a captain who had not stopped his men from shooting up a village—men, women, and children—because they (or a VC hiding in the village) had killed one of his men; a huge organization of soldiers who sold postal money orders (some soldiers made tons of money illegally); and the illegal sale of army equipment to the Vietnamese army (ARVN) by soldiers who pocketed the money.

My time with the *OW* in Vietnam was very intense, and I had a hard time adjusting to life in the United States afterward. Deep relationships formed quickly in the life-or-death environment of Vietnam. Because tomorrow—who knew?

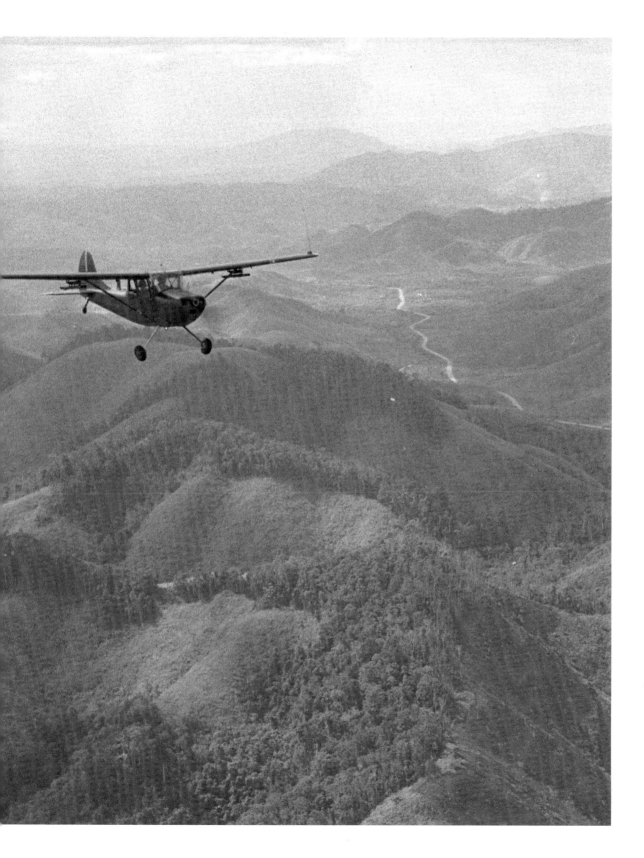

Back home everyone seemed to wear a mask, feelings were hidden, and it took a long time to make friends. And nobody understood what I had experienced, even though I was interviewed on TV, radio, and in newspapers.

When I first visited a supermarket after being in Asia for a year and a half, I almost fainted, suddenly overwhelmed by too many brightly colored cans to choose from. I had been shopping at small stores and markets where you interacted with the shopkeeper. A huge supermarket with no one to help you—it seemed inhuman. Being human, I eventually adjusted.

◀ **CYNTHIA COPPLE**
Bird Dogs fly at about 1,200 feet over the rugged terrain of Kiến Hòa province. One of the Bird Dogs is doing a "wing over" to lose altitude fast and go down for a closer look at the ground.
June 6, 1969 | Kiến Hòa

ART GREENSPON

ANN BRYAN, the Saigon editor in chief for the *Overseas Weekly*, greeted me cordially but with reserve in front of her desk in the small space her bureau rented from the more prosperous *Newsweek* magazine. The office was located in a villa just across the street from the Notre Dame Cathedral in Saigon. I was sweating through my shirt, not being used to the 90-plus-degree noonday temperatures common for late December in that part of the world. She seemed like a no-nonsense woman, a female boss in a man-centric war zone.

I had arrived in Vietnam a few days earlier, December 25, 1967. As a Christmas gift to myself, I was heading out to cover the biggest and most controversial news story of the decade. I had bought a one-way ticket to Saigon and arrived with $50 in my pocket on a two-week tourist visa. I was determined to show the world not just what the "truth" of the war was but also what a great photographer this naive and brash twenty-five-year-old could be.

Military Assistance Command, Vietnam (MACV) was in charge of credentialing all journalists in the country. To be accredited as a freelance photographer, I needed two letters from established news organizations stating that they would buy pictures from me and that if I were wounded or killed what remained of me would get home safely. The United Press International (UPI) had already given me one letter, and Ann would hopefully supply the second. I viewed it as a job interview, showed her some of my earlier work from the United States, and made sure she knew about my previous experience as a TV reporter in New York City. She seemed impressed and agreed to provide the needed second letter.

There was a good news–bad news quality to my deal with the *Overseas Weekly*. The rate they paid was substantially more than what I got from UPI. *OW* paid $35 for each picture published in the paper, while UPI paid only $10 for each picture they selected whether it moved on the wire or not. At UPI I got to keep the outtakes and had the right to sell the unused pictures. The onerous part of the *OW* deal was a little like a Faustian bargain. They would pay more but got to take all of my negatives and ship them off to headquarters in Germany, never to be returned or seen again. Ann made me the offer somewhat apologetically but said that was the best she could do. I wavered for a moment but quickly realized I was almost broke and needed to get out of Saigon quickly so I could get to work and, better yet, freeload off the military. We shook hands and I left the office a few minutes later. Of the approximately six hundred journalists accredited to cover the war at any one time, only about fifty to seventy-five of us covered combat on a regular basis. Most of the others were satisfied to wander over to MACV headquarters at five every day to attend the military's daily press briefing, where body counts and rosy battle reports were handed out around the room. For those of us who cared to be with the troops in the field, five o' clock could be spent

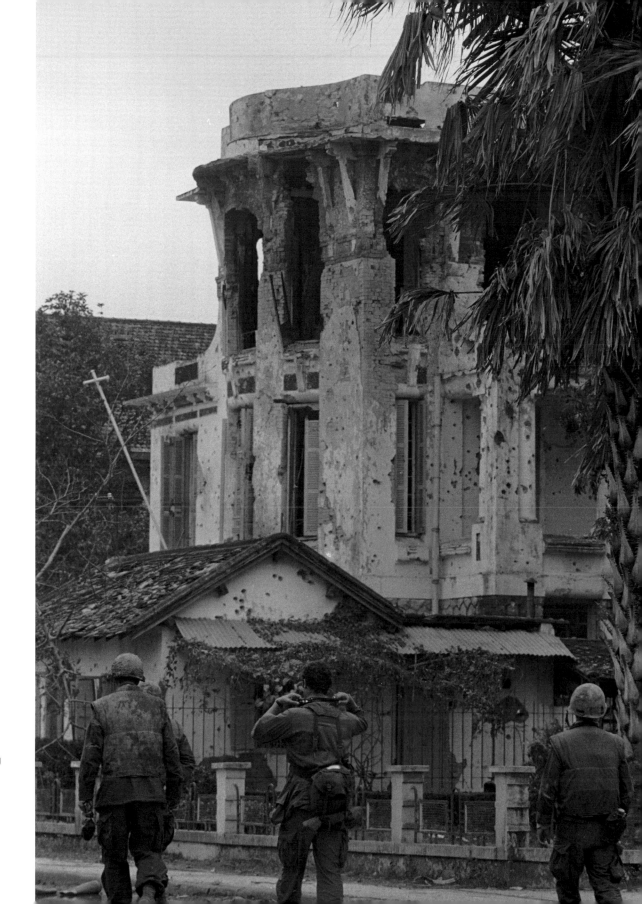

▶ ART GREENSPON
Newsmen tread along Lê Lợi Street along
the southern bank of the Perfume River.
February 1968 | Huế

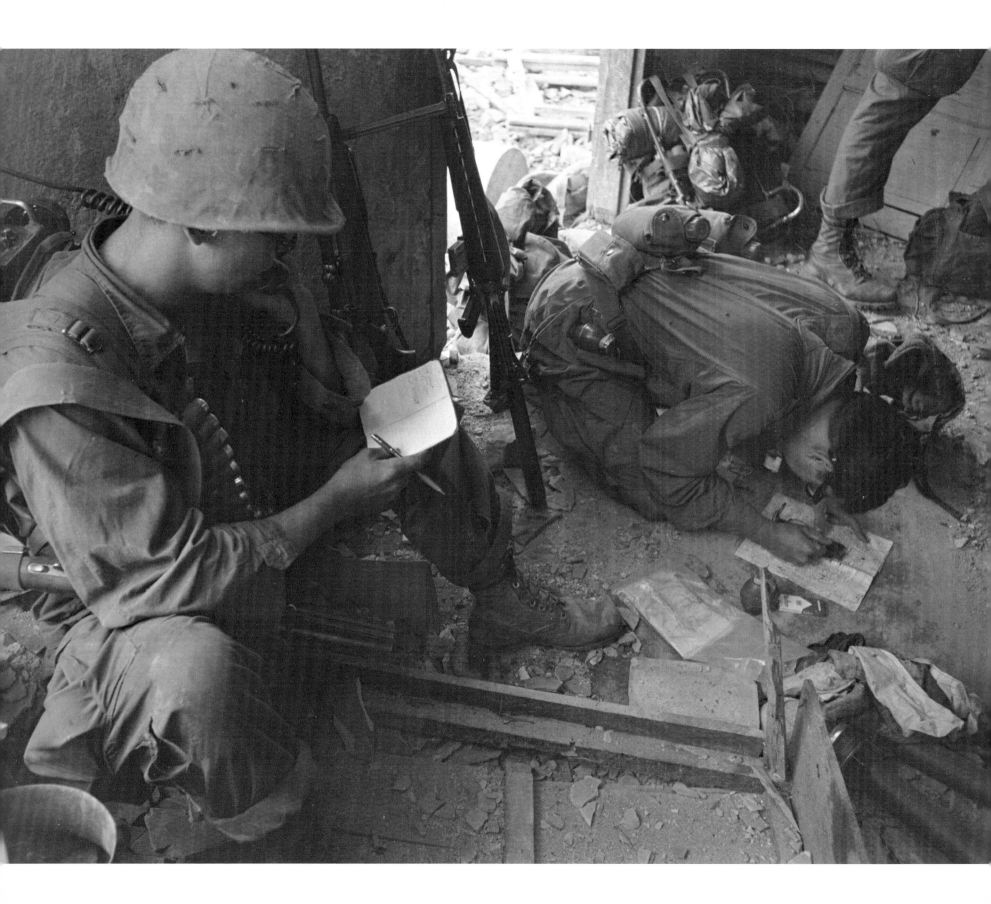

eating Ham and Lima Beans, a particularly noxious C ration dinner, shivering in rain-soaked fatigues somewhere in the dense triple-canopy jungle.

On the few occasions I was invited to a field-grade officers' mess, which was limited to those whose rank was major and above and was offered only at bases far from the fighting, I quickly discovered it was better not to disclose my affiliation with the *Overseas Weekly*. It had been banned from distribution at the PXs around the country and was primarily hawked by the street urchin newsboys who swarmed the city streets and off-base honky-tonks that the soldiers frequented. *OW* had a tabloid reputation. It was often muckraking in its approach. It saw itself as the soldier's ally, and the grunts saw it as a refreshing alternative to the military's more mainstream *Stars and Stripes*. A chill would take over the officers' mess the few times I admitted I was stringing for *OW*.

I was a freelancer and traveled wherever I wanted, covering military operations I thought would generate sellable photos. Pictures of combat sold easily. But it seemed to me that *OW*'s photo budget was pretty limited. I would spend some time in the field, return to Saigon with undeveloped film, drop it off for processing and first selection at UPI, and then stroll up to see Ann with the remaining negatives. Since UPI didn't have much of a budget for freelance pictures either, there were quite a number of good shots still available. Ann would make contact sheets, highlight some pictures she liked, and then ship everything off to Germany, never to be seen by me again. The nagging problem I presented for her was captions. I hated writing captions, and we wrestled over that for my entire

tour in Vietnam. Ann wanted to know the names of the people in the pictures. I argued that after an intense shelling or fierce firefight, I didn't feel right asking for the names, ages, and home towns of guys who, a few minutes earlier, had come close to seeing eternity. I often trembled after those encounters myself and certainly didn't feel like asking for mundane information.

It wasn't long before I became disenchanted with the number of pictures that were appearing in the paper and therefore the amount of money I was making from *OW*. I stopped showing them pictures after I found more affluent audiences at the Associated Press and Time-Life. After being a no-show for a few weeks, I ran into Ann on the street. She firmly reminded me that I owed her pictures. After all, she had helped launch my career in Vietnam. Some of the pictures in the Hoover Archives exhibition are a result of that conversation.

In February 1968, the North Vietnamese Army (NVA) had overrun the ancient imperial city of Huế as part of their Tết Offensive. Realizing the enormity of the story, I rode a military landing craft loaded with artillery shells from Đà Nẵng up the Perfume River, as it was the only way to gain access to the early fighting to retake the city. The picture of the Marine recoilless rifle team fighting there has a special meaning for me. Some fifty years ago, the picture was printed quite large on the front page as part of an *OW* story describing the battle. Ann proudly showed it to me, and I was quite pleased. And then it disappeared. All of those negatives were swallowed up by what seemed like a giant German vacuum and swept away to who knows where. For me the pictures forever after lived only in my mind's

ART GREENSPON
Radio operators of B Company receive, transmit, and decode messages about their units movement and maneuvers.
March 1968 | Huế

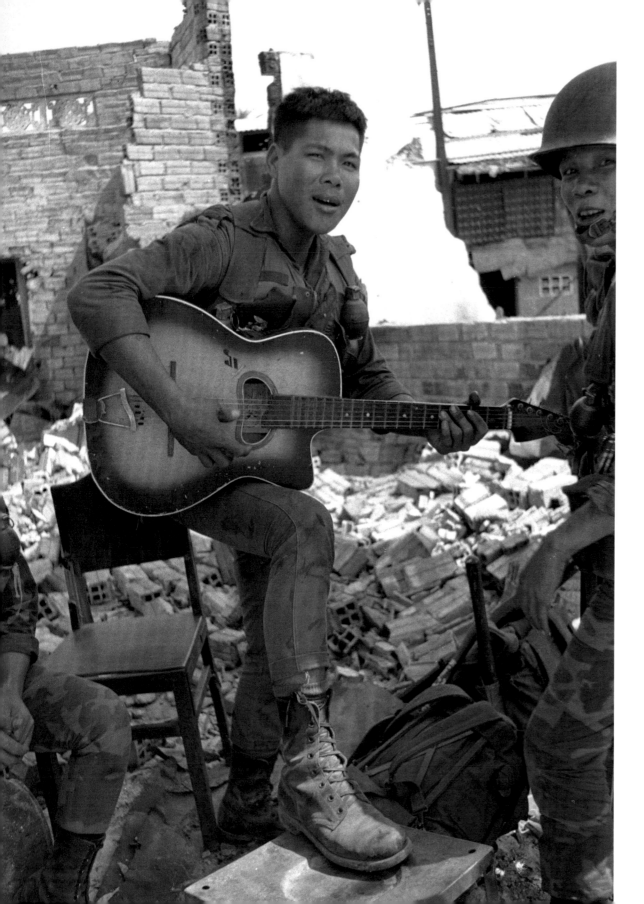

ART GREENSPON
An unidentified ARVN soldier sings in the midst of the rubble.
March 1968 | Huế

eye. Many times over the years I thought about traveling to Europe to search out my long-lost progeny. But somehow life always intervened, and I became resigned to the idea that losing them was just one of the costs of doing business in that war zone.

And then, in 2014, the Hoover Archives jolted my life. In a stunning email, they notified me that they had acquired the Vietnam picture collection of *Overseas Weekly*. Some of my pictures were now in their archives. I was thrilled and horrified at the same time. I was overjoyed to have the opportunity to see my photographs once again. But it also stirred up troubling memories and emotions that I had worked hard for decades to keep in safe storage.

Combat scars everyone, soldiers and journalists alike. And the psychological wounds don't heal, even after fifty years. In many different ways,

most find techniques to build neuronal pathways around the stark horror and tragedy that frequent every war zone. My way was, as much as possible, to avoid reading, thinking, or talking about my Vietnam experience. Unfortunately, I had taken one war picture that has become iconic over the decades. It wouldn't let my sleeping dogs lie. And now, Hoover has stirred up a whole new set of traumatic recollections and resentments. I am both excited at seeing some of my lost photos and, at the same time, troubled by the memories they spark.

Humanity demands collections like the archives at Hoover so researchers everywhere can see the unfiltered evidence of both war and its consequences. Each will draw their own conclusions about what is true. I am honored to have contributed one small piece to this historical record.

DON HIRST

THE JOURNEY TO BECOMING an *Overseas Weekly* photographer really began during my first Vietnam tour as an enlisted soldier in the US Army, from 1964 to 1965, when I saw a movie in our aviation battalion's small outdoor theater. The title escapes me now, but it was about traveling by sea around the world, shooting a documentary about the trip.

My interest was stoked. It looked neat, and I thought it would be fun. I decided that I wanted to become a photographer. After a less-than-successful try at a photography correspondence course, I did learn enough to be able to develop film. Consequently, I became the *de facto* photographer for the 14th Aviation Battalion while also doing my regular Army job. I wasn't exactly a pro in the photo arena, however.

That became very apparent when I managed to ruin the negatives for an official photo of the new battalion commander. So they summoned a real Army photographer to do the job. I watched enviously as he quickly did what I had been trying to do. While feeling a bit crushed, I also learned about the Army's twelve-week still photography school at Fort Monmouth, New Jersey. Then came the tough problem of how to get selected for it.

But the Army offered a solution: reenlist in exchange for a guaranteed slot in the school. That was a no-brainer for me. In exchange for spending what amounted to an extra two years in uniform, I received orders to report to the school in January 1966. My first camera was the standard Army Speed Graphic, which shot four-by-five-inch sheets of film, one shot at a time. Slow and cumbersome was an understatement.

After graduation, I was assigned to Fort Knox, Kentucky, where I spent months working in a photo lab but also shooting some photos. Then came an assignment to Berlin, which was divided by the infamous Berlin Wall. I gained much experience there, including the thrill of seeing many of my photos appear in the *Berlin Observer*, the official Army paper for the Berlin Brigade. That was a big step but miles away from my goal of becoming a civilian newspaper photographer.

I had a burning desire to make that transition but saw no real way to do it from Berlin. The potential solution was risky: volunteer for a second tour of duty in Vietnam, where hundreds of civilian journalists were covering the war. From there, I thought, maybe I'd somehow have the opportunity to become one of them. In what amounted to playing Bet Your Life, I volunteered to return to Vietnam. A few months later I found myself part of the photo operation run by the 54th Signal Battalion—but nowhere near an opportunity to break into the civilian news business. We spent more time performing maintenance on unit jeeps than taking pictures.

I had just one combat photo assignment, about a week long. Unfortunately, I spent much of the week hospitalized with a high fever of unknown origin before joining a unit from the 1st Cavalry Division. Going directly from a hospital bed to a

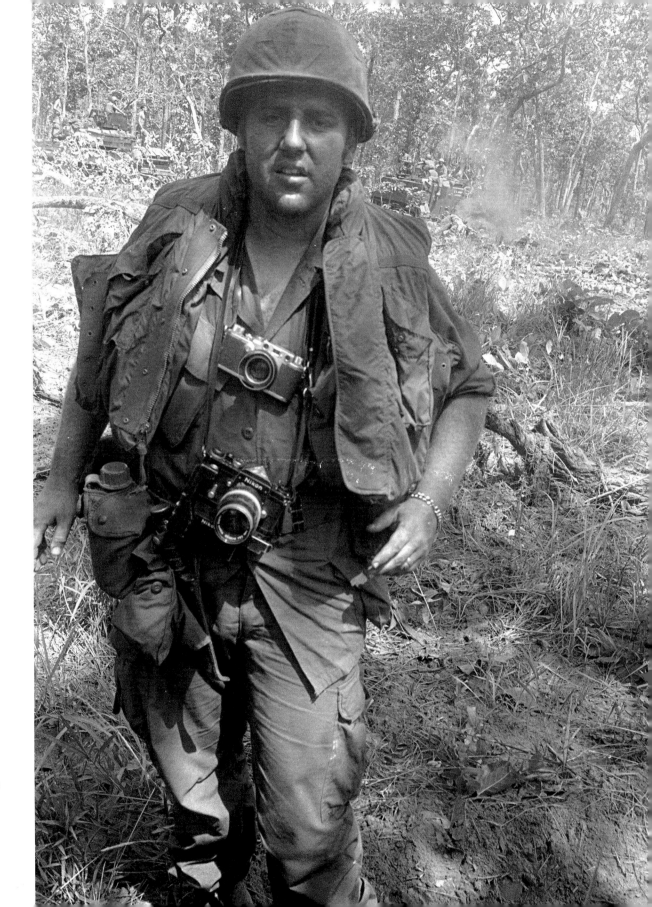

▶ **_OW_ STAFFER**
Overseas Weekly reporter and Pacific
Bureau Chief (1972–73) Don Hirst.
May 11, 1970 | Cambodia

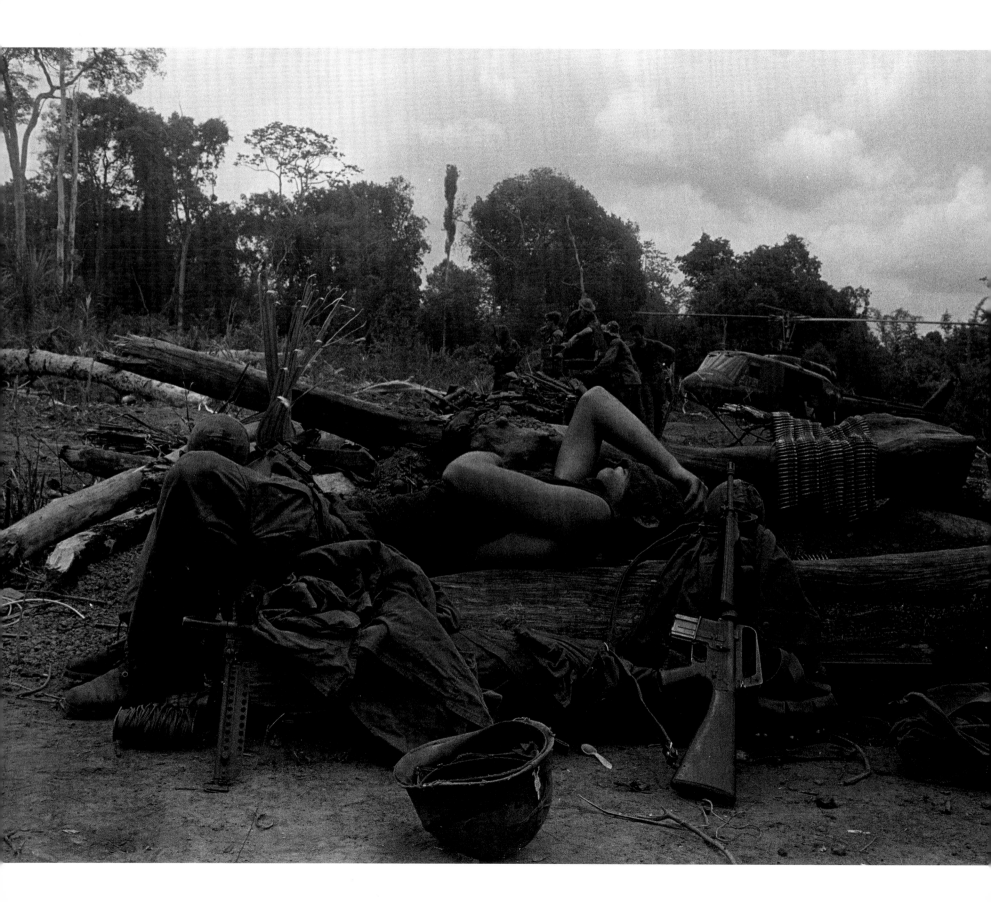

combat helicopter assault wasn't exactly my smartest move. Incredibly weak from the fever, I somehow managed to last almost two days before I collapsed. My first combat photo assignment ended with me being hoisted through the triple-canopy jungle to a medical evacuation chopper. That was my first and only ride on a jungle penetrator, a device designed to evacuate patients through thick jungle when no landing zone is available.

After months of jeep maintenance punctuated by occasional photography, I'd had enough. If I couldn't become famous, I figured I could at least be comfortable for the rest of my tour if I somehow managed to wrangle a transfer to Saigon. Luck was on my side. I'd learned that a crusty old master sergeant I'd worked with in Berlin was in the public affairs office in Headquarters Area Command (HAC), which was a housekeeping unit for Saigon that performed many essential support tasks such as providing lodging, rations, and transportation. He needed a photographer, and he remembered me and my Berlin work. Using the NCO Mafia, he made the transfer happen.

HAC, as I soon learned, had many dealings with the Saigon press corps. One of those journalists was Ann Bryan, the bureau chief for the *Overseas Weekly*. I convinced her to give me a try for a freelance gig (strictly off the books since I wasn't supposed to work for anyone but the Army). The idea was to show, in photos, what guys could do in Saigon on their day off. She liked my photos and ended up using a bunch of them in an issue of the *Overseas Weekly*. We agreed on a made-up byline to keep me out of trouble. I think I was paid $15 a photo, but the money really didn't matter. This was the first work I'd sold to a newspaper, and I was thrilled.

But that was only the beginning. It was around this time that the Tết Offensive erupted throughout South Vietnam—including the US embassy. I was fortunate enough to take one Army photo of the action at the embassy that was used worldwide in military and civilian newspapers. It showed two American military policemen from the 716th MP Battalion leading away a captured Viet Cong sapper—an enemy soldier skilled in penetrating the defenses of a base or facility to destroy things and generally create havoc—involved in the attack. My photo of the captured sapper has seen lots of use over the years, including as the cover shot of at least two books.

I credit that photo with being the springboard that led to a long career in the news business. A couple of months later, I received a letter from Ann Bryan offering me a job as a photographer/reporter with the *Overseas Weekly* in Saigon. The pay was a princely $100 a week and no life insurance. I jumped at it, of course, and never regretted the move. A framed copy of that letter hangs in my home office. In later years, Ann and I joked about the huge starting pay. It wasn't a lot, but it was enough to live on. Plus, she allowed me to supplement my income by doing occasional freelance photography and reporting for other news outlets—primarily the Associated Press, which over the years purchased and used many of my photos (again under a pseudonym). One of them, taken during the 1972 Easter Offensive, ran on the front page of the *Washington Post*.

The *Overseas Weekly* offered me a mix of assignments that gave a good snapshot of what US troops experienced while serving in Vietnam. Some days were spent in a military courtroom covering

DON HIRST
A weary soldier takes a break at Landing Zone Evans, Cambodia.
May 11, 1970 | Cambodia

courts-martial proceedings generally involving major crimes like murder, serious drug offenses, and assorted acts of violence. In all, I covered around one hundred twenty or so trials, more than half of them murder cases. On several occasions, famous civilian attorneys like Melvin Belli and Henry Rothblatt were part of the defense team.

A lot of my work involved covering military units in the field, in the air, and at sea performing combat operations. Walking through jungles and swamps with infantry units, riding on nighttime combat missions aboard Air Force gunships like the AC-47, and observing naval gunfire missions from inside one of the sixteen-inch turrets of the battleship USS *New Jersey* were all part of the job. Over the years I gained many lifelong friends from those combat missions and even was made an honorary member of the elite 173rd Airborne Brigade by the unit's commanding general. I also learned the hard way not to go back to combat units I'd covered. Too often I found that people I'd written about were killed sometime after I left.

Working for the *Overseas Weekly* was an incredible experience for me, one that I will never forget. Over the years, I switched from a photographer/reporter to a writer who also took lots of photos. You will see several of my favorite ones among the negatives that now reside at Stanford. Two in particular are especially memorable because they were really good and also because I nearly was killed while taking them. One, shot during my foray into Cambodia in May 1970 when American troops crossed the border for extended combat operations, shows an armored personnel carrier hitting a delayed-action mine we had just passed over. The

other, taken in early 1971, shows an F-4 Phantom dropping napalm to keep the unit I was accompanying from being overrun.

I have worked for other news organizations since, serving as everything from writer to editor. But nothing was as fun as those years, from September 1968 to February 1974, when I worked for the *Overseas Weekly*. By the time I left, to take a job with *Army Times* in Washington, I had gone from a green young journalist who had a lot to learn to the Pacific bureau chief for the *Overseas Weekly*. Those were wonderful years, despite all the stress of covering the Vietnam War. I didn't exactly make a fortune with the *Weekly*. But I left there with a wealth of mostly good memories.

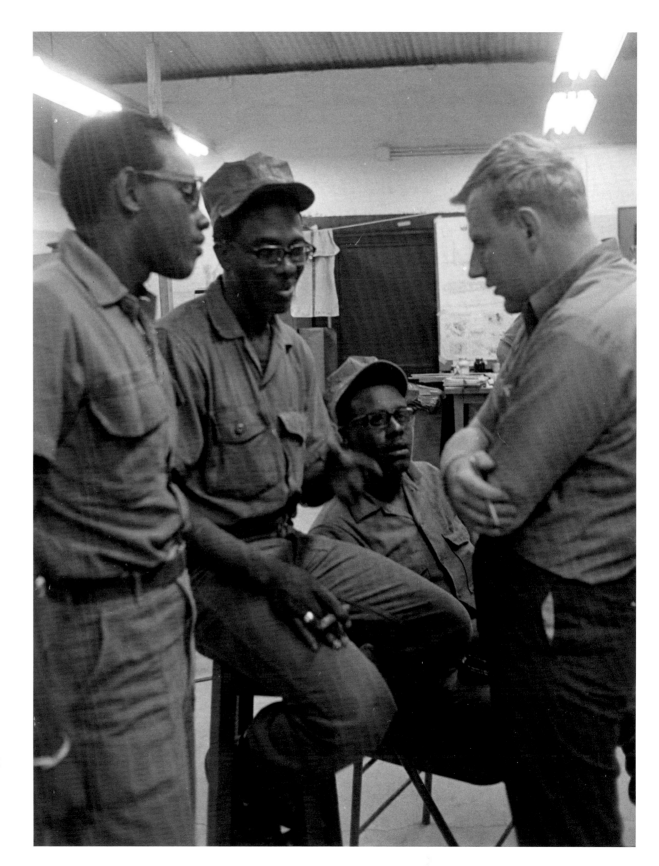

▶ **DON HIRST**
Overseas Weekly reporter Don Hirst
interviews Navy sailors regarding a racial
incident in Đà Nẵng.
1968 | Đà Nẵng

BRENT PROCTER

THE ONLY LOTTERY I've ever won was a life-changer in ways I could never have imagined. This seminal event had the most prosaic of beginnings in my native New Zealand. My birth date came up in the national selective service ballot in early 1964. First prize was a three-year commitment to queen and country as a weekend warrior. There was no second prize.

Vietnam was already hogging the headlines, and I was a year into my first job as what they used to call a cadet reporter. I had, after high school, managed to hire on with my local afternoon daily, the *Southland Daily News*. I had taken to journalism like a duck to water. I had, at best, a cursory interest in Vietnam. That was to change dramatically one penetratingly cold winter's night in Dunedin, New Zealand, in June 1965.

We were called to a special midweek parade at the Army Hall. The barracks' heavy steel doors were suspiciously closed and locked as we went into formation. The commanding officer, after reading relevant sections of the formidable-sounding Official Secrets Act 1951, then ordered us to fill out forms that were, in effect, mobilization papers. A month before Prime Minister Keith Holyoake committed an artillery battery to serve alongside Australian forces in the growing conflict in Vietnam. It turned out to be the thin edge of a thick wedge.

No sooner was the ink dry on my mobilization papers then I decided there was no way I was going to Vietnam in any military capacity and, most certainly, not as a conscript. As it turned out we, unlike our Australian counterparts, weren't summarily dispatched to the war zone.

It was because I was so steadfast in my resolve not to serve there in uniform that I decided to go to Vietnam as a civilian correspondent. Not only had the war become the world's biggest story, it was also, to my mind, the most perplexing conflict of the twentieth century. So I went from one extreme to the other. On the one hand, I was prepared to become the equivalent of a refusenik; on the other, my curiosity knew no bounds. I simply had to find out what was going on.

That, I told myself, is what journalists are supposed to do. The only problem was that nobody would send me. Our national news agency, the New Zealand Press Association (NZPA), for whom I was then working, had dispatched two correspondents there for varying durations, but by the time my ambition was peaking, it had decided to end any active coverage. I wasn't dissuaded. I then went to Sydney, Australia, and hired on with NZPA's counterpart, Australian Associated Press (AAP), with the avowed intention of somehow winning one of their six-month rotated Vietnam berths. Not only was I passed over, I was fired on the grounds I was "too pushy," probably because I was forthright in wanting to become one of their war guys.

If discouragement was the name of the AAP game, it failed. I became even more determined. My journalistic fortunes, however, continued to plummet: I was fired from the next two jobs I managed to score. I filled my down-and-out days taking long

walks and plotting. The upshot was that I sketched what I considered to be a daring plan: I'd go to Vietnam by myself, alone and entirely unsupported. I'd roll the dice and take my chances.

After paying my one-way airfare, I had a bankroll of about US$400. That's not much now; it wasn't much then. I left Sydney on July 19, 1969. The Apollo 11 astronauts were, coincidentally, en route to the moon. I touched down in Saigon, via Hong Kong, the next day, about the same time Neil Armstrong and Buzz Aldrin landed at the Sea of Tranquility. I've often joked I knew exactly how they felt.

The travel agency I had used in Sydney booked me into the only hotel they had listed in Saigon. It turned out to be the landmark Caravelle Hotel. Not only was it the most luxurious hostelry I'd ever stayed at, it was, at US$80 a night, alarmingly expensive. After one night—I managed to find cheaper digs the next day— I found myself in the customary position of being almost broke. I had letters of introduction from two news organizations in New Zealand, and those, fortunately, were sufficient to gain accreditation as a correspondent.

Accreditation was key. With it you had access to all US military transport, installations, and bases; without accreditation you were a lost cause. I

▶ *OW* **STAFFER**
Overseas Weekly reporter and Saigon bureau chief (1970–71) Brent Procter. January 10, 1970 | South Vietnam

quickly made contact with the New Zealand forces' headquarters at the grandiose-sounding Free World Forces headquarters and arranged for a visit to Núi Đất, the joint Australia-New Zealand base set up in an old rubber plantation in Phước Tuy province, just south of Saigon.

I spent ten days at Núi Đất. On return to Saigon I pressed my portable typewriter into service and cobbled together a color piece. I posted it off, on spec, to several newspapers in New Zealand, along with cover letters. Only one newspaper published my offering: the *New Zealand Herald* in Auckland. The *Herald* was, as it remains, New Zealand's largest-circulation daily. They gave me top op-ed billing under a substantial byline.

It was at that point I heard of Ann Bryan and the *Overseas Weekly*. Fellow New Zealand correspondent Peter Arnett told her about me and arranged for us to meet, which we did. It became instantly apparent that we were, literally, on the same page. I was in desperate need of work, and she, most important, was in dire need of reliable freelance help. I began working exclusively for her. One of Ann's two staff writers quit a few weeks after we linked up and she offered me his job, which I was overjoyed to accept.

Ann was engaged to ABC News correspondent Frank Mariano and when he was reassigned Stateside in early 1971 she nominated me to take

▶ **BRENT PROCTER**
Paratroopers climb into the Vietnamese Air Force (VNAF) C-47, bound for their first jump after a three-week course at Vietnam's airborne training school. The atmosphere was described by the photographer as "carnival-like."
January 10, 1970 | South Vietnam

BRENT PROCTER
Unidentified Navy sailors on the
destroyer USS *Brinkley Bass.*
May 14, 1970 | South Vietnam

over her job, but as bureau chief rather than editor, which was her designation. I held the position until August 1971 when I, too, quit. I did so after surviving a road convoy ambush in the Central Highlands near Đà Lạt. In the space of little more than two years, the death toll among correspondents in Vietnam had risen from about seventeen to something on the order of forty. Reporters Without Borders places the death toll of correspondents covering the war in Vietnam and in neighboring Cambodia at sixty-three. I knew many of those who lost their lives, most notably Larry Burrows of *Life* magazine. I had had dinner with him the night before he went into the field on what became his last assignment.

Ann started the Pacific edition of the *Overseas Weekly* in 1966 and went on to win huge professional admiration, not only for the quality of her product but also because of her grit and courage. Among the plaudits she earned was one from

Newsweek star Edward Behr. In his memoir, *Bearings: A Foreign Correspondent's Life behind the Lines* (1978), he says the Pacific edition of the *Overseas Weekly* was the only US publication to tell the true story of the Vietnam War while the conflict was in progress.

At one time Ann proudly displayed a poster on the office notice board that declared, "Happiness Is Being Exposed by the *Overseas Weekly*." The Pacific edition of the *OW*, almost exclusively, reported on the underbelly of US involvement in the controversial war and, as such, holds a unique place in the annals of modern war reporting. My two years with the *OW* are the most memorable of my forty-year career in journalism. Nothing else comes close. Those years changed my life and opened up unimaginable and richly rewarding vistas.

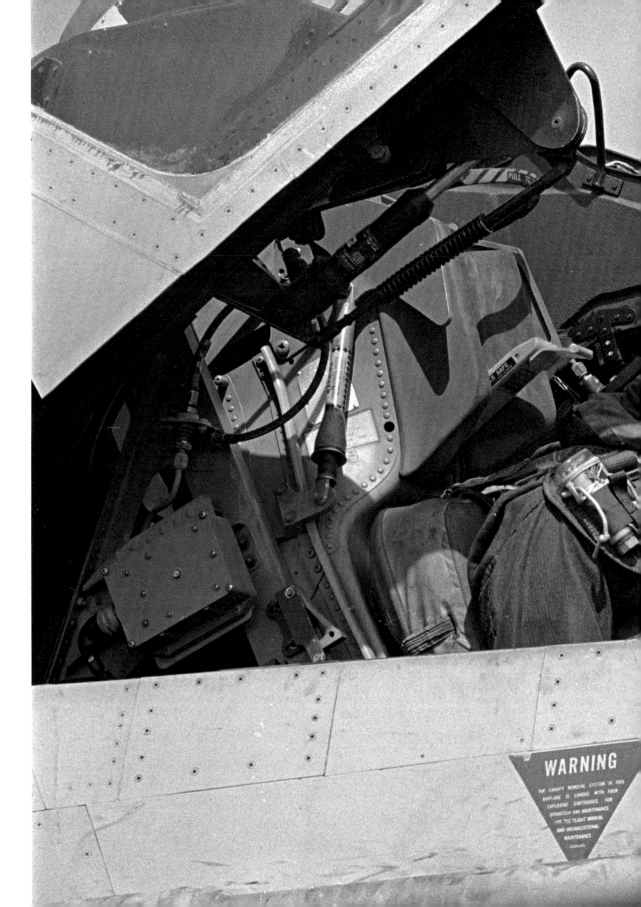

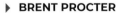 **BRENT PROCTER**
Naval aviator prepares preflight inspections of his jet attack plane aboard the USS *Ranger*, flagship of Yankee Station.
May 15, 1970 | South Vietnam

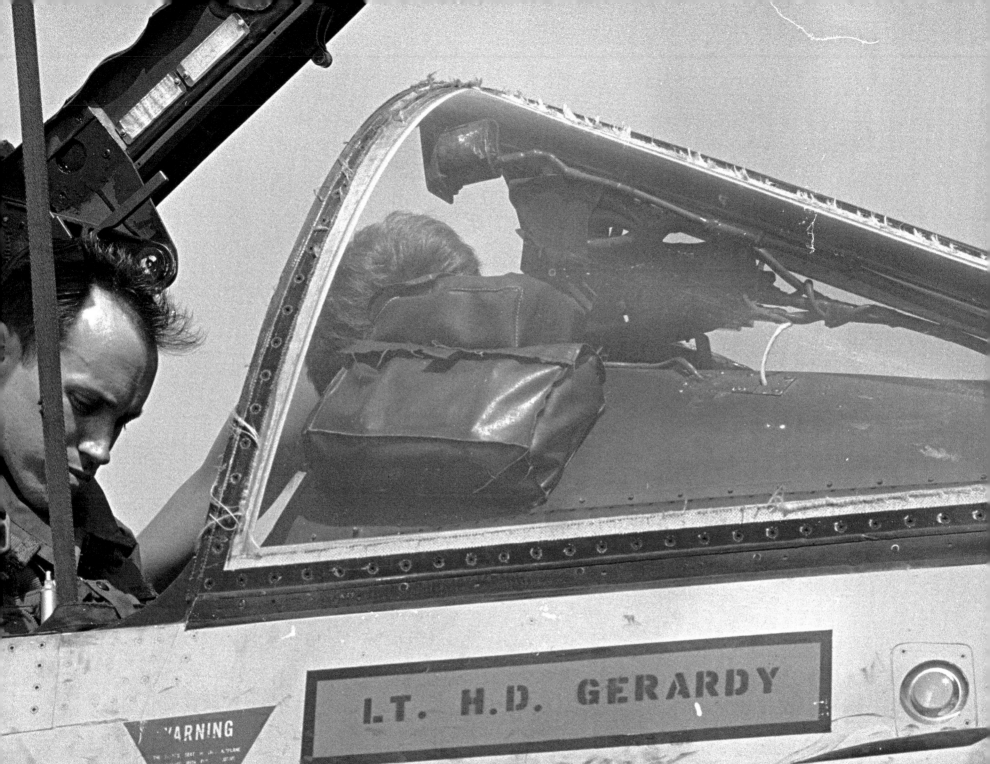

LT. H.D. GERARDY

WARNING

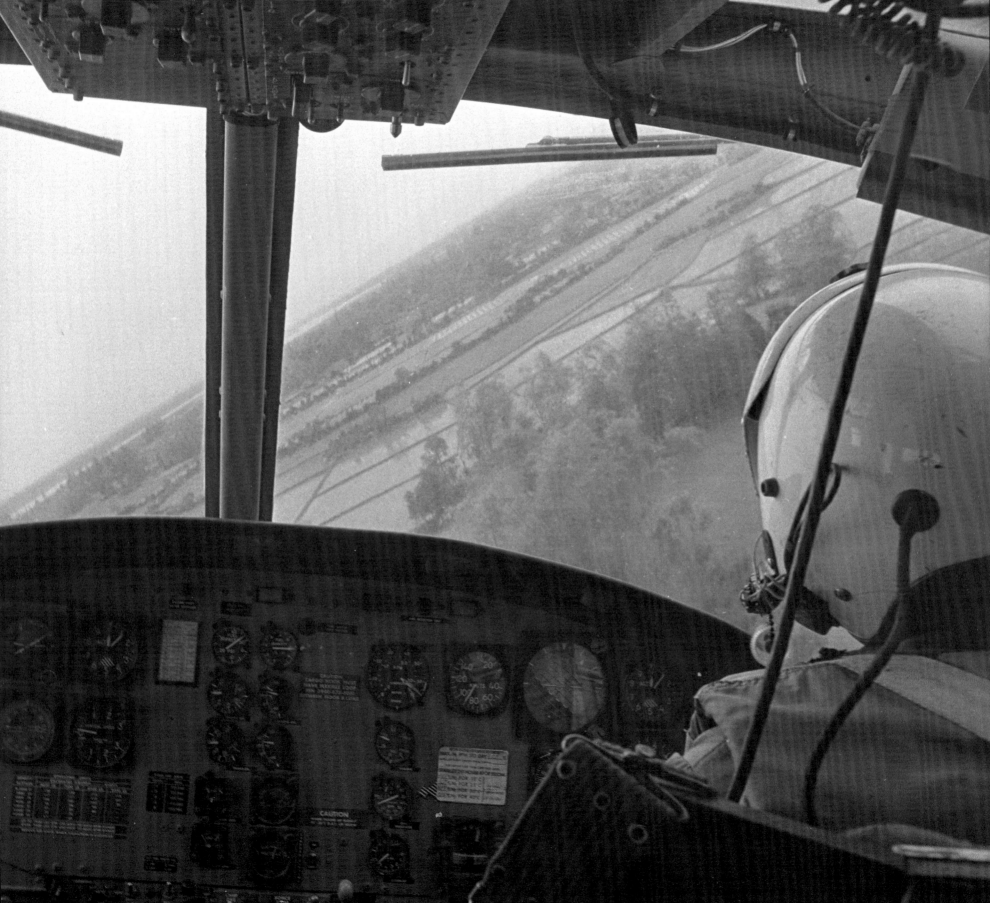

SELECTED PHOTOGRAPHS OF
THE *OVERSEAS WEEKLY*, PACIFIC EDITION

THE WHOLE WORLD IN THE VIEWFINDER.

ART GREENSPON
Aerial view of the city of Huế.
1968 | Huế

▲ **ART GREENSPON**
A 4×4 utility vehicle parks next to a
weathered ancient temple.
1968 | Tam Kỳ (near Huế)

▲ **ART GREENSPON**
Vietnamese boys pick up wood and debris
from the streets of Huế.
March 1, 1968 | Huế

▲ *OW* STAFFER
Vietnamese schoolchildren from Cam
Linh Elementary cross a dirt road.
April 4, 1970 | Qui Nhơn

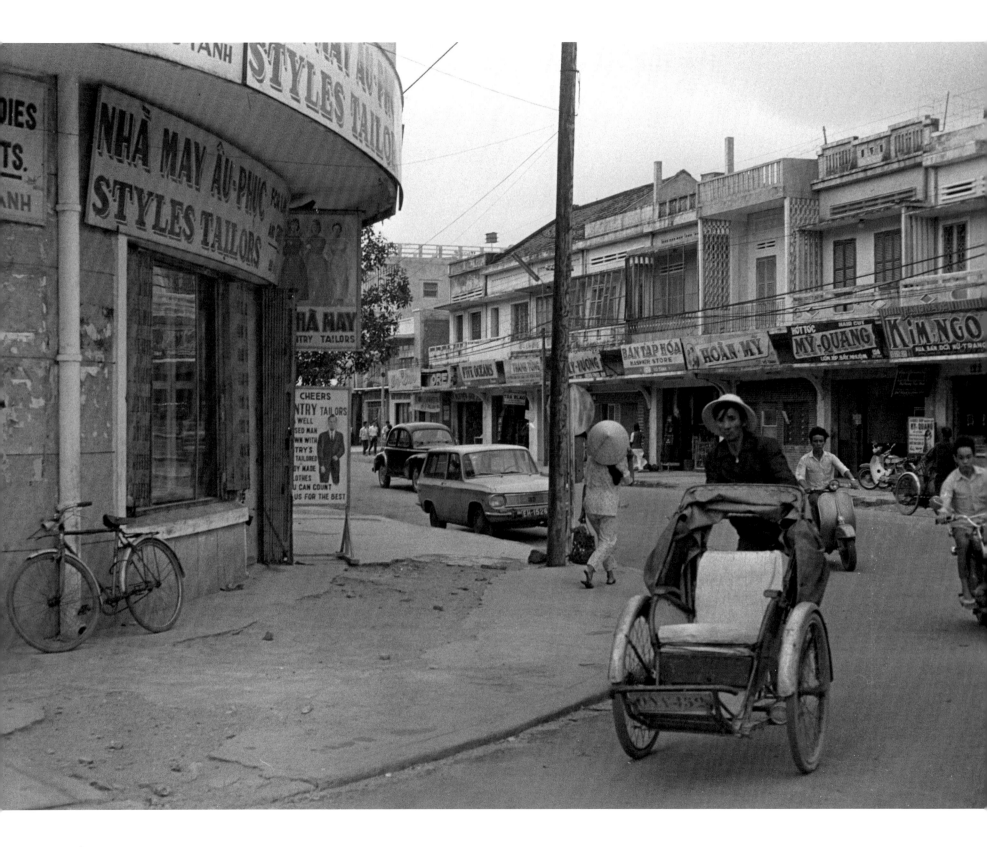

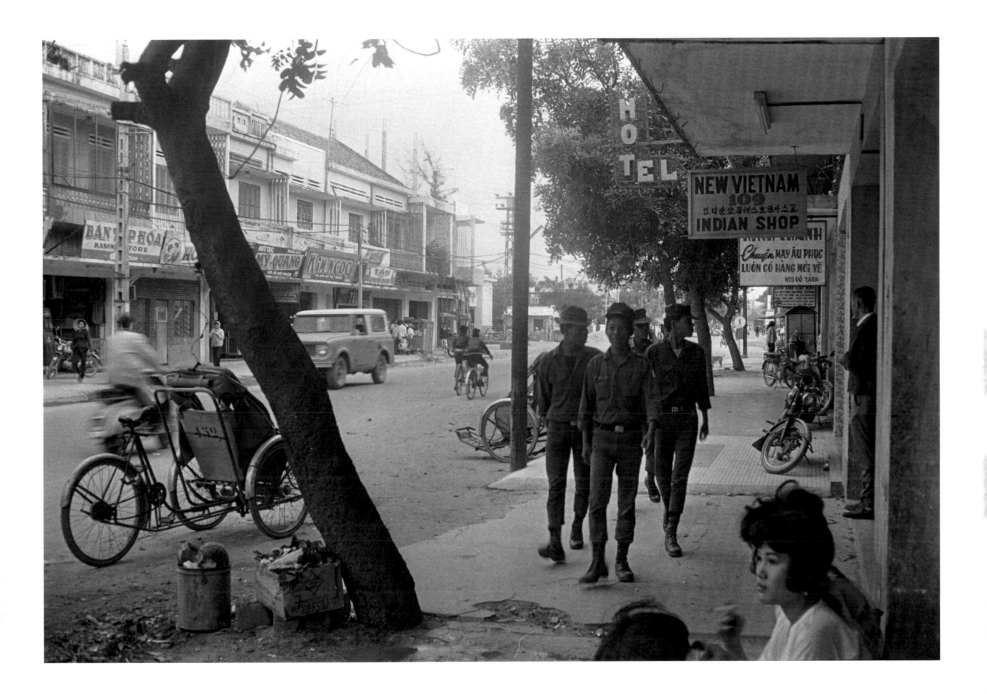

TOM MARLOWE

A cycloist pedals through the barren streets of Qui Nhơn, which was ordered off limits to American soldiers due to racial violence among the military police.

January 10, 1970 | Qui Nhơn

TOM MARLOWE

ARVN soldiers walk along the sidewalk in Qui Nhơn, a coastal city in central Vietnam.

November 25, 1969 | Qui Nhơn

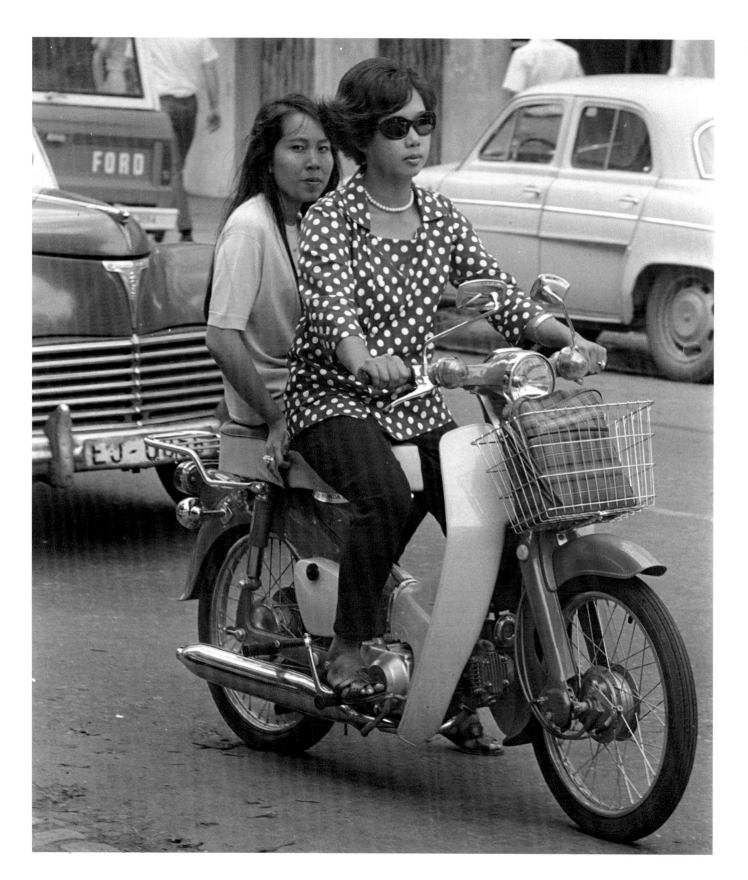

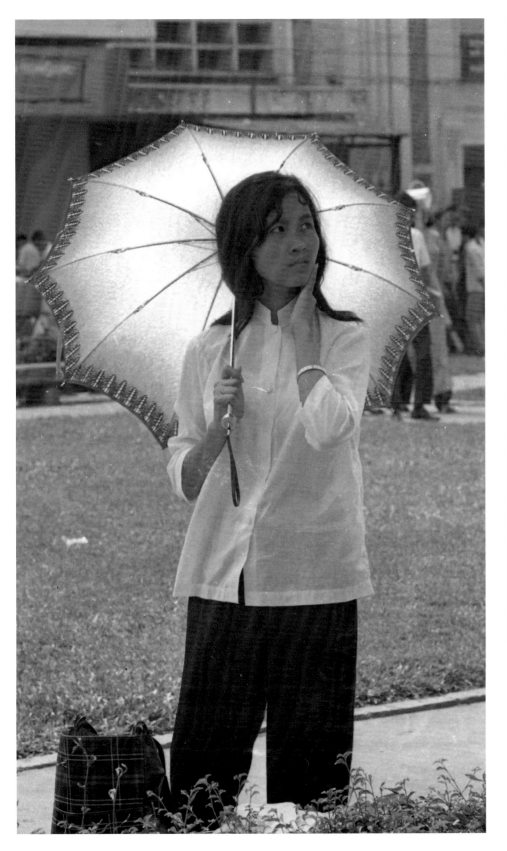

▲ *OW* **STAFFER**
◀ Vietnamese women take a Sunday stroll in Saigon.
1968 | Saigon

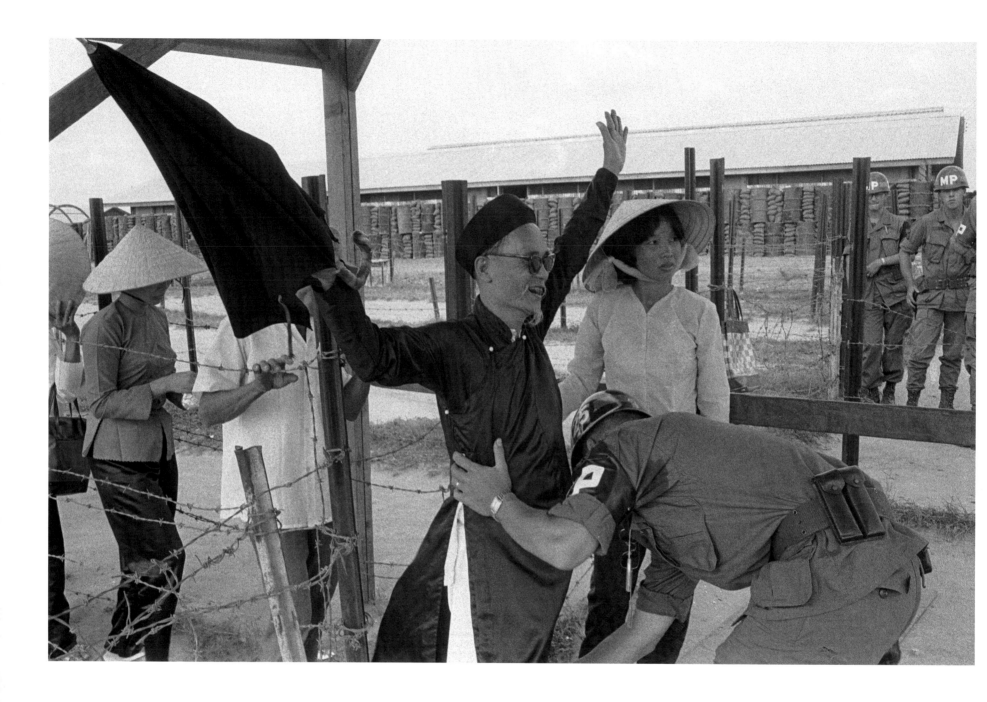

▲ **OW STAFFER**
A Vietnamese man is inspected by
military police as he crosses the Củ Chi
security check point.
February 1, 1969 | Củ Chi

▶ **OW STAFFER**
Montagnard refugees relocate into a newly
constructed home in Buôn Mê Thuột.
May 16, 1969 | Pleiku

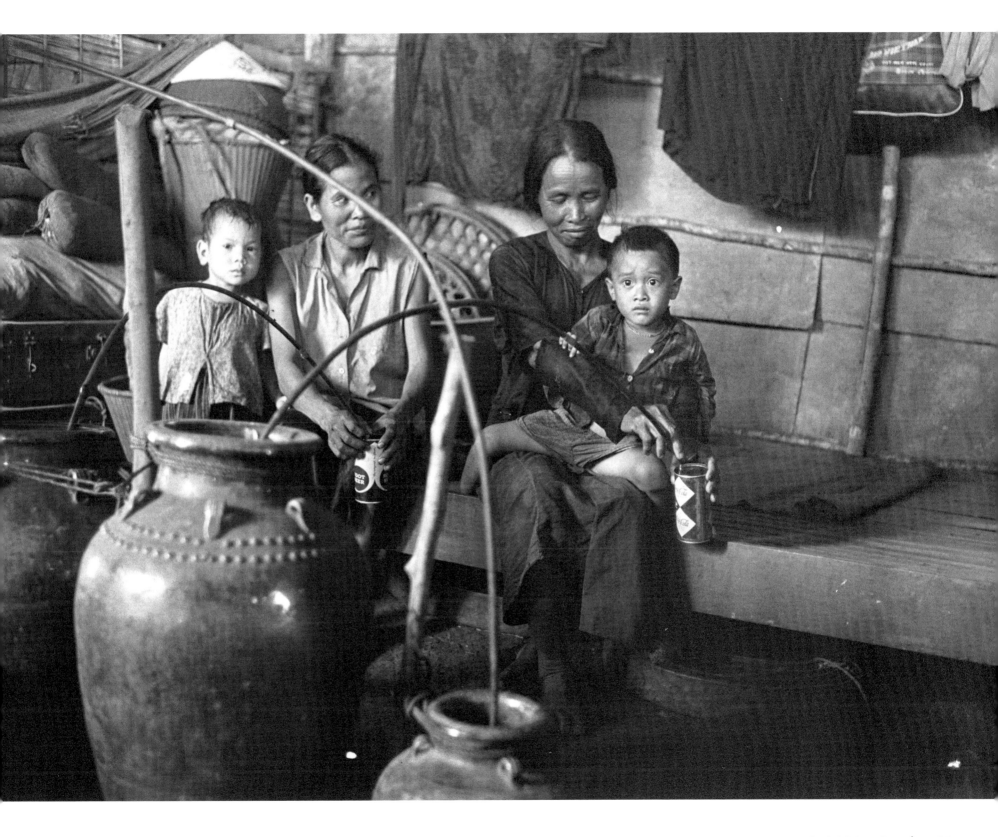

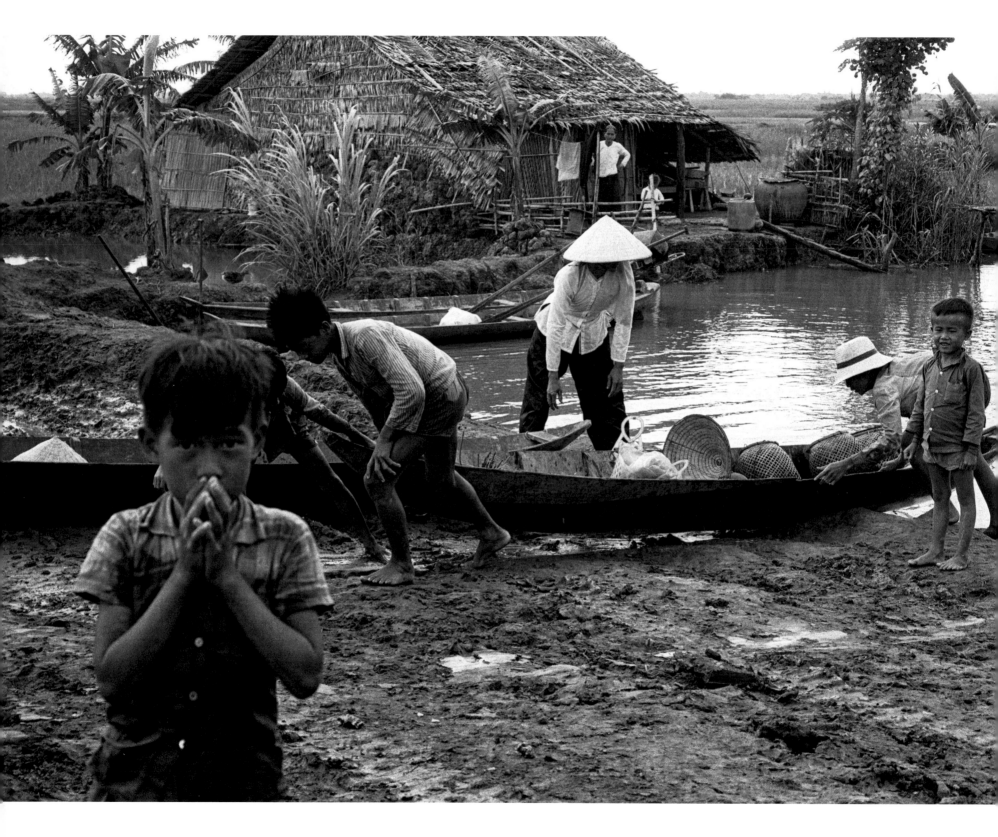

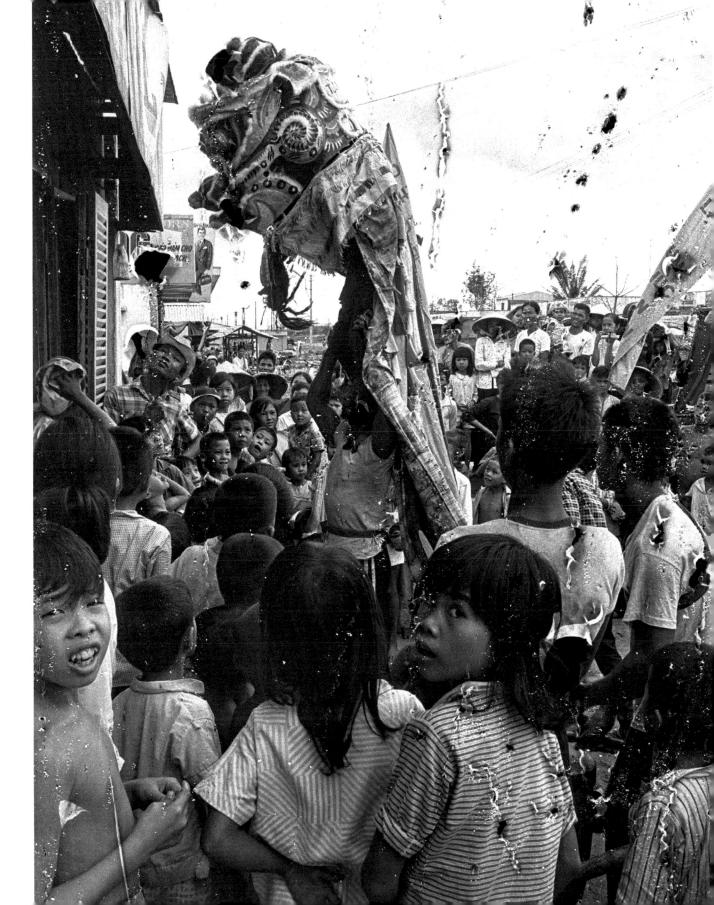

◀ **OW** STAFFER
Villagers in Cần Thơ.
August 30, 1969 | Cần Thơ

▶ **DON HIRST**
Lion dancing at a Buddhist celebration
in Saigon.
August 3, 1969 | Saigon

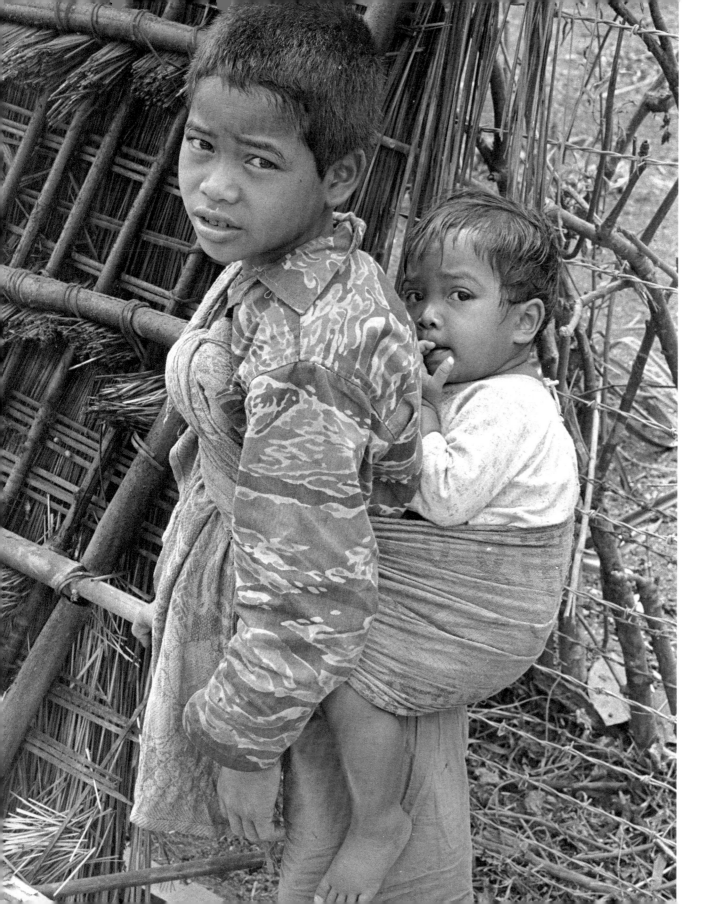

CATHY DOMKE
Montagnard children in a hamlet
five miles from Pleiku.
April 4, 1970 | South Vietnam

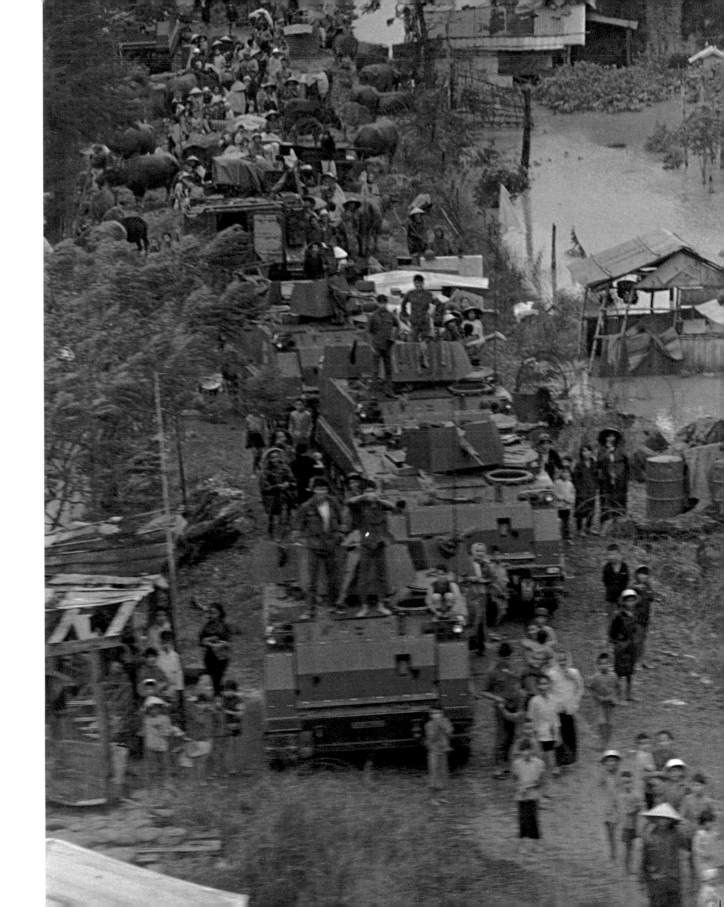

DON HIRST
An aerial view of flood-ravaged Đà
Nẵng, where hundreds of thousands of
Vietnamese citizens were rescued from
the swiftly rising waters by US Marines.
November 3, 1970 | Đà Nẵng

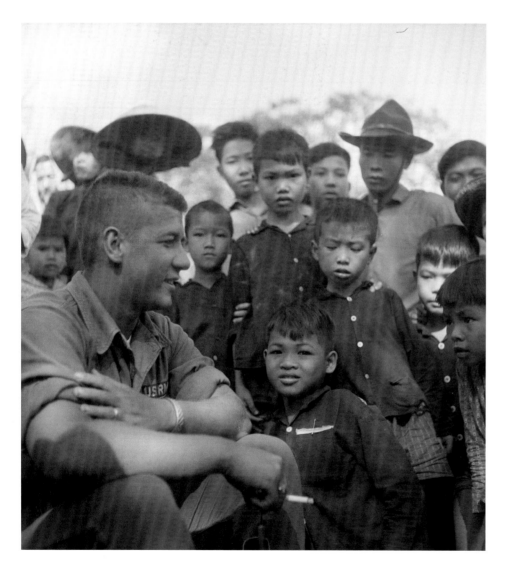

▲ *OW* **STAFFER**
The US Civil Affairs unit in Gia An village.
July 1, 1969 | Gia An

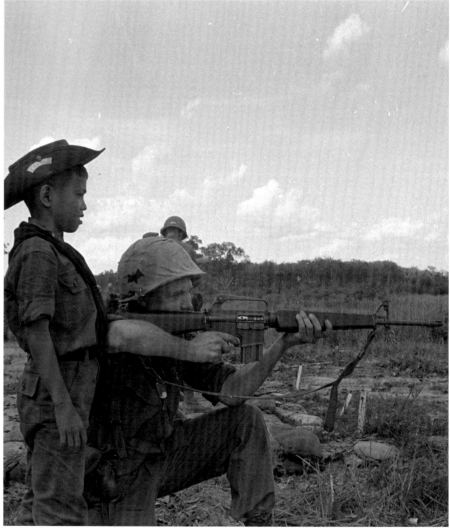

▲ *OW* **STAFFER**
Second Lieutenant Timothy Ganahl shows Howell, a young Vietnamese orphan from Lai Khê, how to work a rifle.
October 1, 1966 | South Vietnam

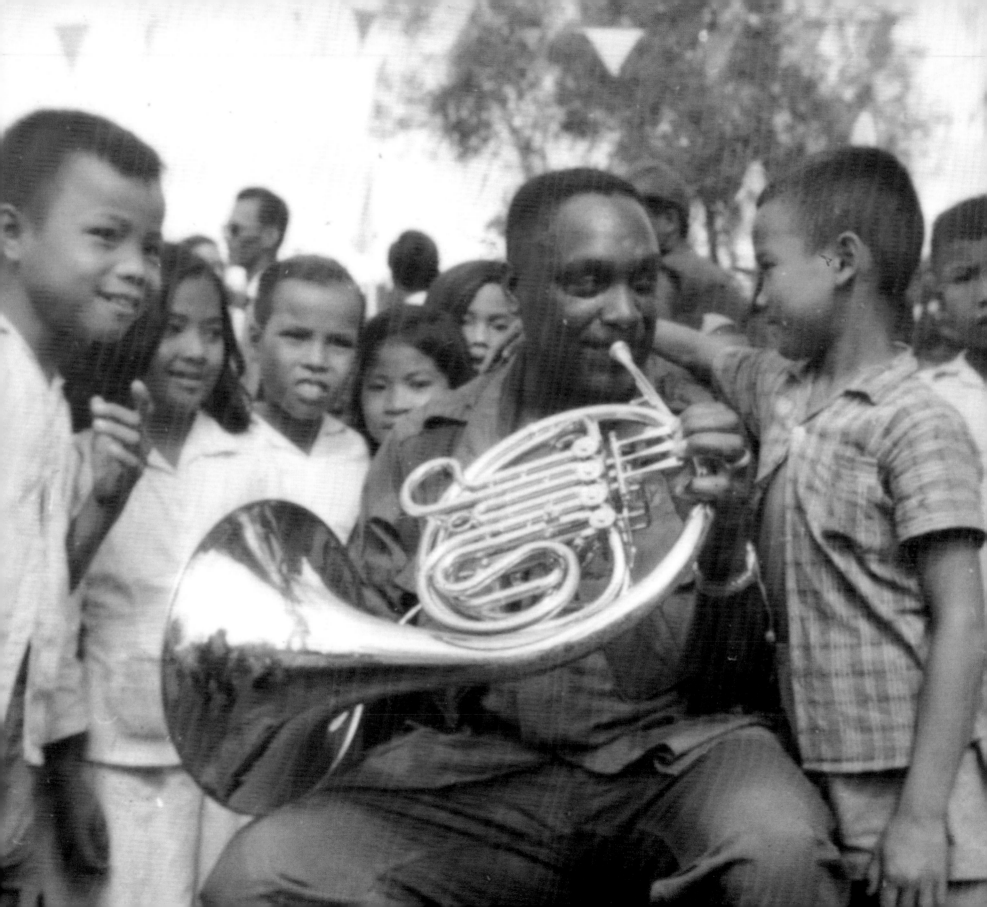

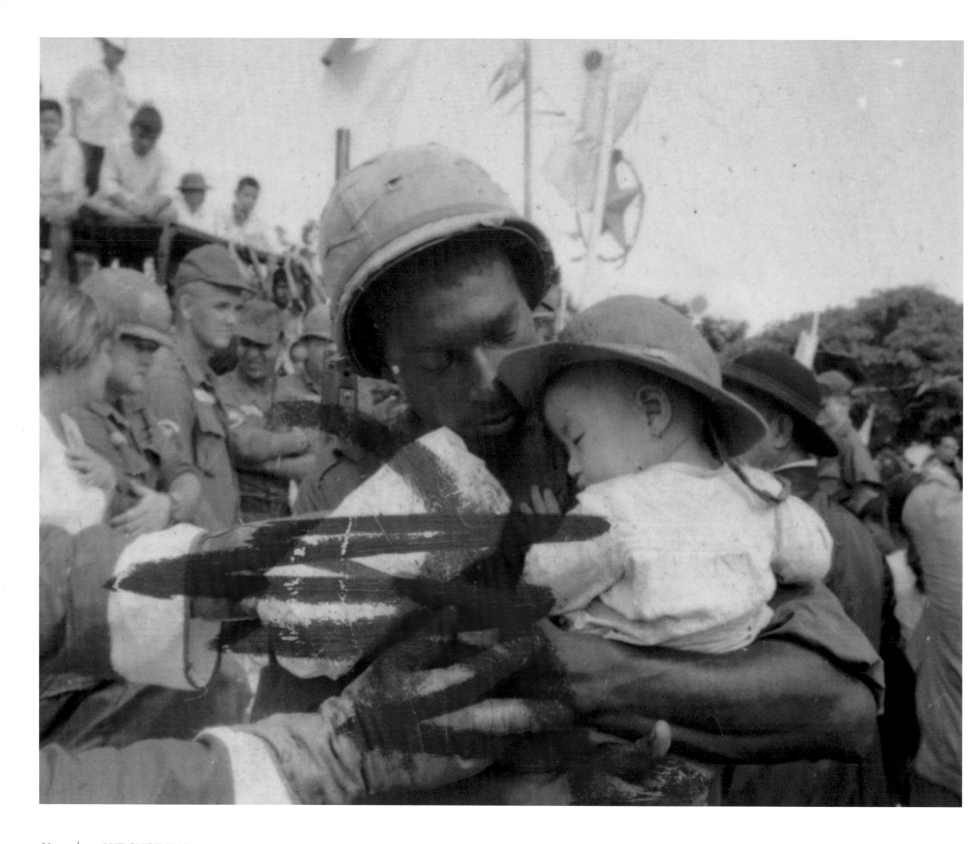

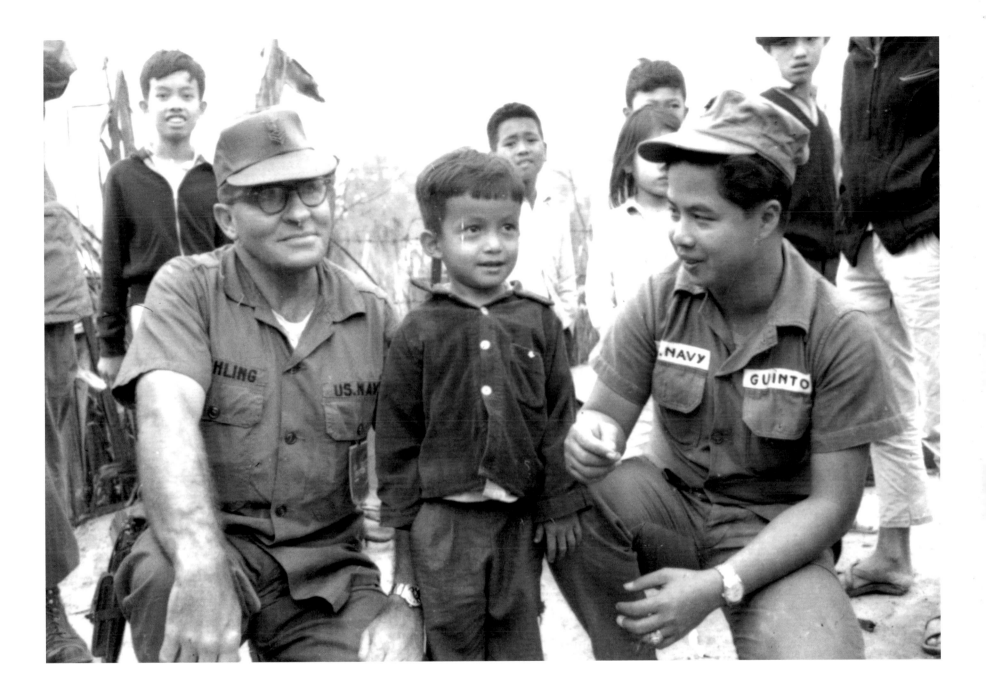

◄ ANN BRYAN
Specialist Fifth Class Jimmy L. Arnold
cuddles a bashful toddler in his arms and
snares a present from Santa for him.
December 25, 1966 | South Vietnam

▲ SAUL LOCKHART
Storekeeper Leo Guinto laughs with a
Vietnamese boy who is too young to
understand the tragedy that struck
his village.
March 19, 1967 | Ap Do (near Đà Nẵng)

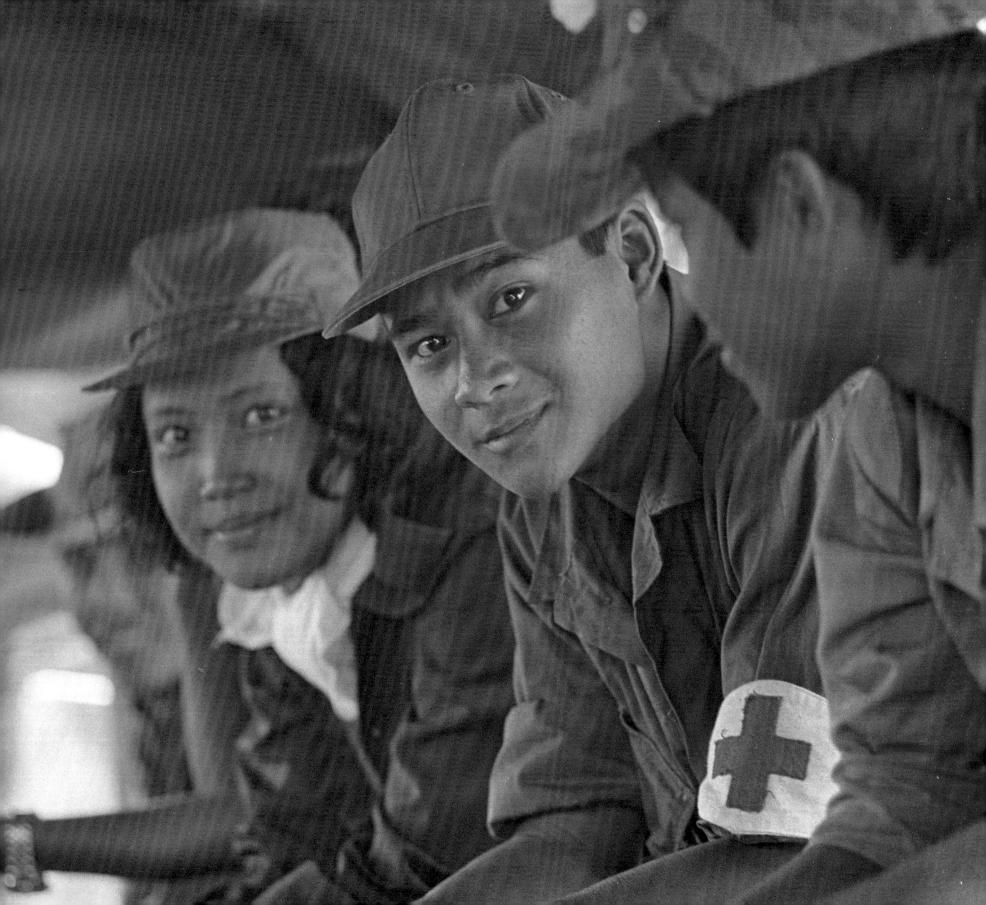

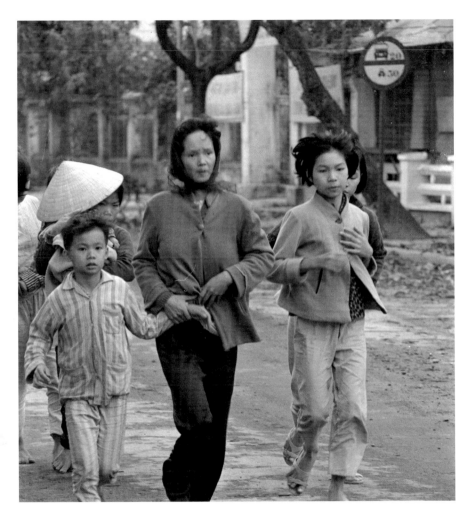

ART GREENSPON
A Vietnamese family flees to escape the gunfire.
1968 | Huế

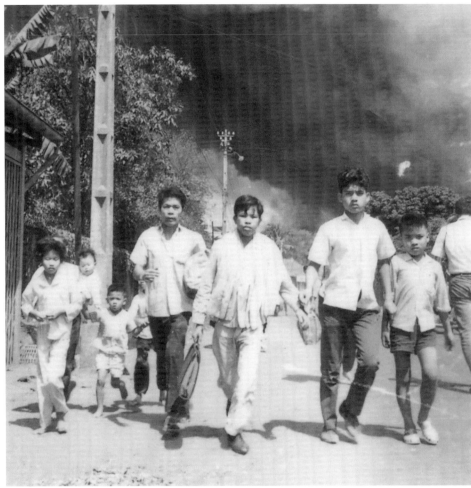

OW STAFFER
Plumes of black smoke billow into the sky as displaced
families seek shelter from bombing attacks.
1967 | Nha Trang

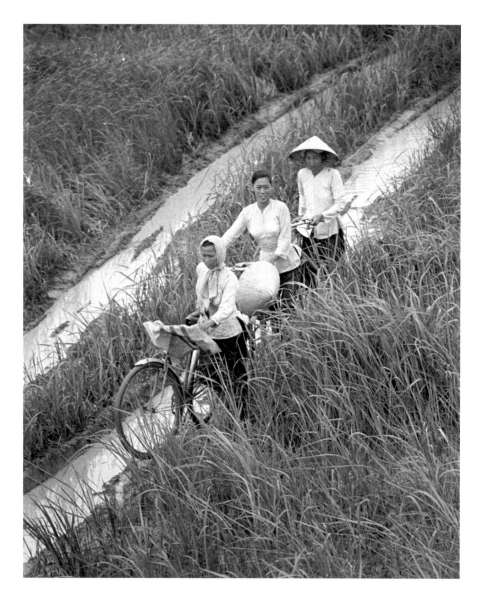

▲ *OW* STAFFER
Vietnamese villagers with the South
Vietnamese flag draped over their bicycles.
1969 | South Vietnam

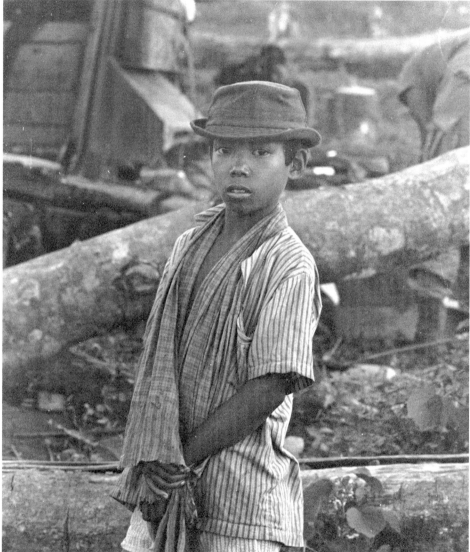

▲ DON HIRST
Cambodian boy near Landing Zone Evans.
May 11, 1970 | Snuol, Cambodia

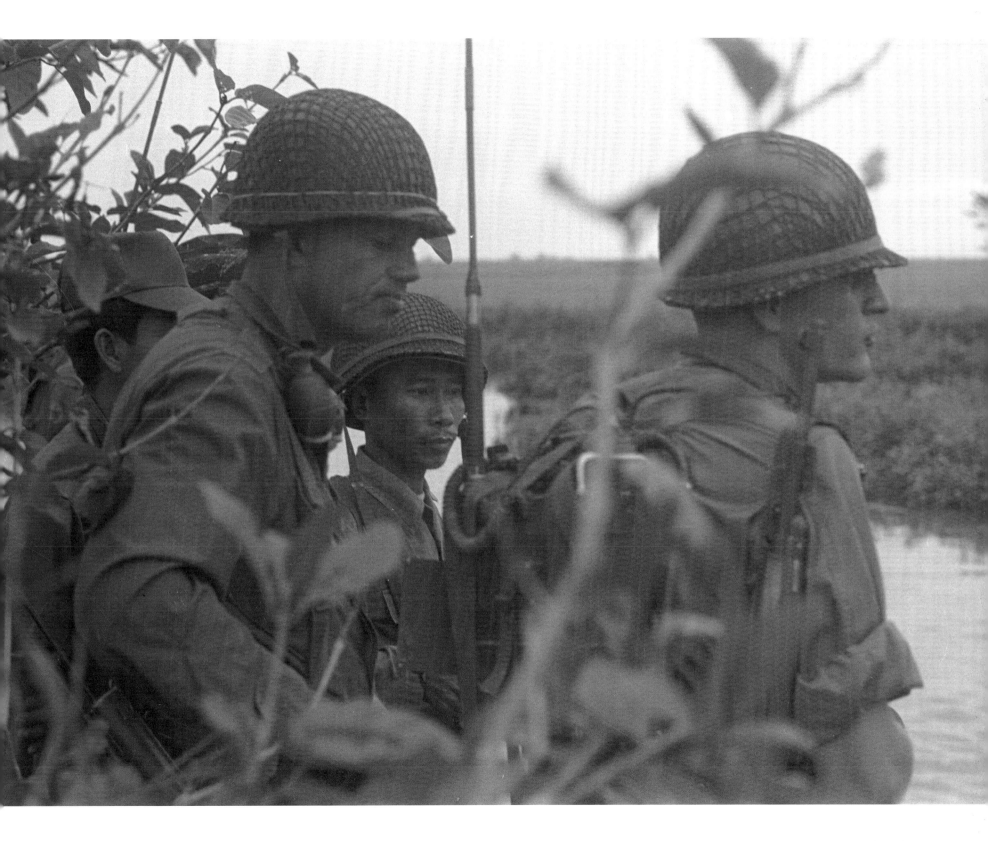

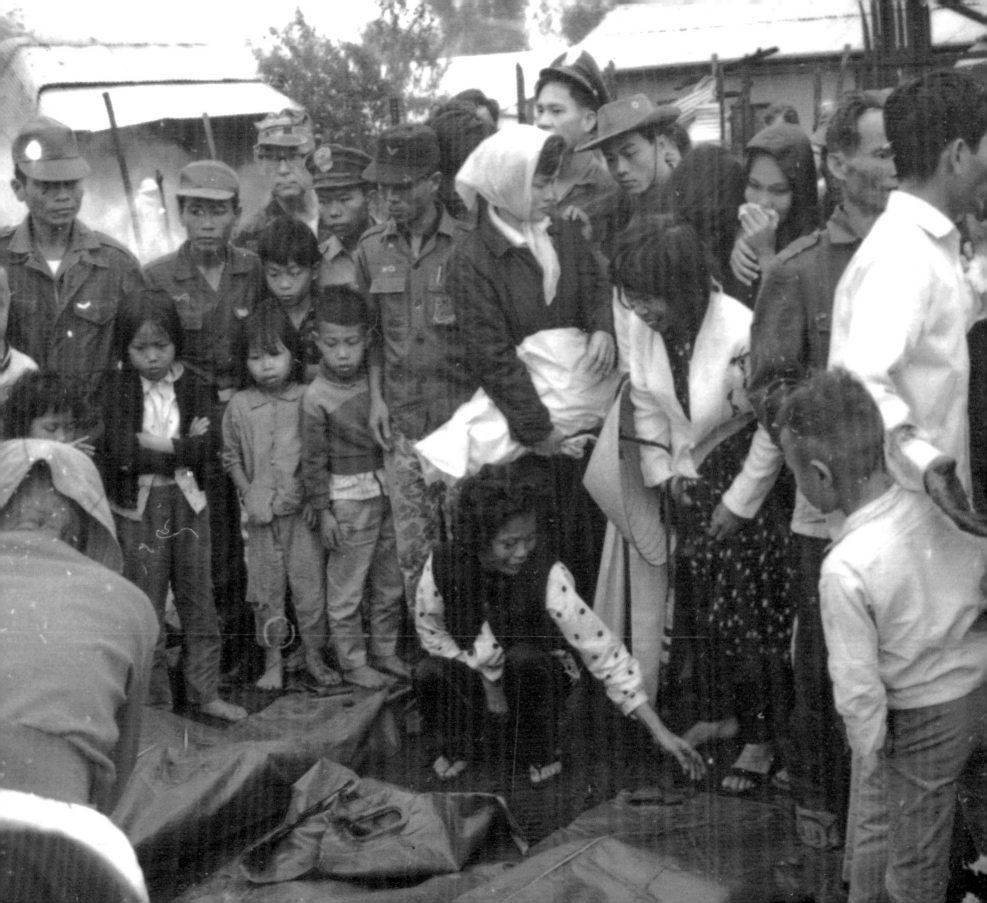

SAUL LOCKHART
Grieving women stand watch
over the bodies of relatives killed
in a North Vietnamese Army (NVA)
rocket attack.
March 19, 1967 | Ap Do (near Đà Nẵng)

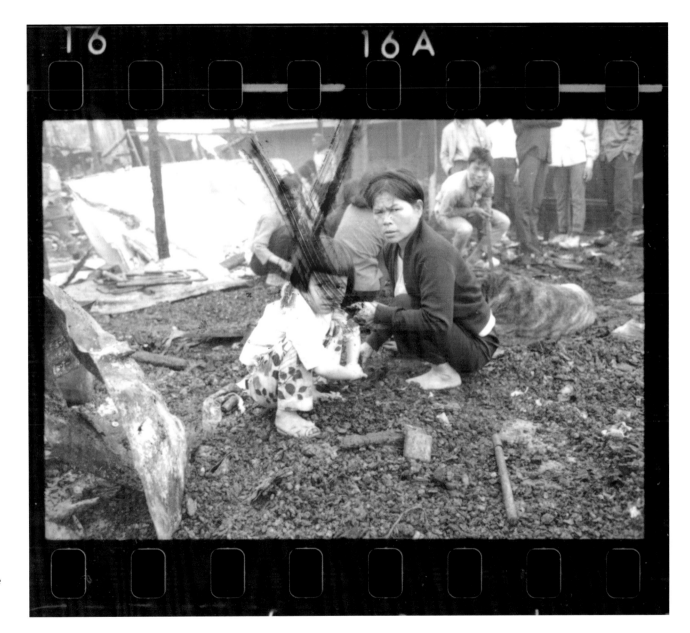

SAUL LOCKHART
Villagers scratch through smouldering
ashes and rubble seeking the remnants
of precious possessions that might still be
buried in the debris.
March 19, 1967 | Ap Do (near Đà Nẵng)

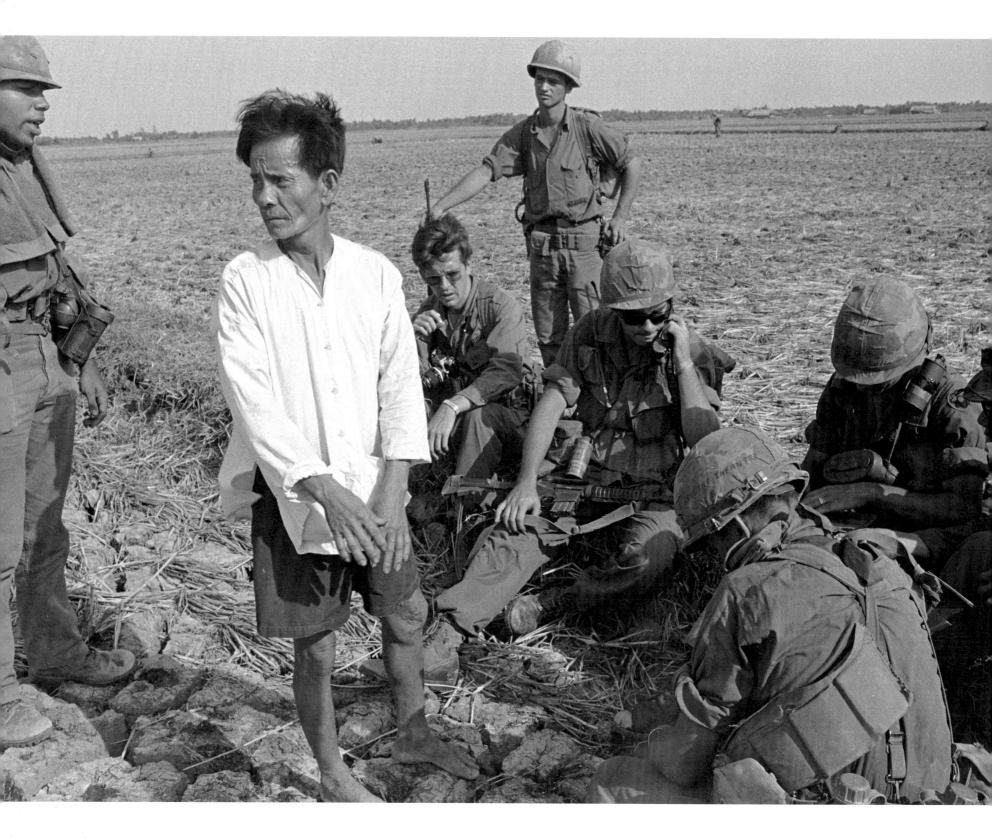

A Vietnamese peasant is questioned about ammunition found in a haystack.

1967 | South Vietnam

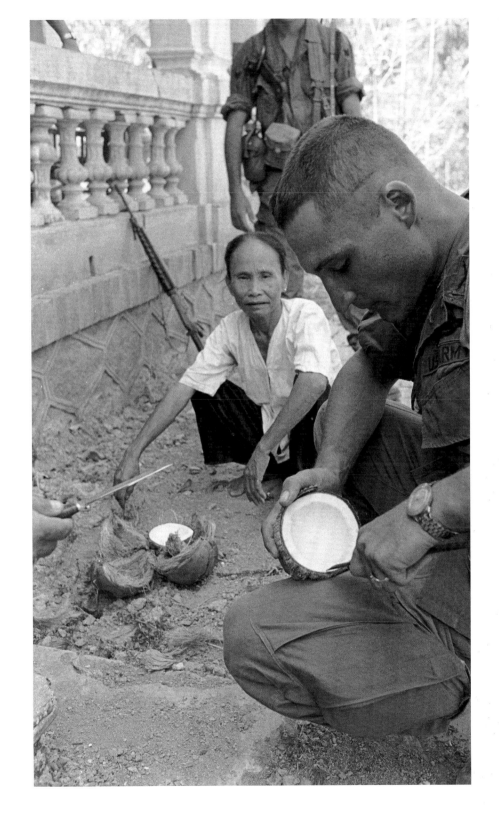

A Vietnamese woman offers a coconut to Lieutenant Herb Borgman.

April 1, 1967 | Rạch Kiến

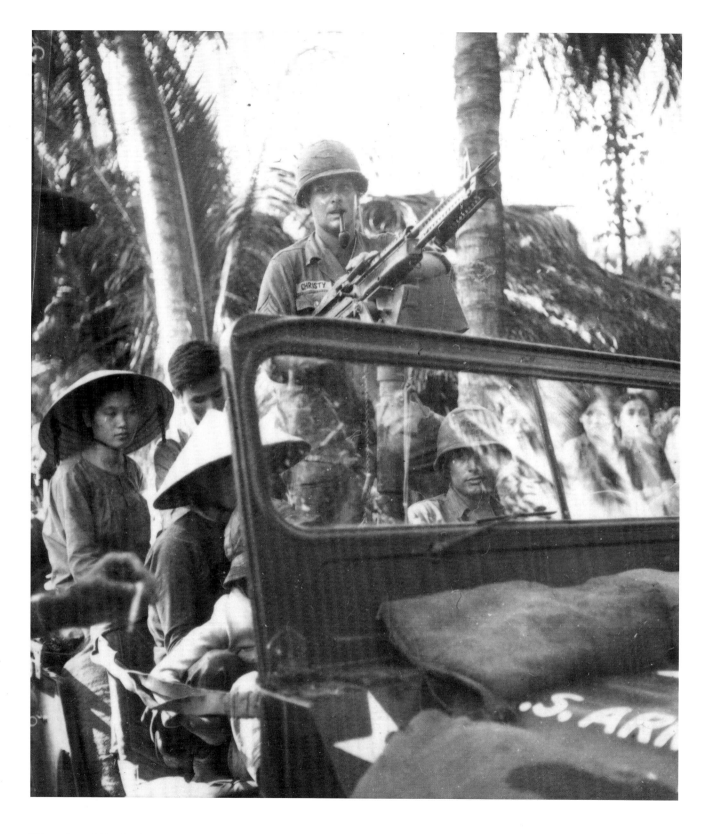

Sergeant Lyle Christy.
July 1, 1969 | Gia An

Red Cross worker Hector Sanchez sings
Spanish tunes to Vietnamese orphans.
1968 | Saigon

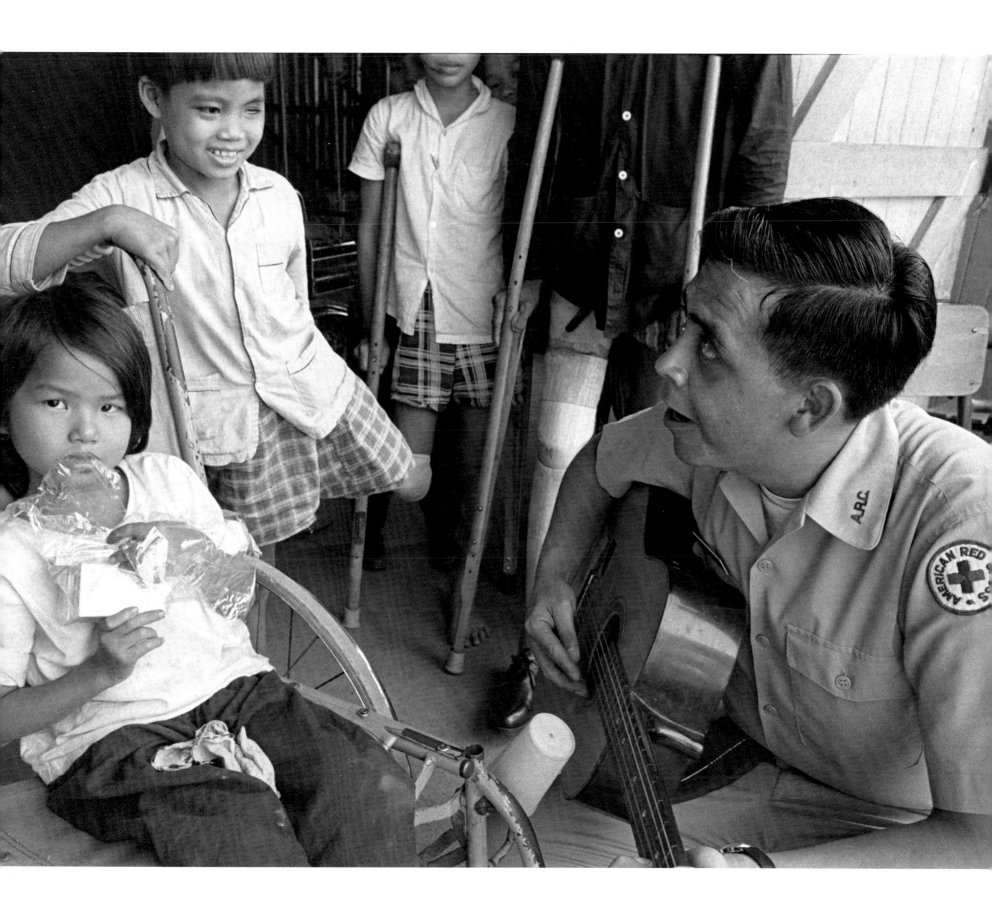

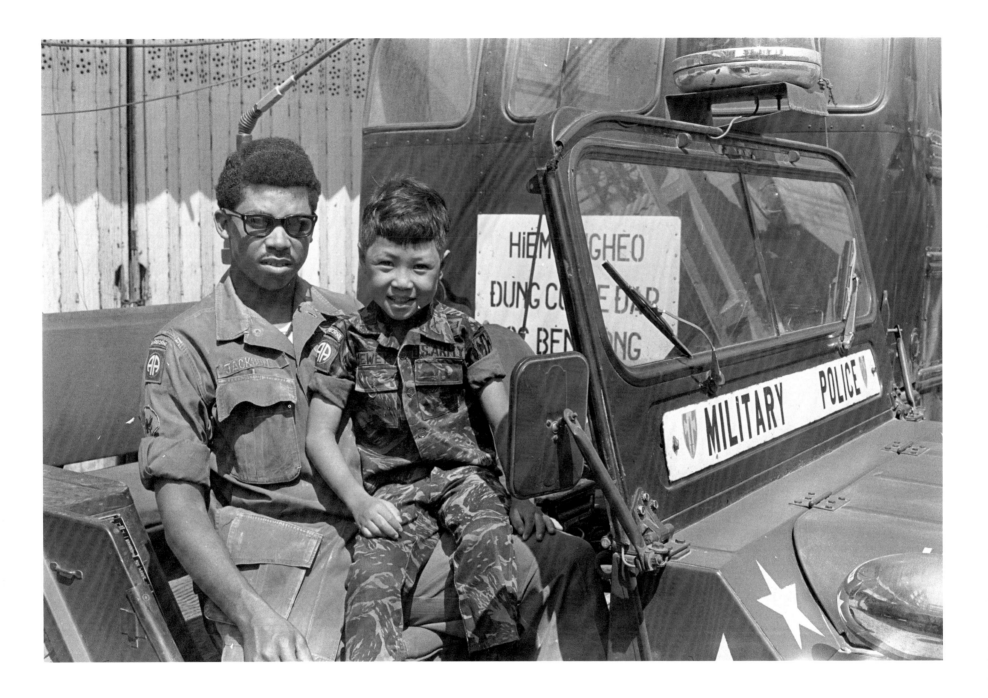

▲ **BRENT PROCTER**
Specialist Fourth Class Michael A. Jackson,
a 716th Military Police patrol driver, with
Dai Uy (Mr. Dewey).
March 2, 1970 | South Vietnam

▶ *OW* **STAFFER**
Private First Class Kenneth McKim of the 64th
Quartermaster Battalion and a young Vietnamese boy
enjoy a Coke at a Tết (Lunar New Year) party for children at
a Buddhist orphanage.
1967 | Saigon

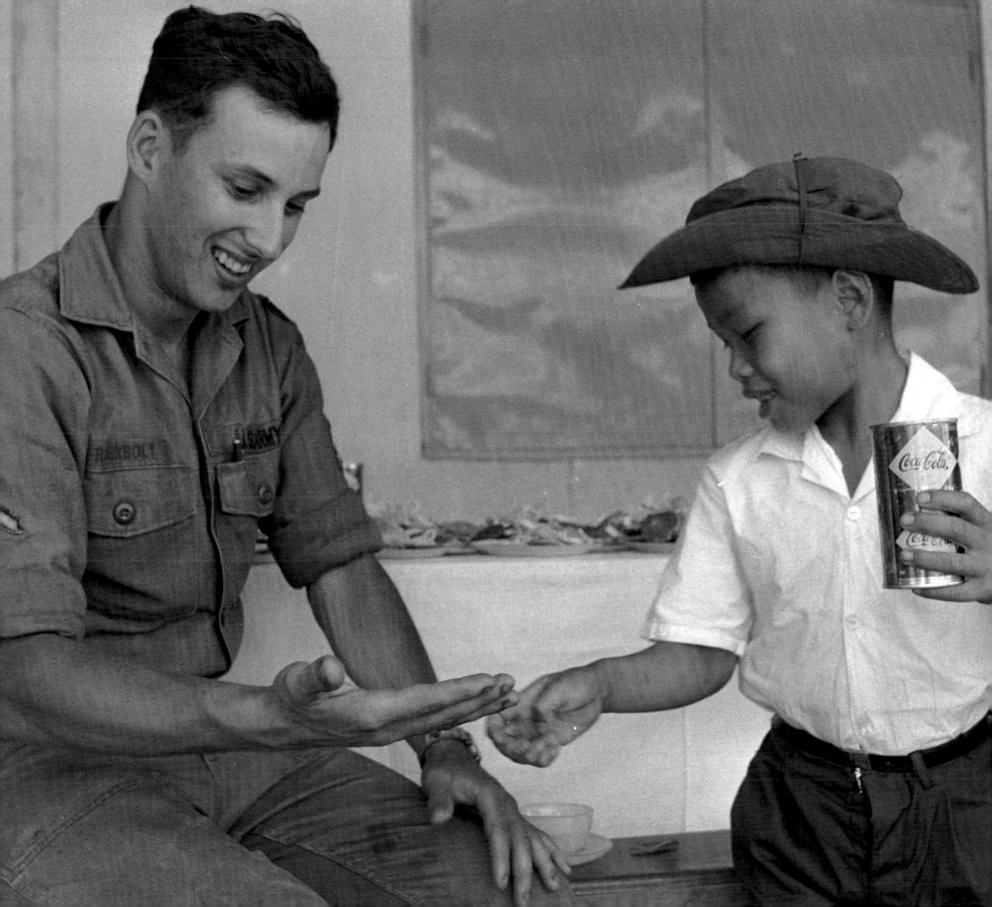

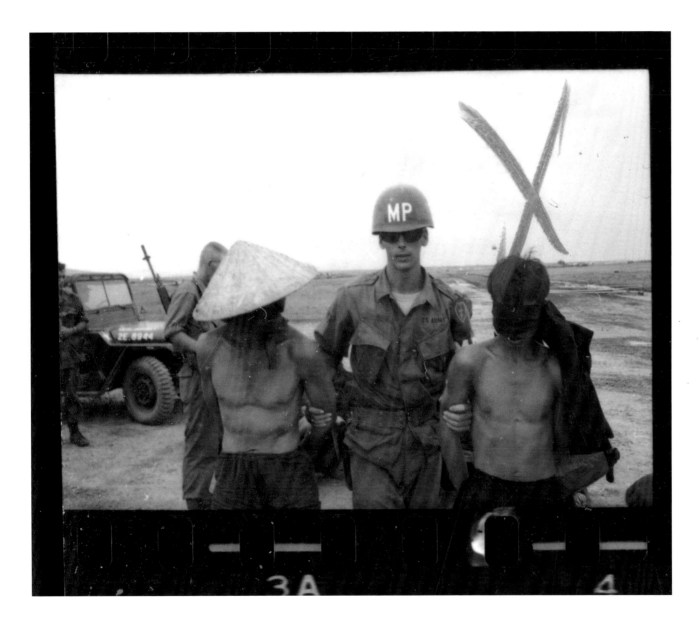

OW STAFFER

Suspected National Liberation Front (NLF) guerrilla soldiers blindfolded and taken prisoner by military police.

December 11, 1966 | South Vietnam

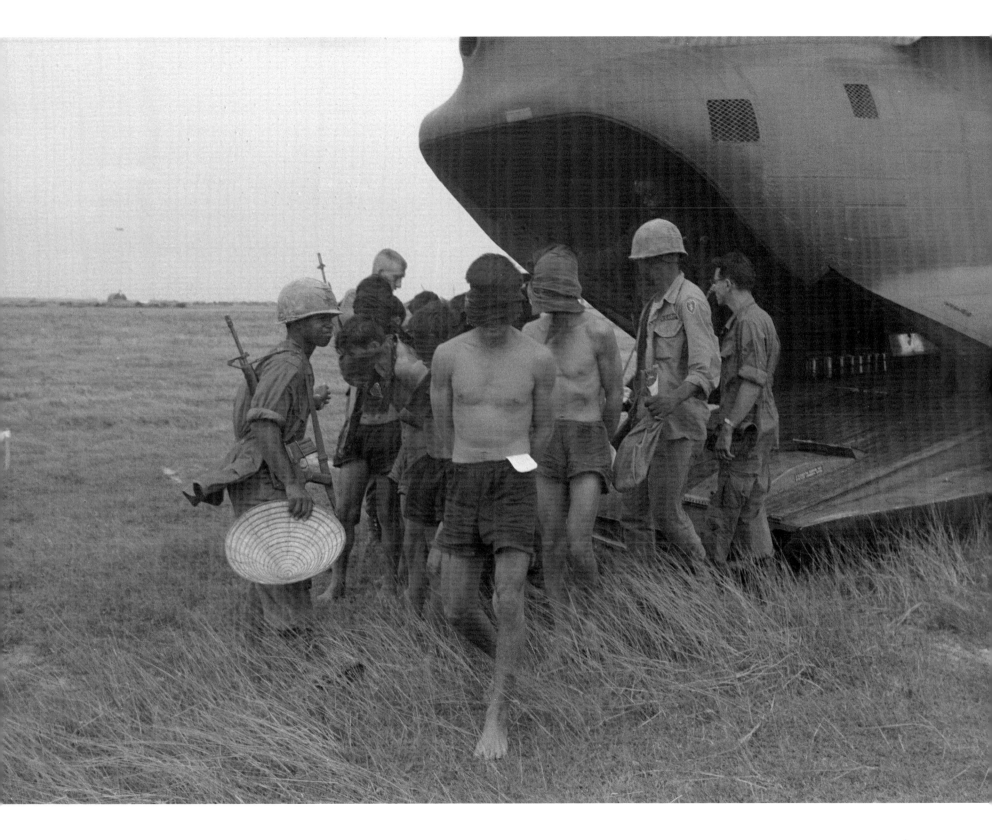

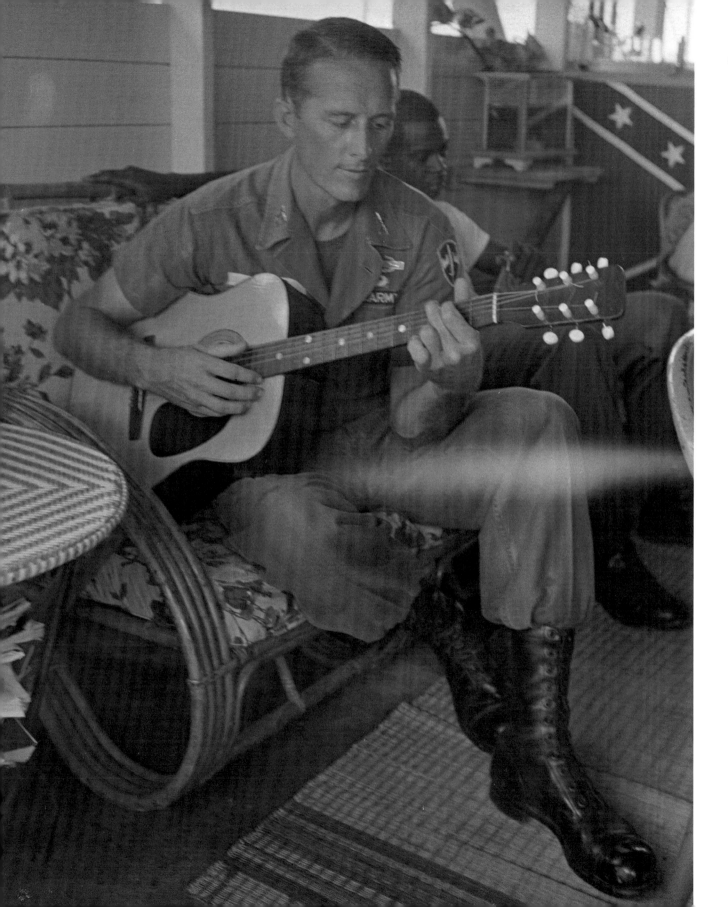

◀ **ANN BRYAN**
Captain Hershel Gober
plays the guitar.
April 7, 1966 | South Vietnam

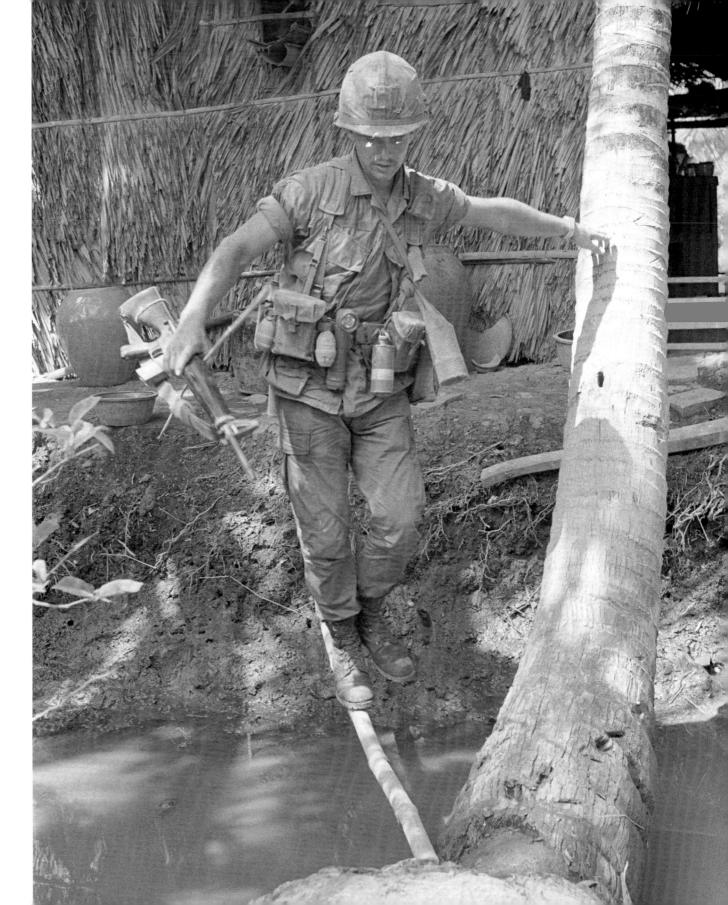

▶ *OW* STAFFER
US soldier crosses narrow branch during a search mission.
April 1, 1967 | Rạch Kiến

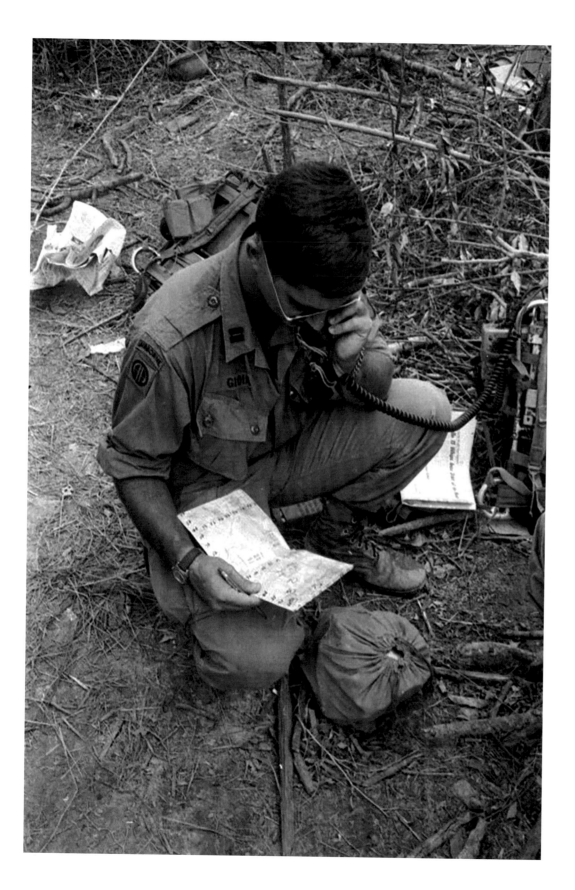

◄ **DON HIRST**
Captain Phil Gioia reviews a map while talking with one of his platoons from A Company, 1st Battalion, 5th Cavalry.

September 13, 1969 | Phước Vĩnh

▶ **ART GREENSPON**
A Marine tank passes a hospital in Huế where a bullet-riddled ambulance sits in front of the entrance.

February 1968 | Huế

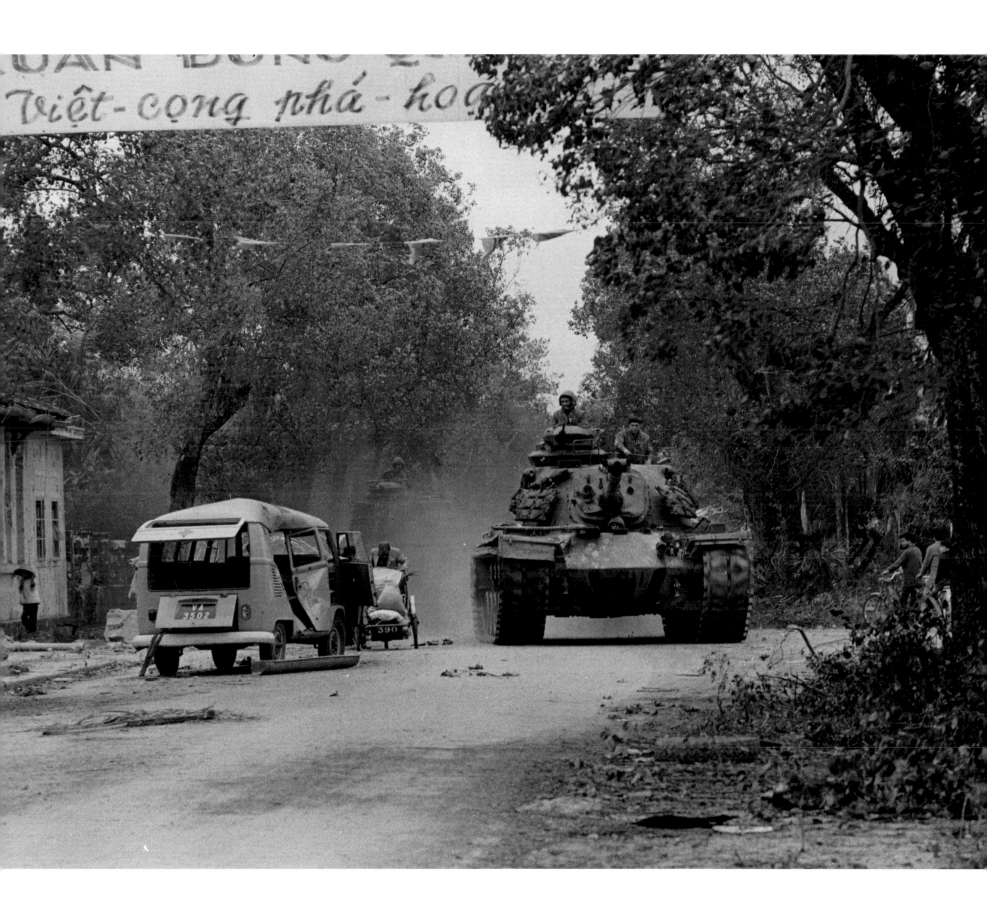

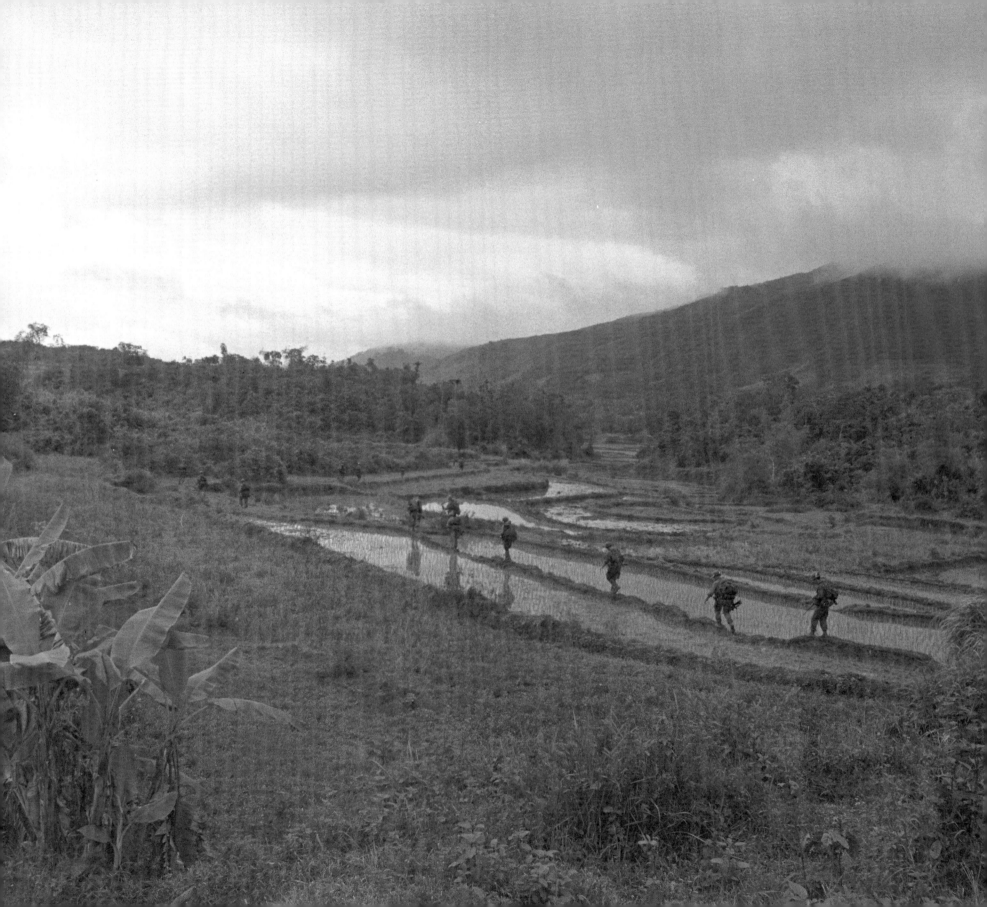

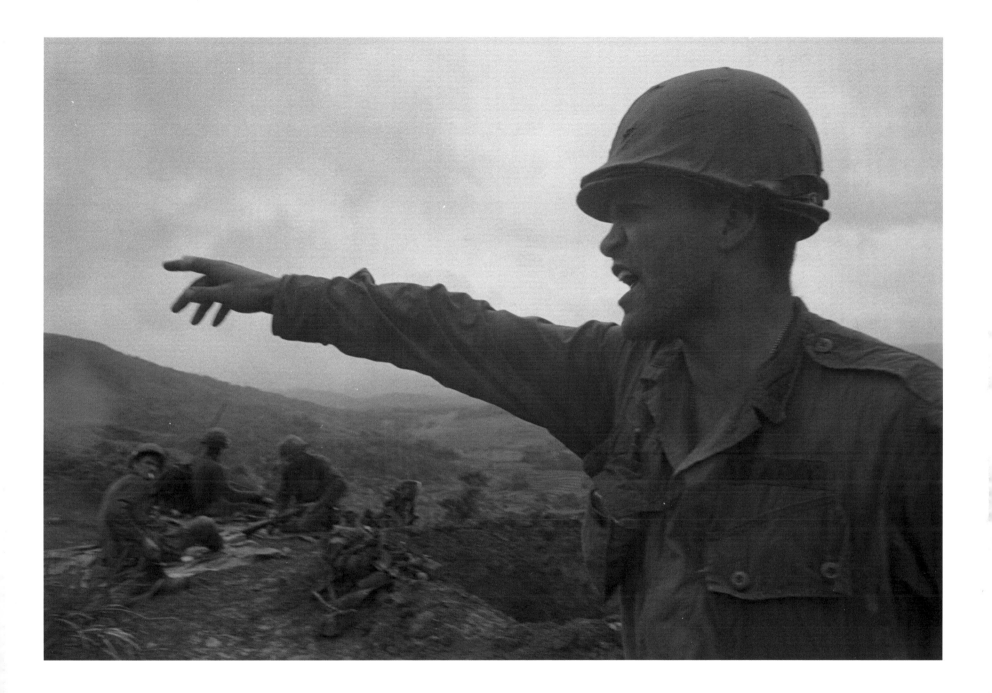

ART GREENSPON
Men of C Company trek through
Quế Sơn Valley.
February 1968 | Quế Sơn

ART GREENSPON
Captain Joseph F. Stringham, who calls himself
the "coldest captain in this man's Army," barks,
"Goddammit, I want you guys over there to get
your boots off," to his company on Black Leach Hill.
February 1968 | Quế Sơn

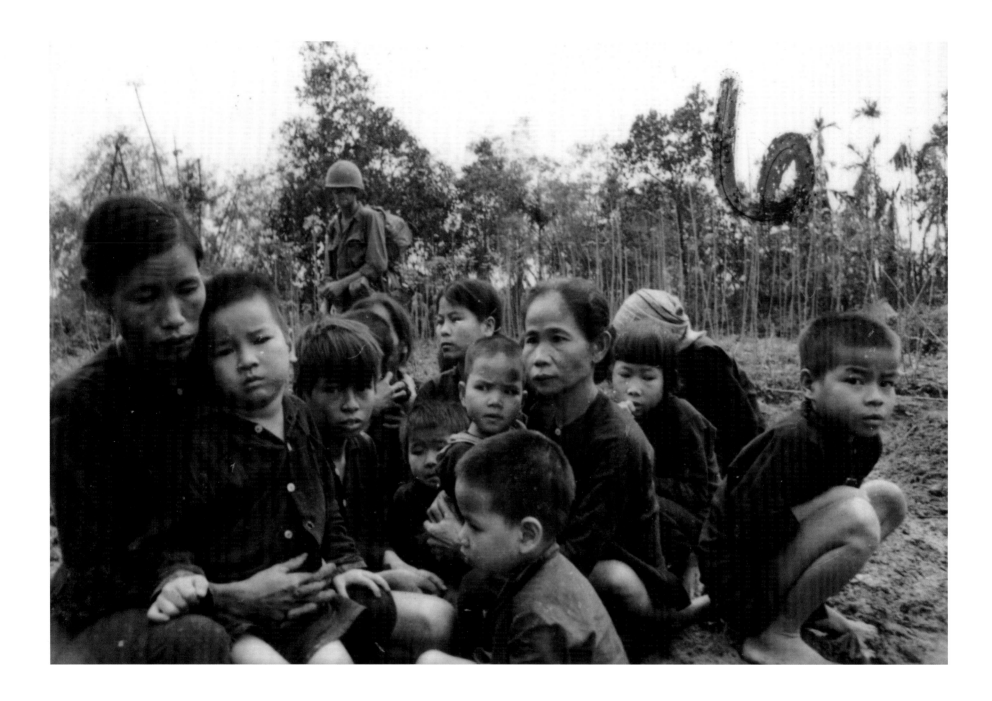

▲ **ART GREENSPON**
Villagers of Quế Sơn Valley are searched
by US infantrymen.
February 1968 | Quế Sơn

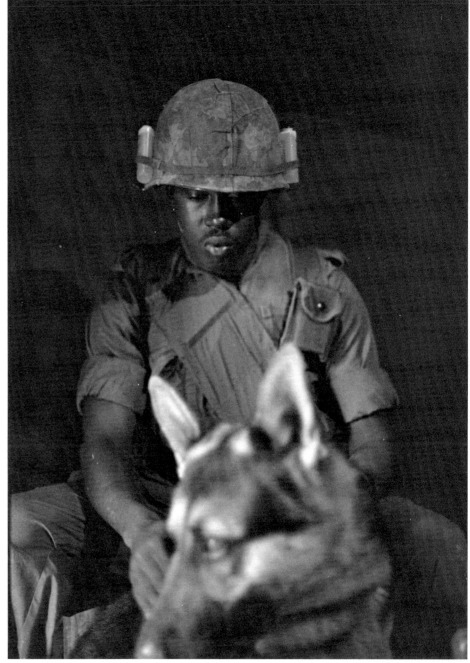

▲ ART GREENSPON

▶ An unidentified soldier of the 4th Battalion, 31st Infantry Regiment, 196th Light Infantry Brigade sits patiently with his scout dog.

February 1968 | Quế Sơn

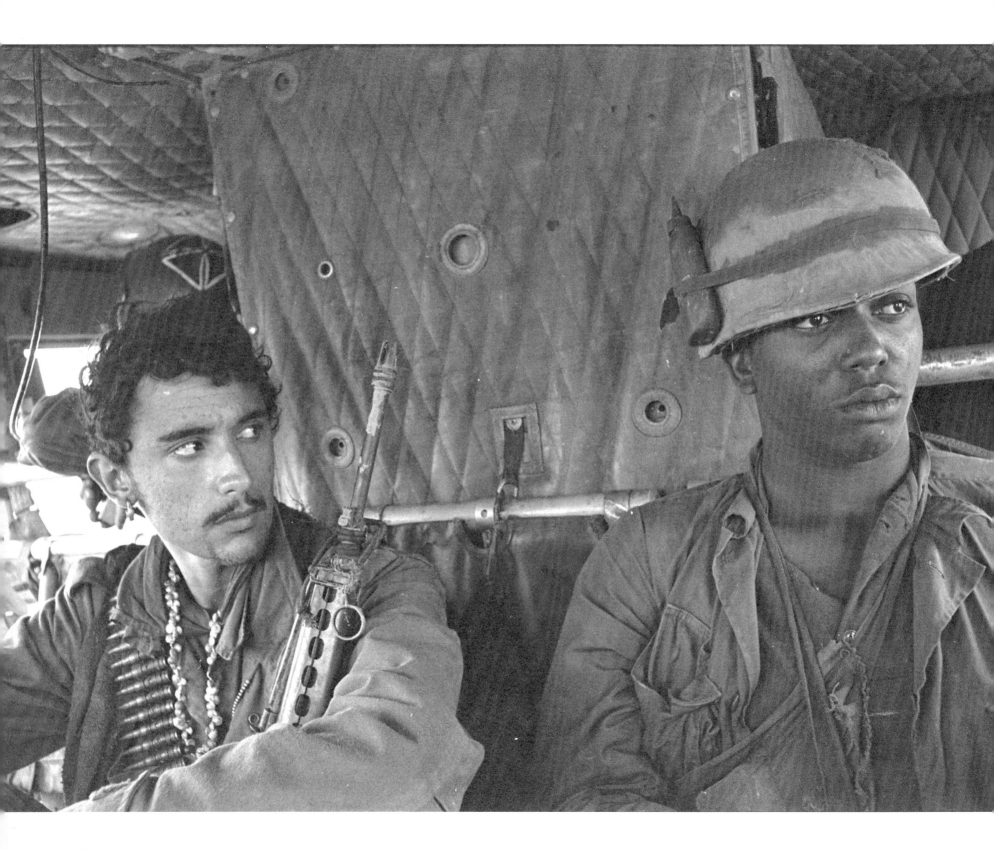

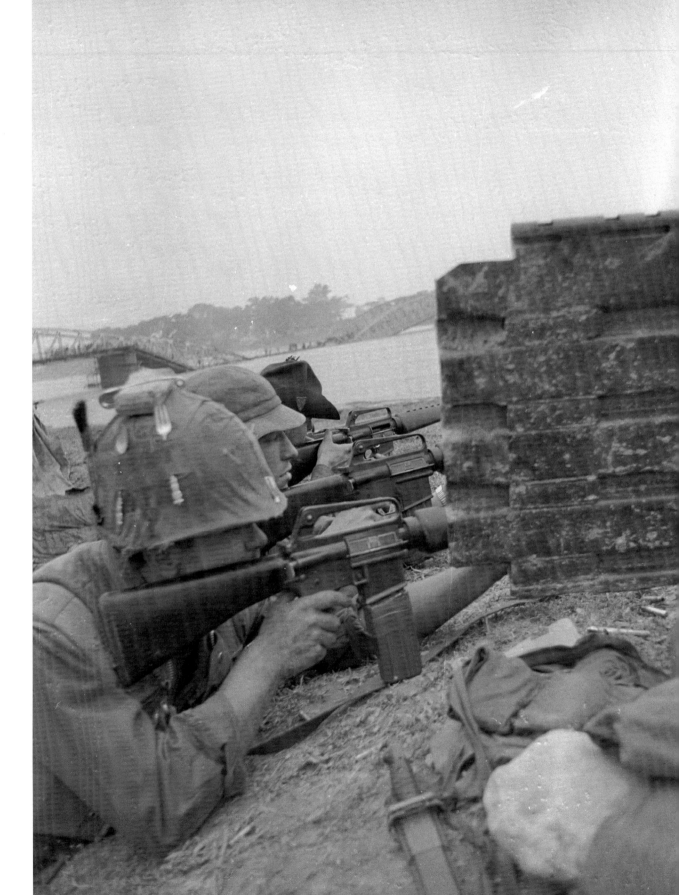

ART GREENSPON
Private First Class Danny Pratti, 21 (*left*),
and Private First Class Freddie Bradshaw,
20, both from A Company, 4th Battalion,
31st Infantry Regiment, 196th Light
Infantry Brigade are picked up by chopper
in the field.
March 1968 | Quế Sơn

▶ **ART GREENSPON**
Unidentified Marines attentively await
their next move.
March 1968 | Huế

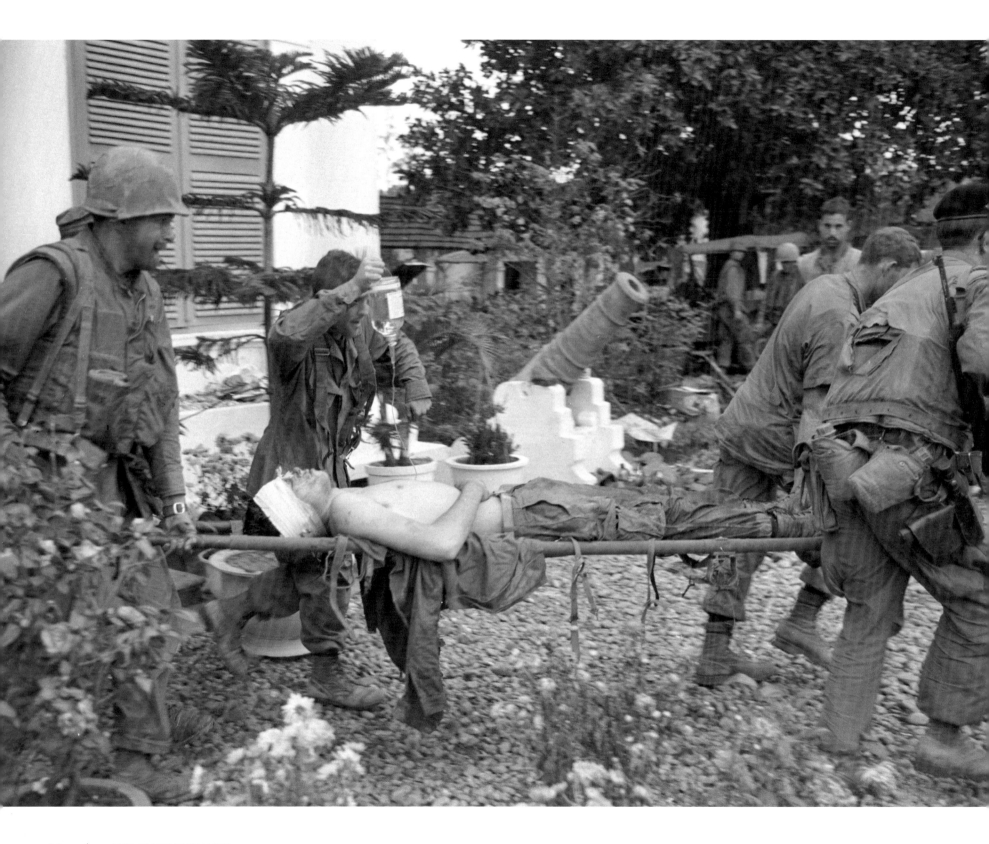

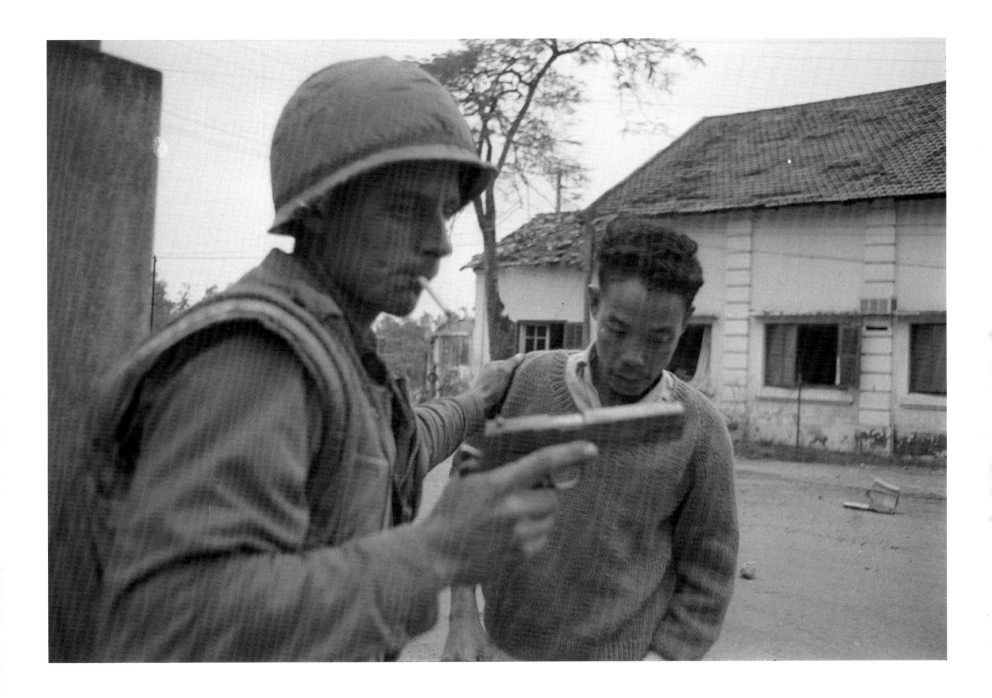

◀ **ART GREENSPON**
Combat medics evacuate a
wounded soldier.
March 1968 | Huế

▲ **ART GREENSPON**
A refugee faces questioning by a
US Marine.
March 1968 | Huế

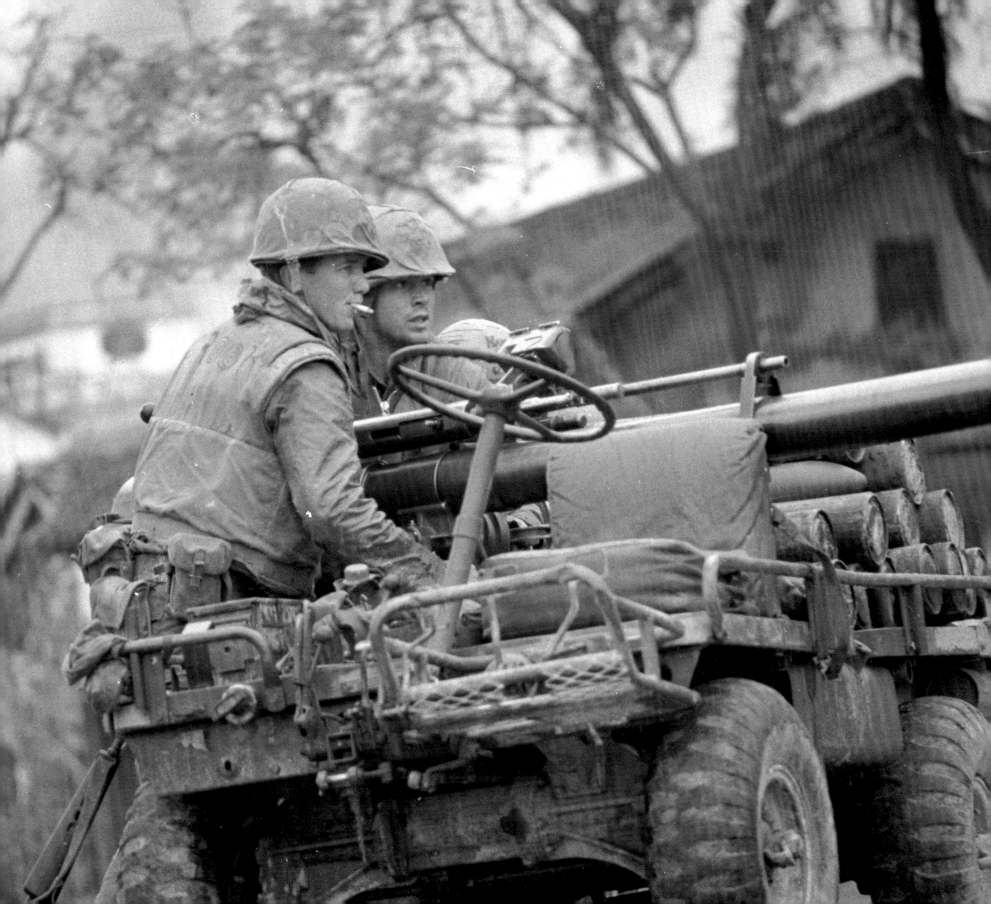

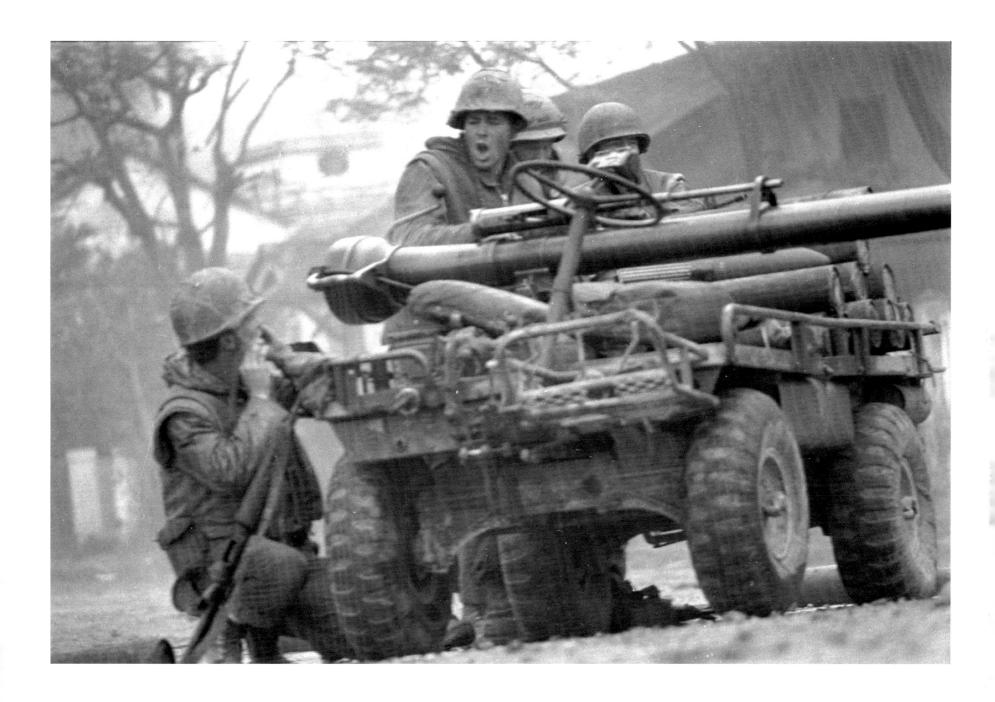

▲ **ART GREENSPON**

◀ A 106mm recoilless rifle team leader barks orders to his crew as they provide fire support for Marines during fighting on the south side.

March 1968 | Huế

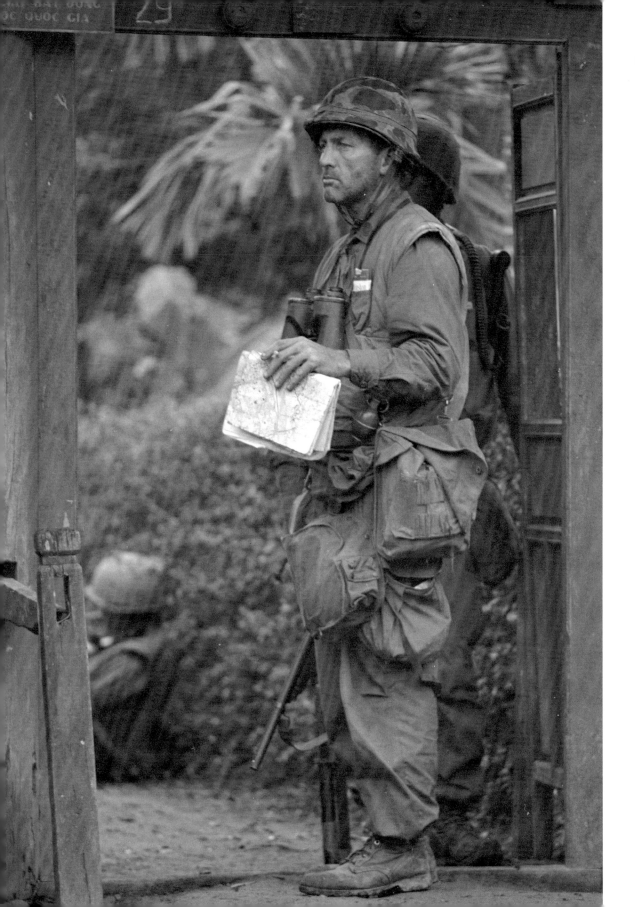

ART GREENSPON
A top sergeant forced into the role of company commander for B Company ponders the next move on the south side.
March 1968 | Huế

▲ **ART GREENSPON**
A Marine from B Company wears a gas mask. Gas was used on occasion to flush the enemy from positions in bunkers and houses.
March 1968 | Hué

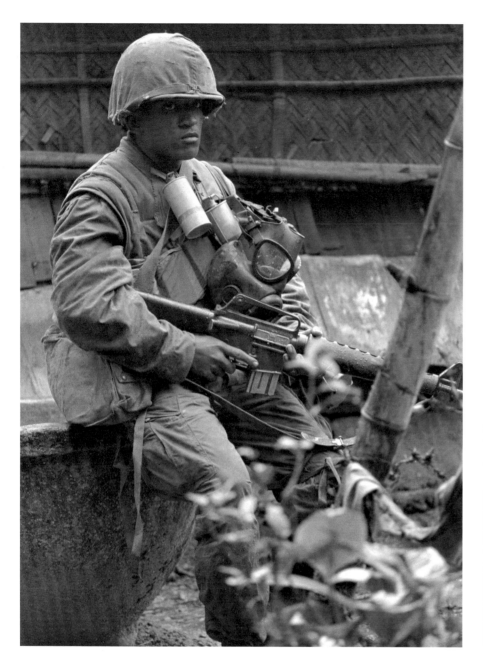

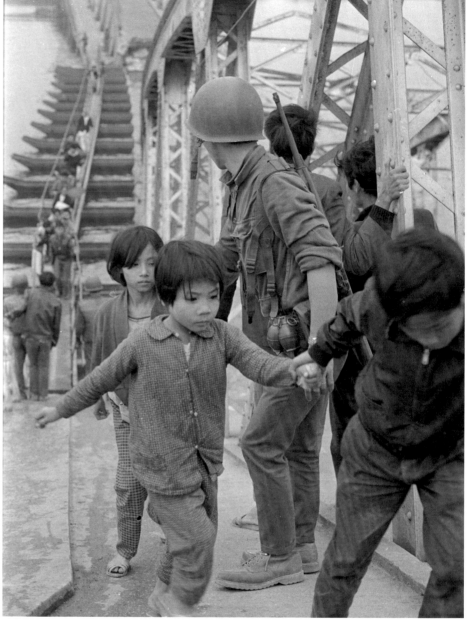

▲ **ART GREENSPON**
A beleaguered US soldier rests on a
flower pot.
March 1968 | Huế

▲ **ART GREENSPON**
Refugees fleeing from the northern side of the Perfume
River cross a pontoon bridge connecting the downed
spans of the destroyed bridge. Moments later, the Army of
the Republic of Vietnam (ARVN) removed the temporary
bridge to prevent more refugees from crossing to the
already crowded southern sector of Huế.
March 1968 | Huế

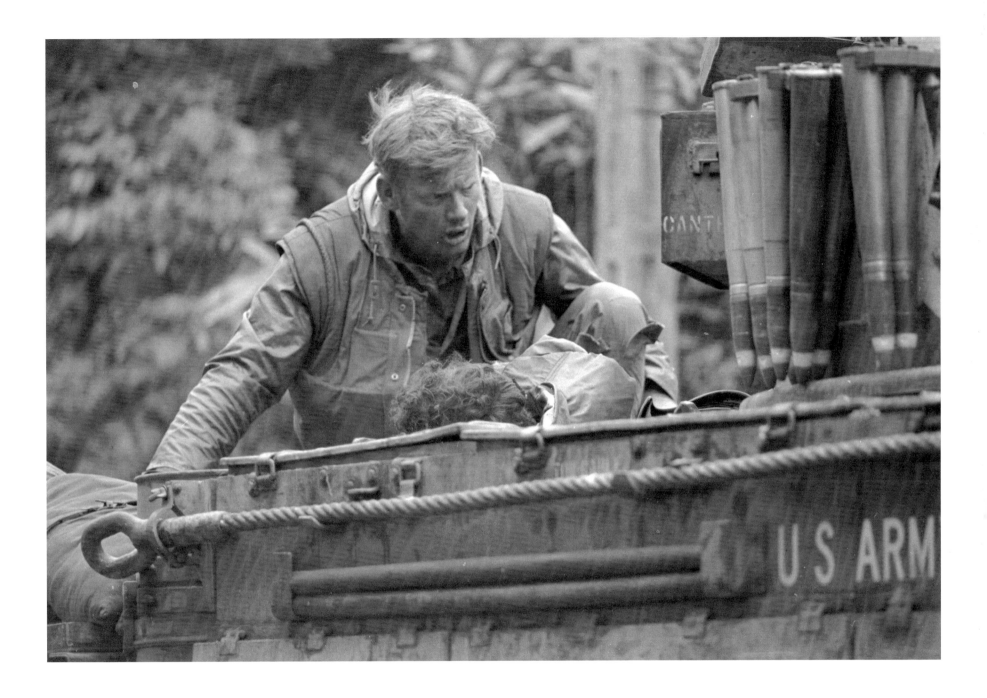

▲ **ART GREENSPON**
An unidentified Marine tends to a fellow Marine wounded during fighting on the south side of Huế.

March 1968 | Huế

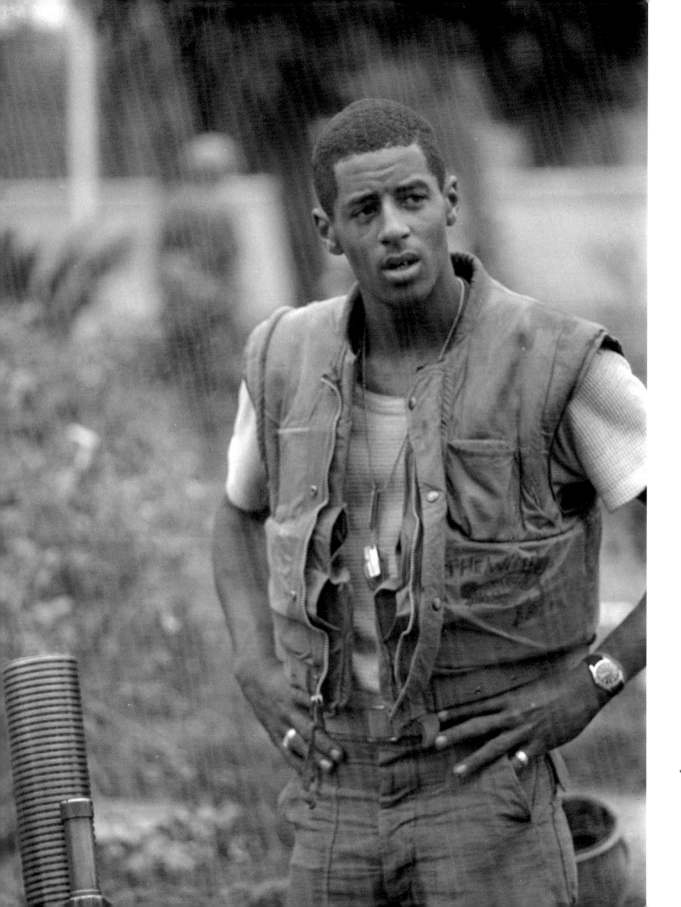

ART GREENSPON
An unidentified Marine pauses to catch a breath during fighting.
March 1968 | Hué

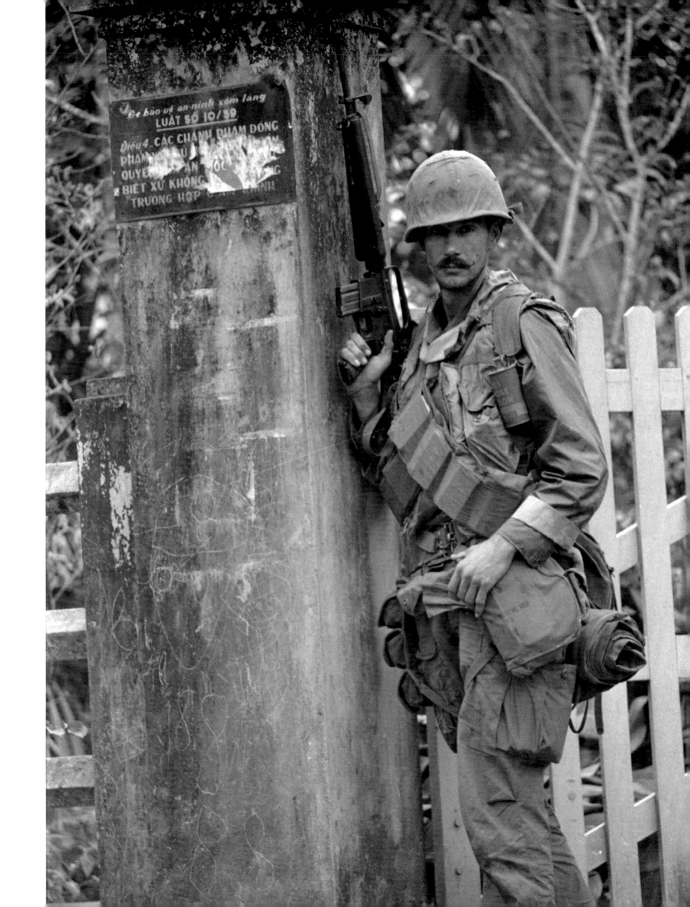

▸ **ART GREENSPON**
Unidentified Marine of B Company.
March 1968 | Huế

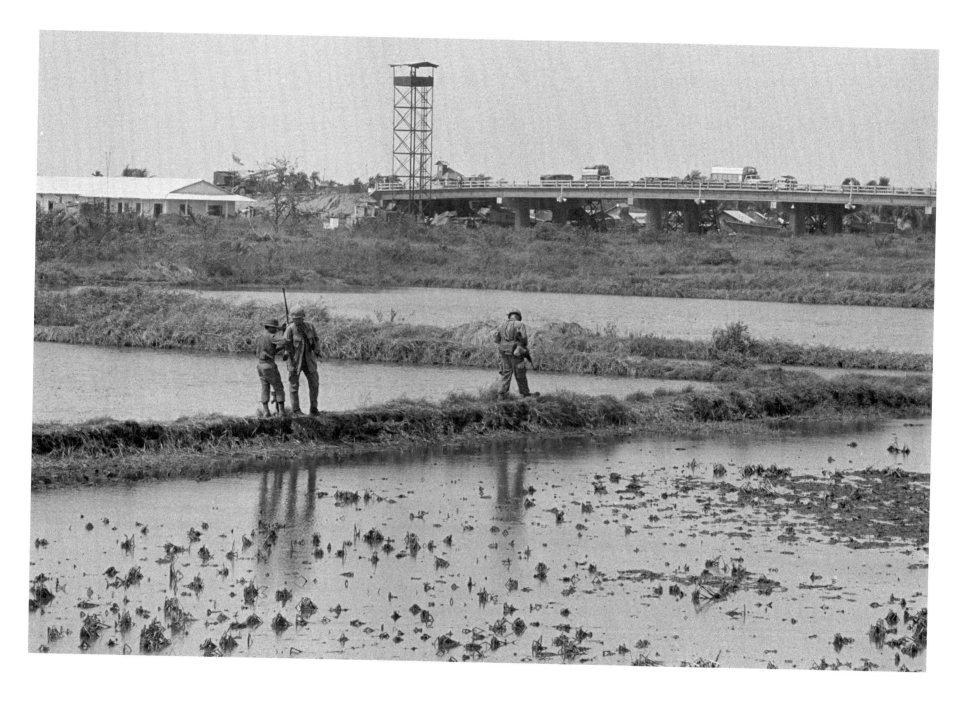

OW STAFFER
Infantry troopers march back to their headquarters.
April 12, 1969 | Saigon

OW STAFFER
Unidentified combat patrols of B Company wade through waist-deep water to cross a paddy field.
1969 | South Vietnam

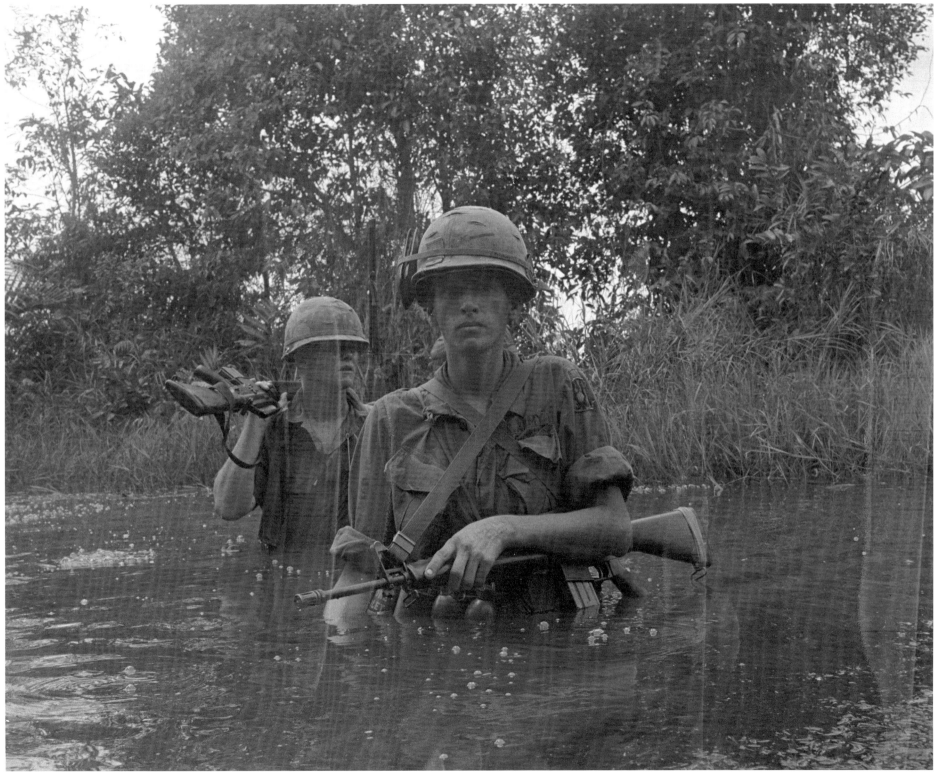

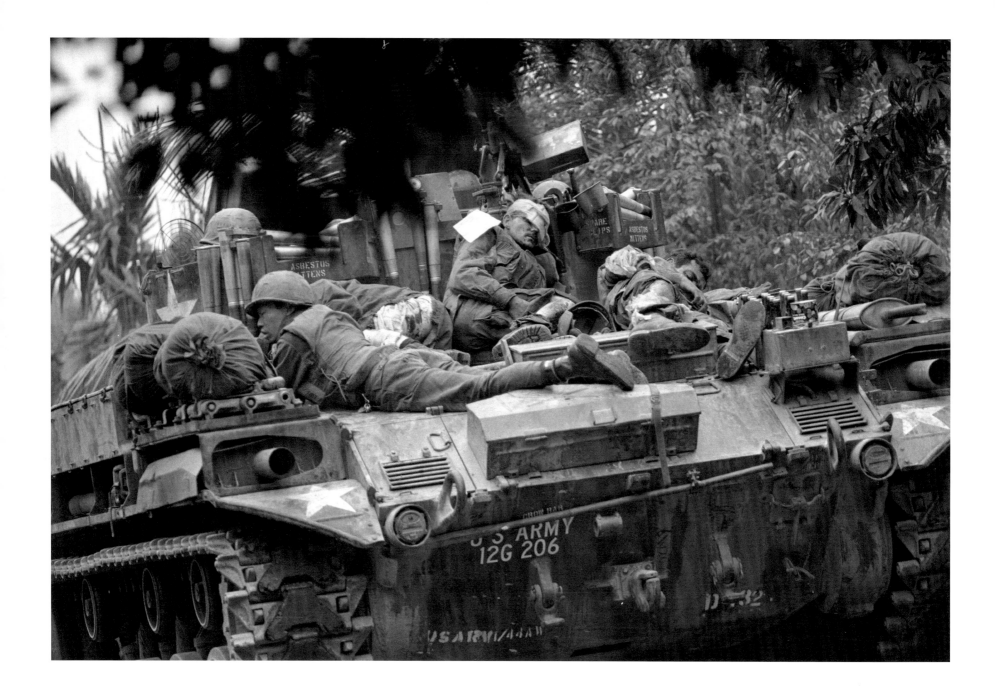

▲ **ART GREENSPON**
Wounded soldiers lie on the back of a
Duster waiting to be medevaced to the
battalion aid station.
March 1968 | Huế

▶ **BOB HANDY**
Air Force C-130s make drops of C rations,
ammunition, and other vital supplies.
March 2, 1968 | Khe Sanh

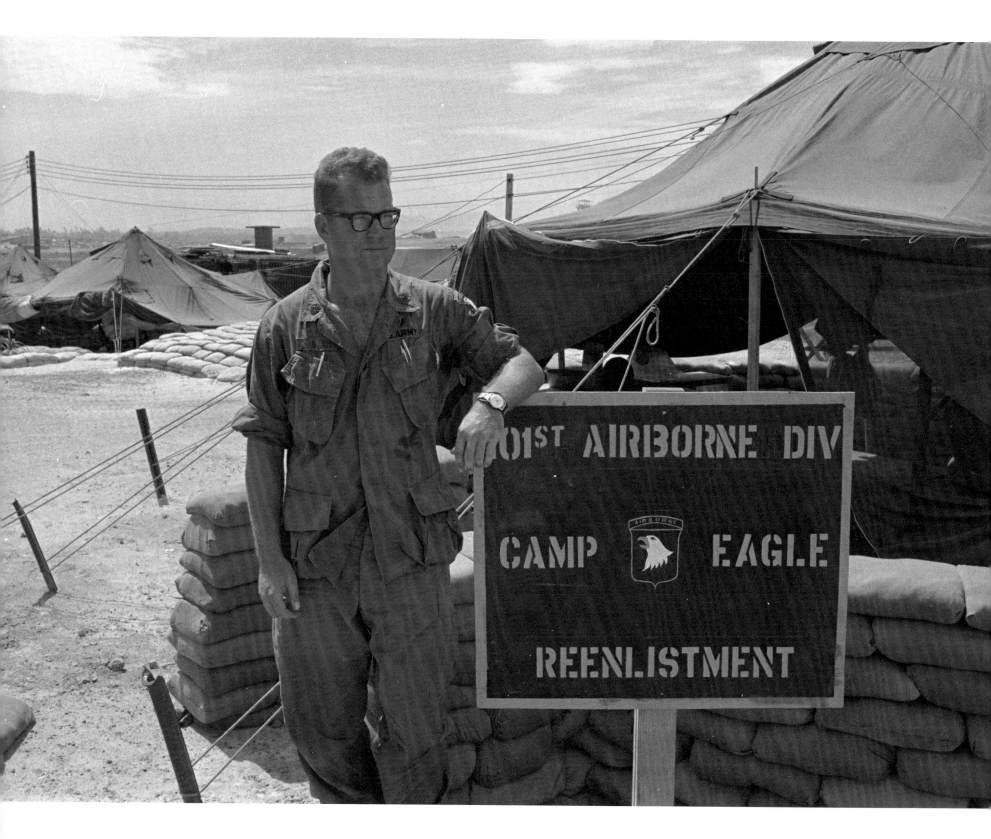

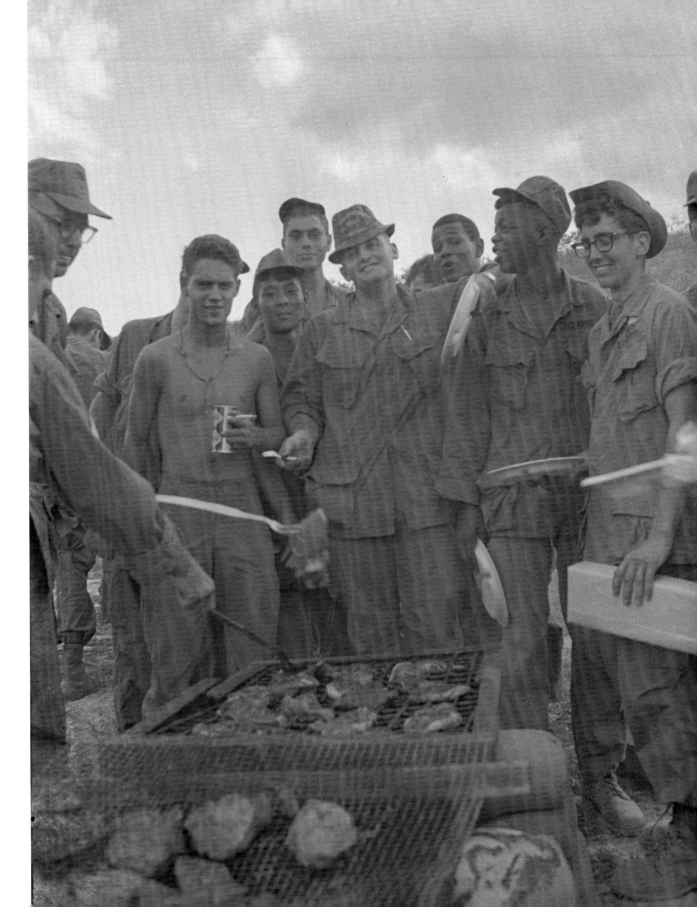

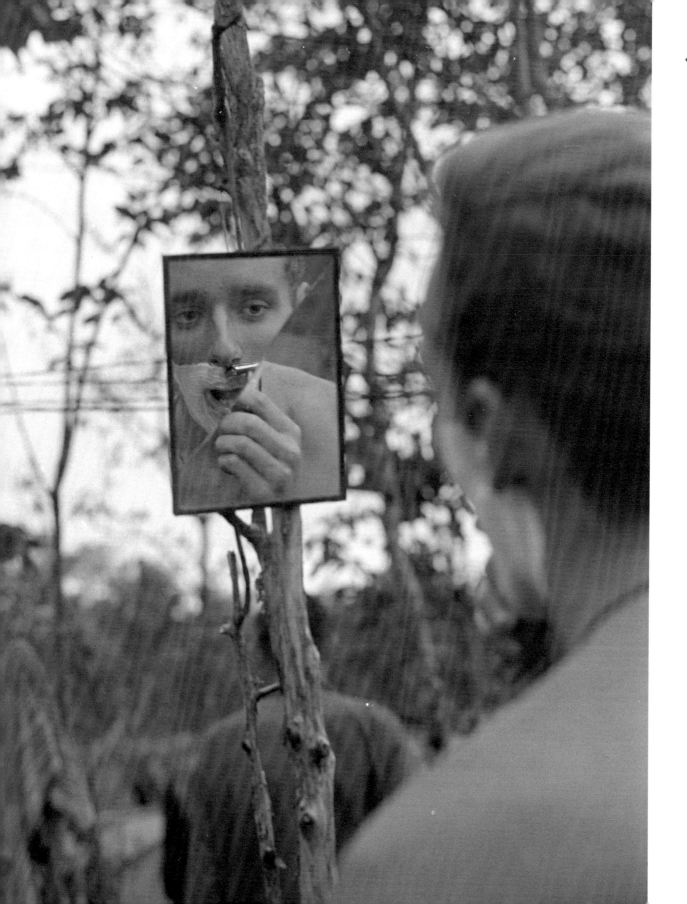

▲ *OW* STAFFER
An unidentified private first class on
search patrol.
1968 | South Vietnam

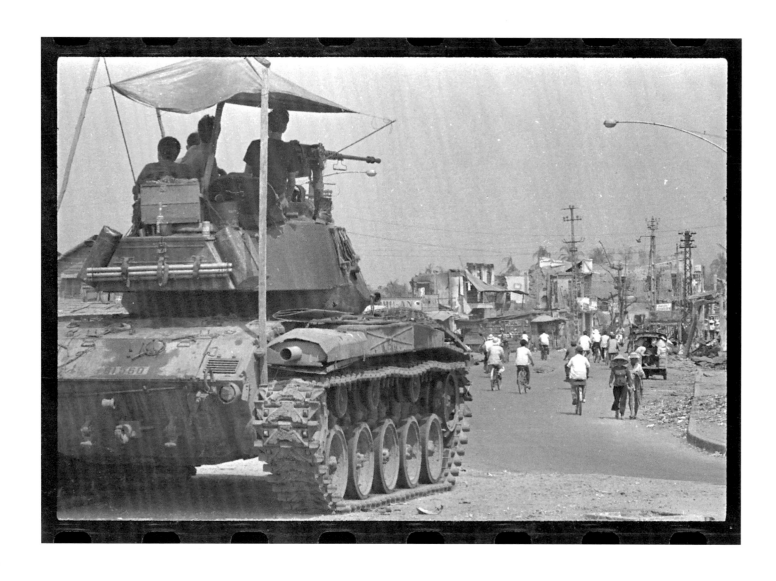

▲ **PHIL JORDAN**
A tank rolls along a war-damaged road
between Long Bình and Saigon.
February 11, 1968 | Long Bình

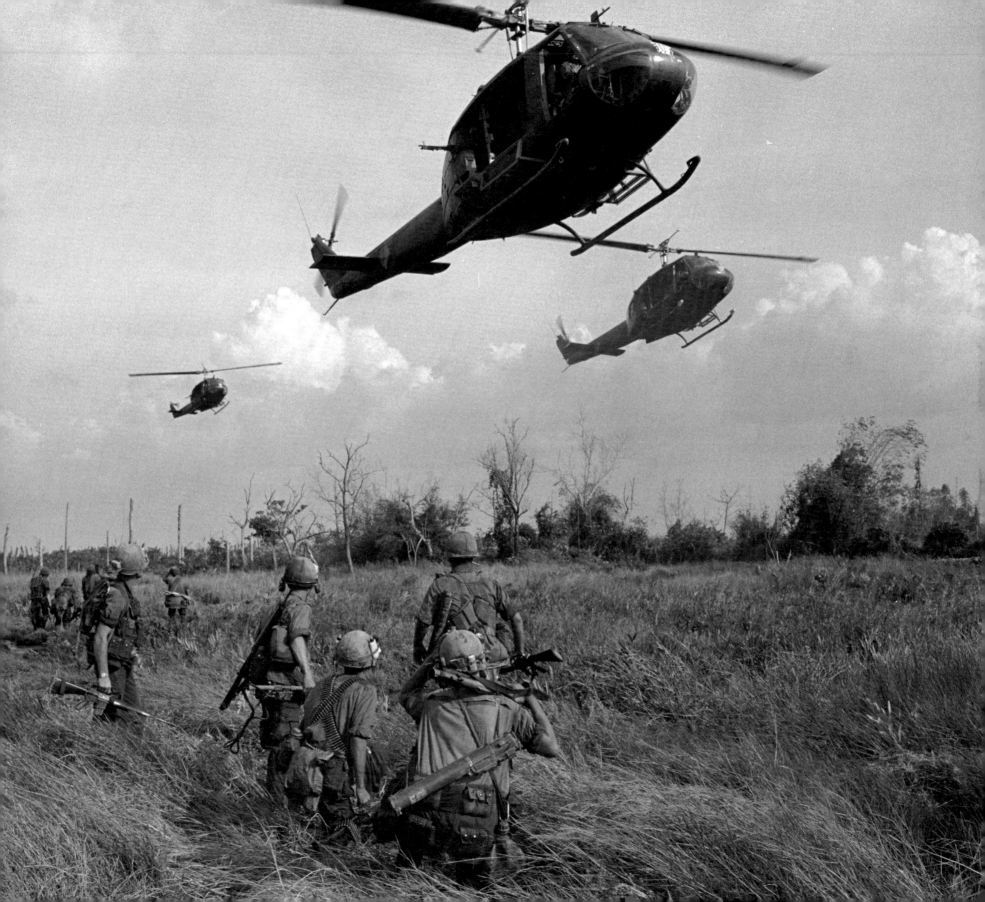

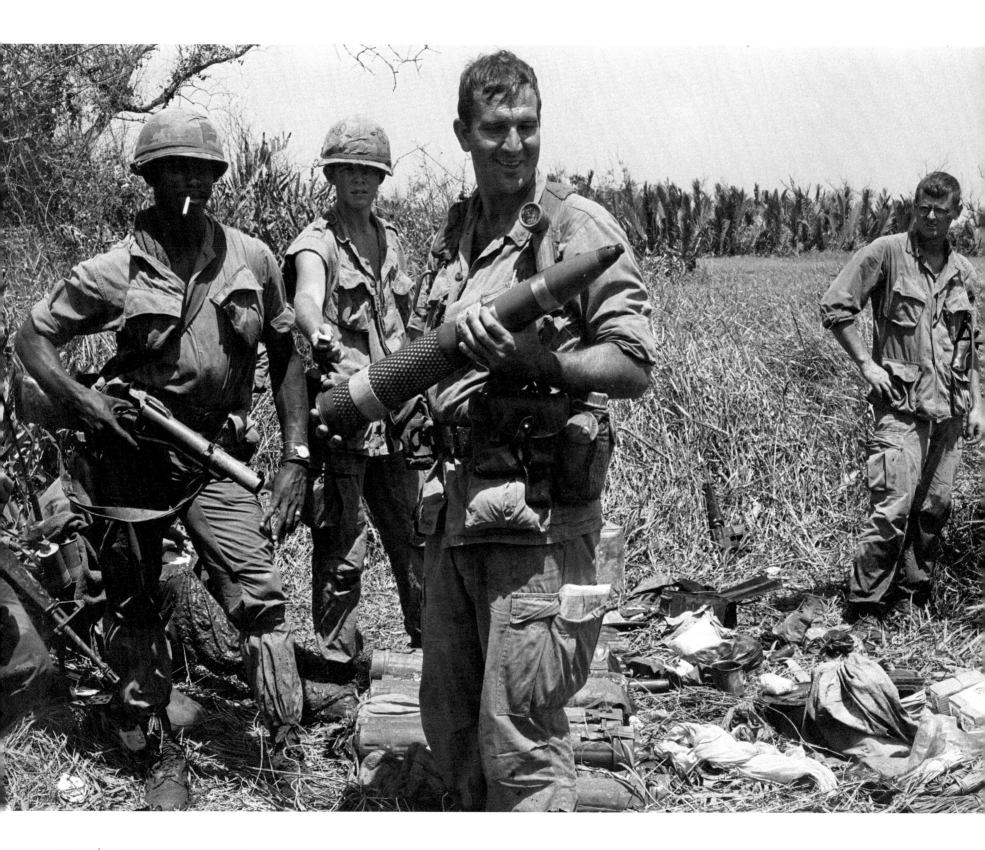

DON HIRST

First Lieutenant James Cox, platoon leader of B Company, 3rd Platoon, 3rd Battalion holds a captured recoilless rifle.

March 22, 1969 | Long Bình

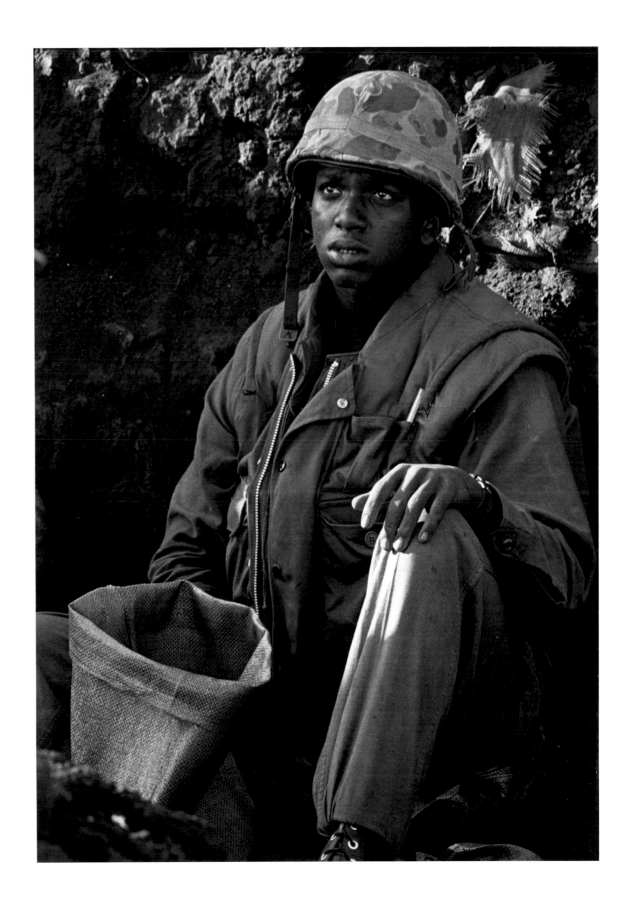

OW STAFFER

An unidentified soldier anxiously peers upward.

May 3, 1969 | South Vietnam

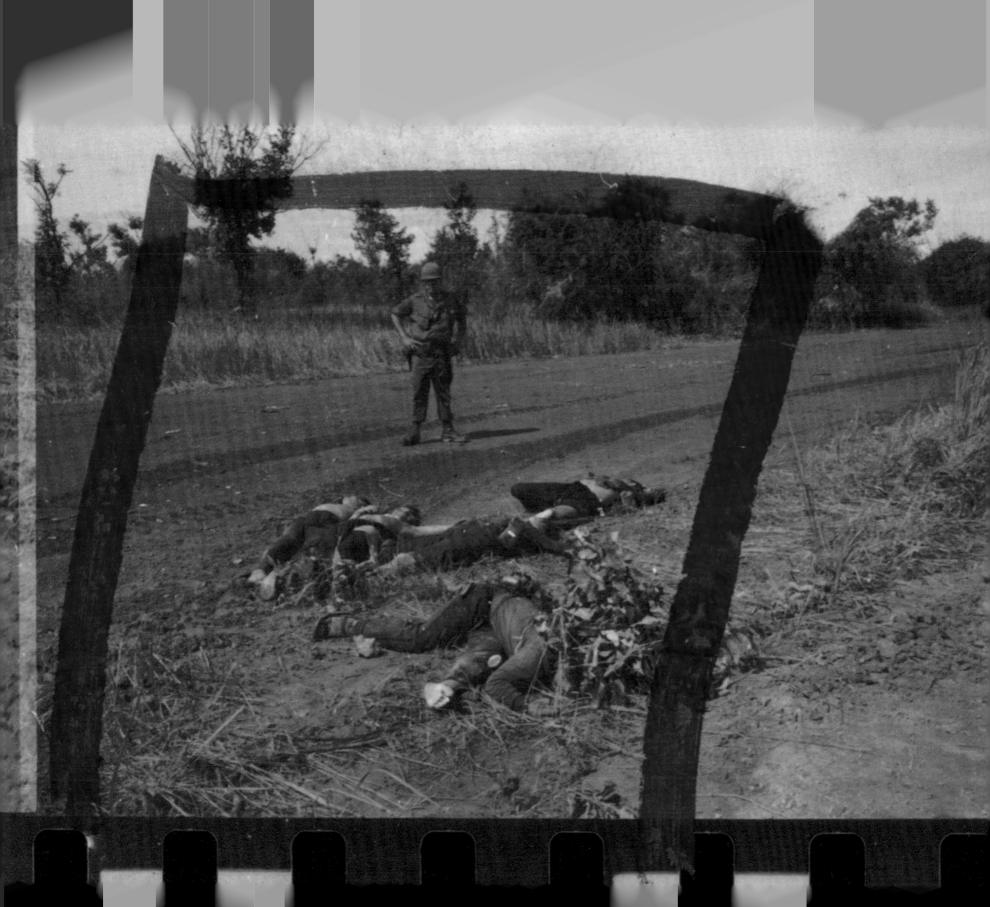

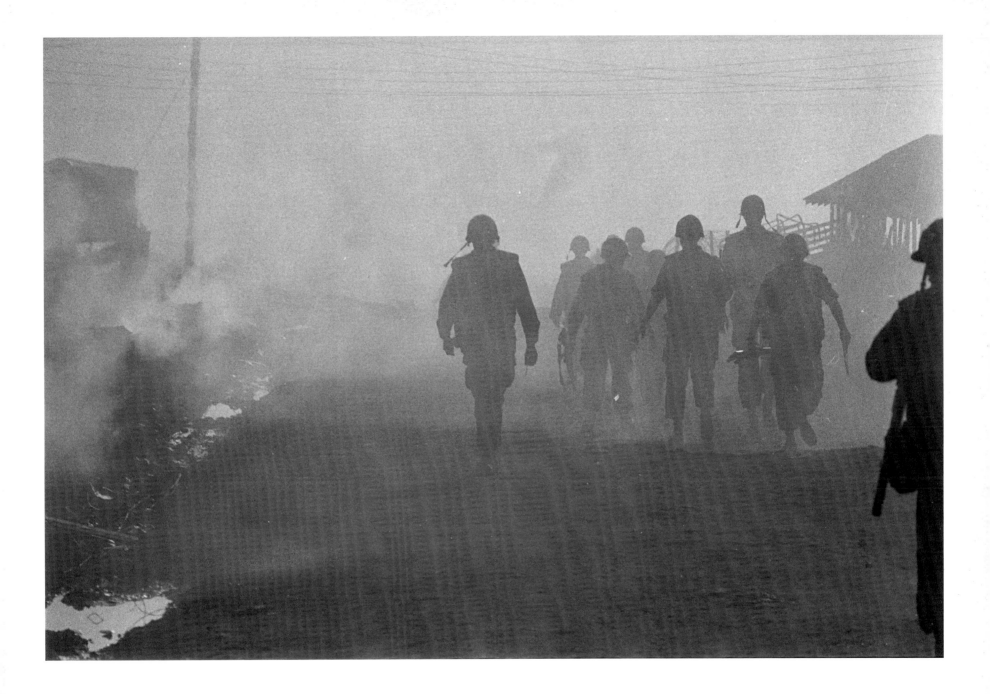

CYNTHIA COPPLE
Is body count a good way to measure who
is winning the war?
1969 | South Vietnam

OW STAFFER
Unidentified soldiers march through the
fog and dust.
May 3, 1969 | South Vietnam

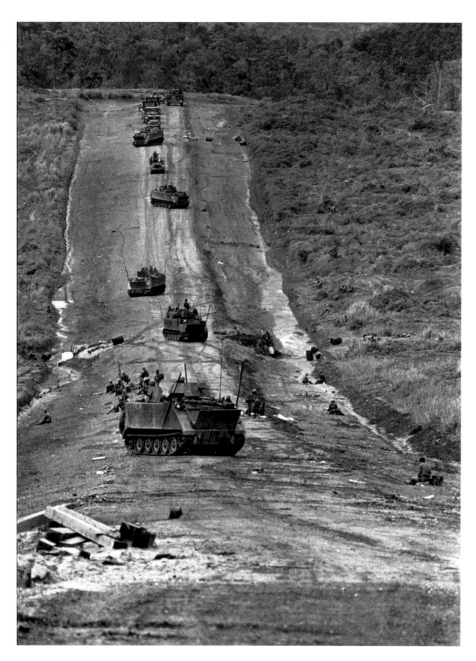

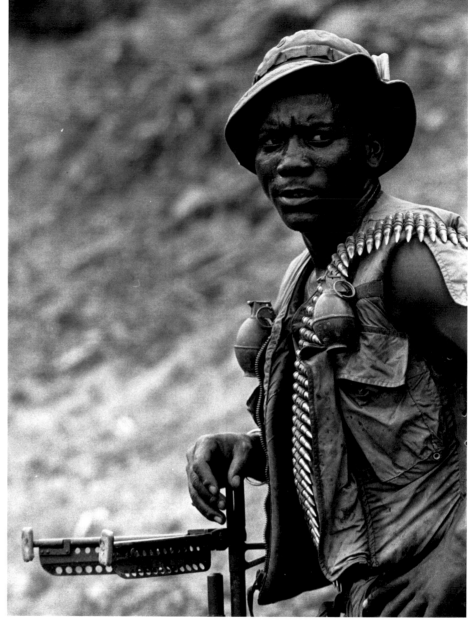

▲ **CHARLES RYAN**
An armored column of combat vehicles,
the first convoy to reach Ben Het after the
siege was broken.

July 26, 1968 | Ben Het

▲ **CHARLES RYAN**
An unidentified US soldier with a soft hat and
ammunition slung over his shoulder says, "I know
we're going to get hit just like the last time."

July 26, 1968 | Ben Het

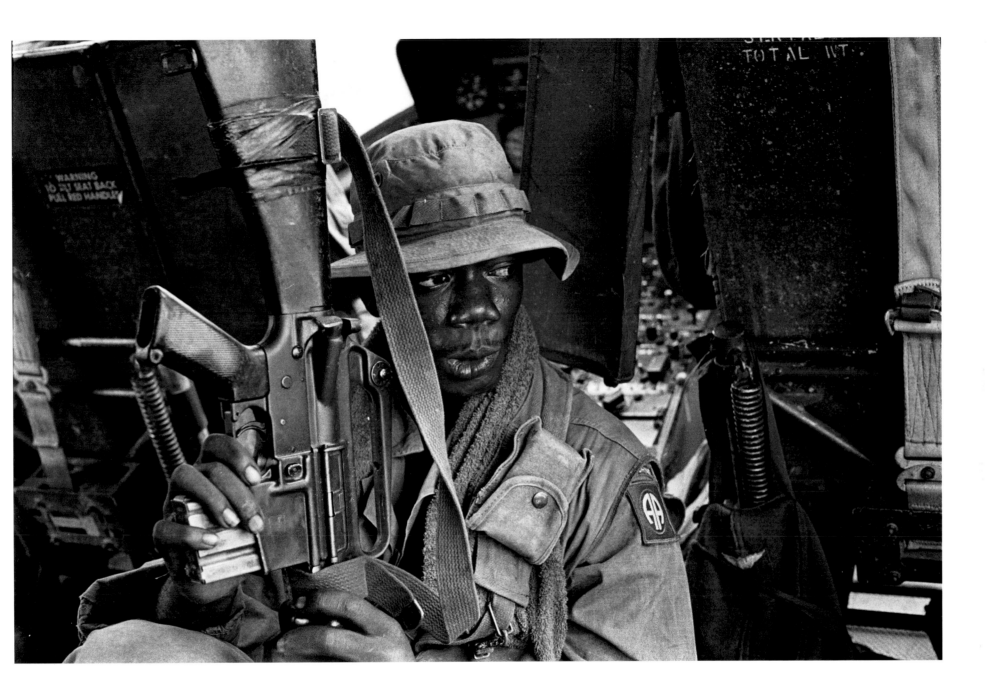

▲ **OW** STAFFER
A long range reconnaissance patrol
machine gunner aboard a helicopter.
November 8, 1968 | South Vietnam

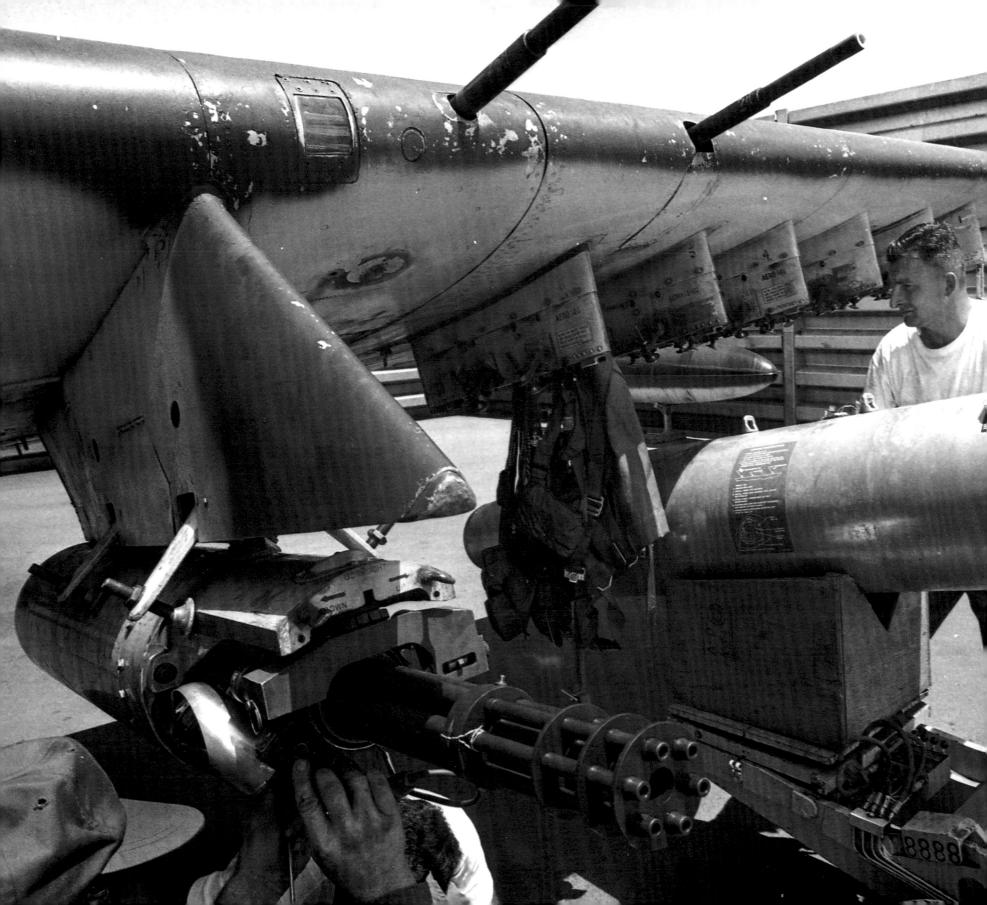

◀ *OW* STAFFER
A 750-pound canister of napalm being loaded onto the wing of an aircraft.
September 2, 1969 | South Vietnam

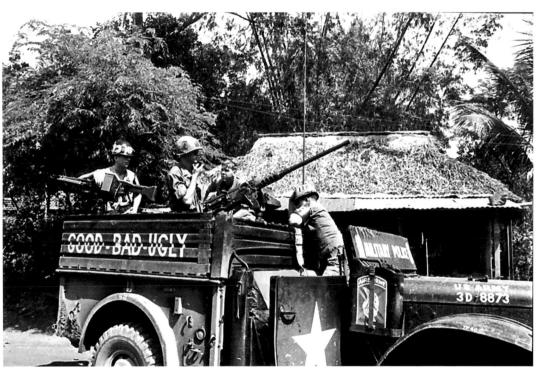

▲ *OW* STAFFER
A gun truck emblazoned with the words "Good Bad Ugly" patrols the backroads.
October 20, 1969 | South Vietnam

DENNIS RUTHERFORD
Sergeant Pedro M. Padilla, the
team leader of the 3rd Squadron,
2nd Platoon, C Company looks
through field glasses.
1970 | Đà Nẵng

DENNIS RUTHERFORD
Private First Class Kenneth M. Matesic
thinks he hears suspicious noises in
the jungle.
July 5, 1969 | Đà Nẵng

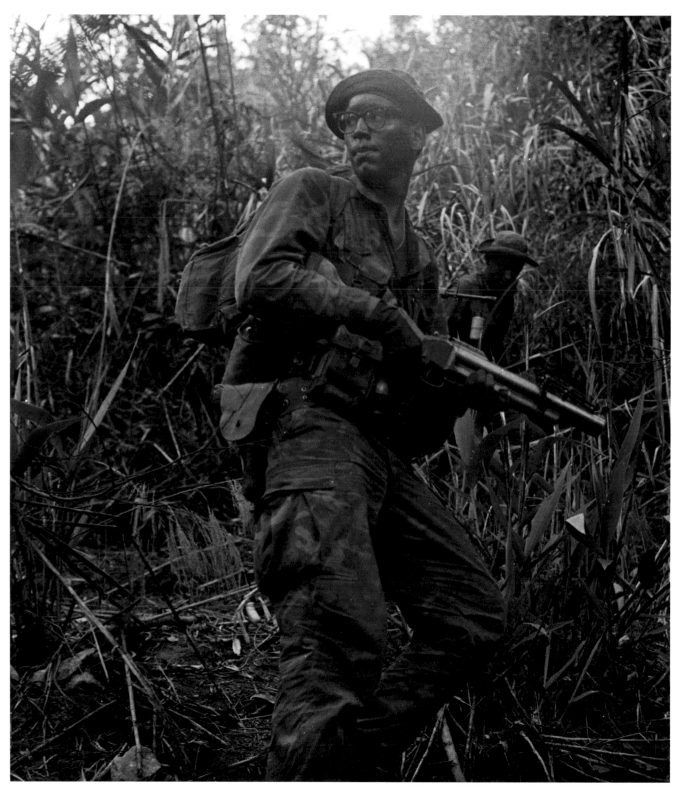

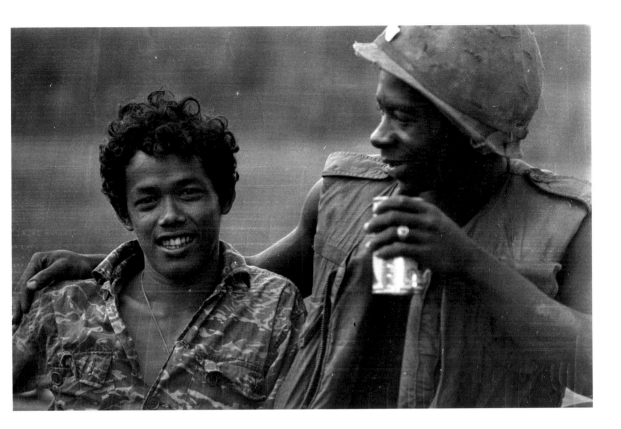

ART GREENSPON
Soldiers share a beer and a moment of camaraderie.
1970 | South Vietnam

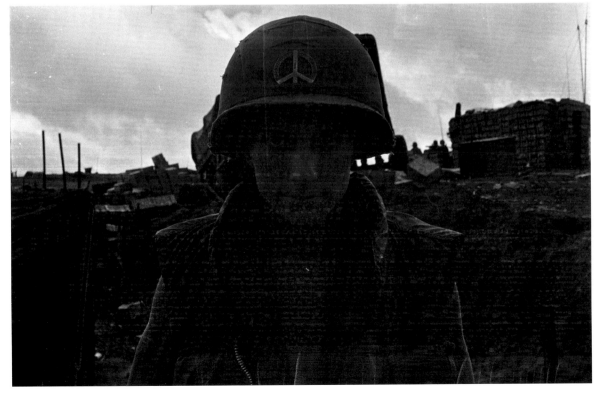

OW **STAFFER**
An unidentified soldier with a peace symbol on his helmet looks intently into photographer's lens.
1970 | South Vietnam

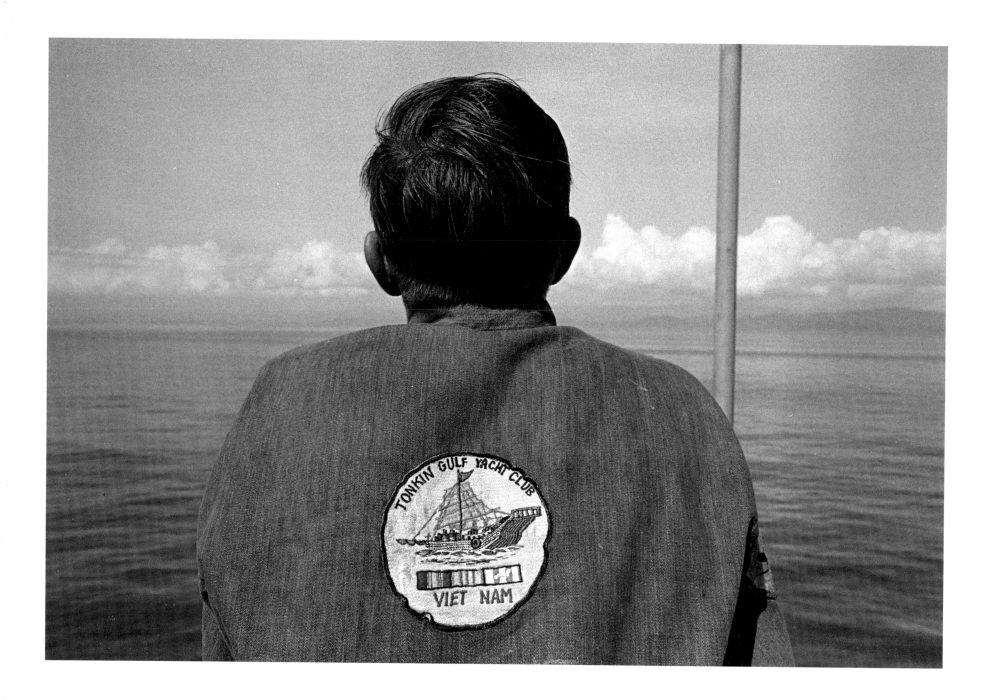

▲ **BRENT PROCTER**
A Navy sailor aboard the USS *Brinkley Bass* peers across the Gulf of Tonkin.
May 14, 1970 | South Vietnam

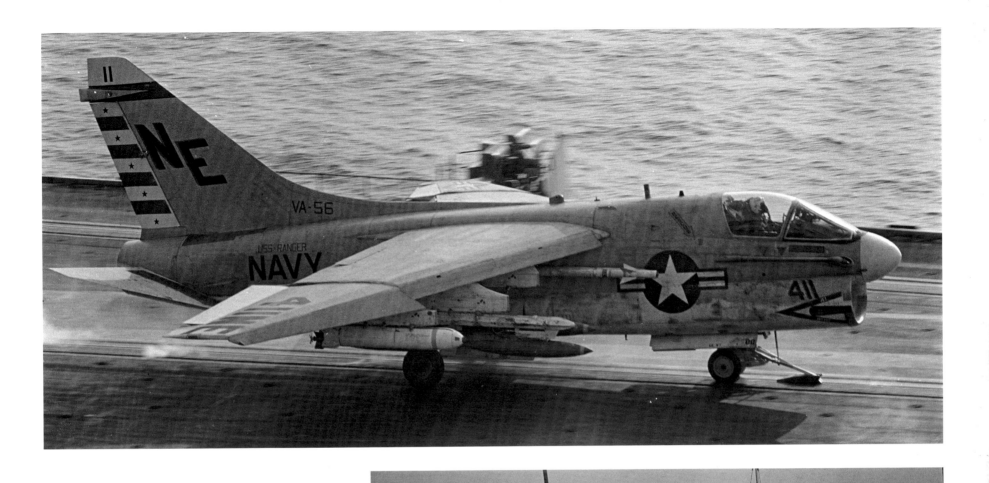

▲ **BRENT PROCTER**
Flight operations aboard the USS *Ranger*.
1970 | South Vietnam

▶ **BRENT PROCTER**
USS *Brinkley Bass* fires its mighty guns.
May 14, 1970 | South Vietnam

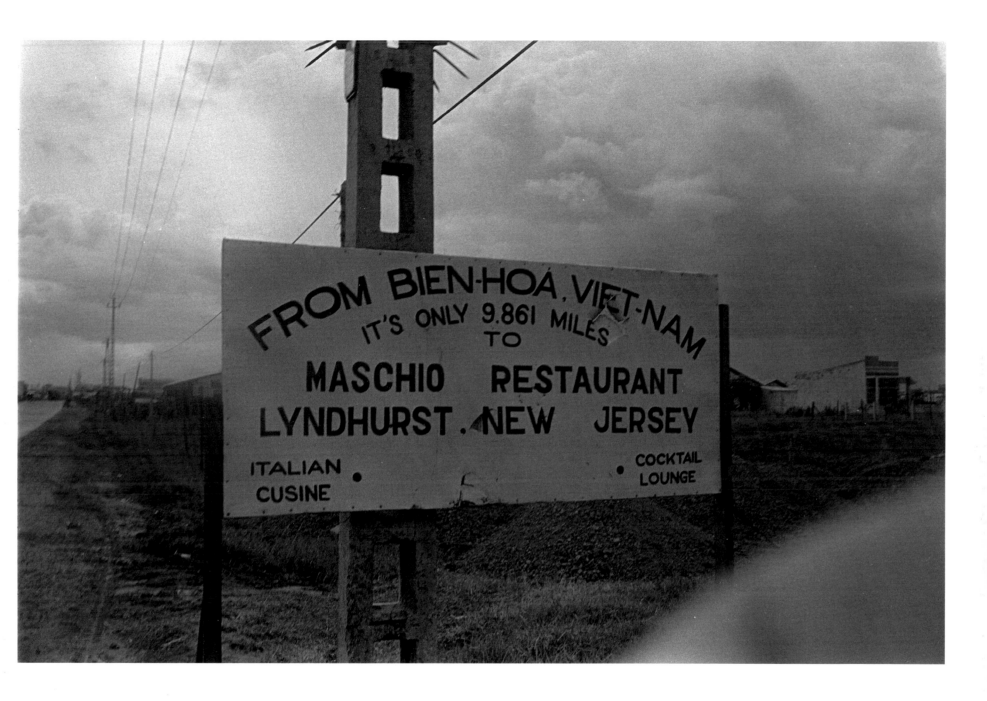

DON HIRST
The road to Biên Hòa.
June 9, 1970 | Biên Hòa

◀ **TERRY REYNOLDS**
Army Chief of Staff General William C. Westmoreland
reviews troops of the 1st Battalion, 327th Infantry,
101st Airborne Division during a visit to Firebase Veghel.
July 16, 1970 | South Vietnam

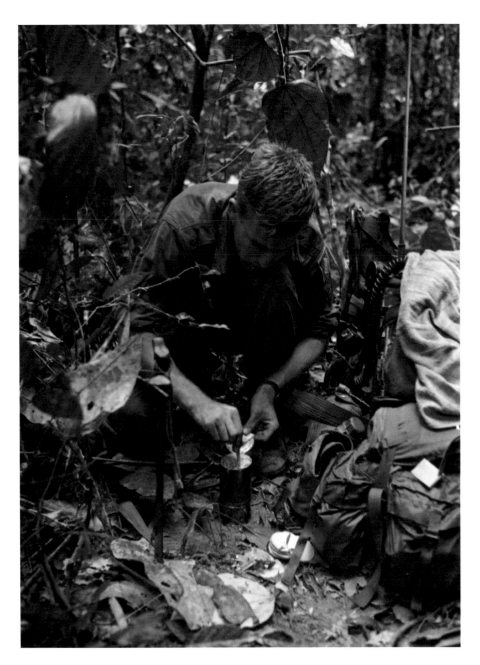

▲ **ANN BRYAN**
Specialist Fourth Class Charles Pike
heats up his own recipe of C ration beans
and cheese.
July 26, 1966 | South Vietnam

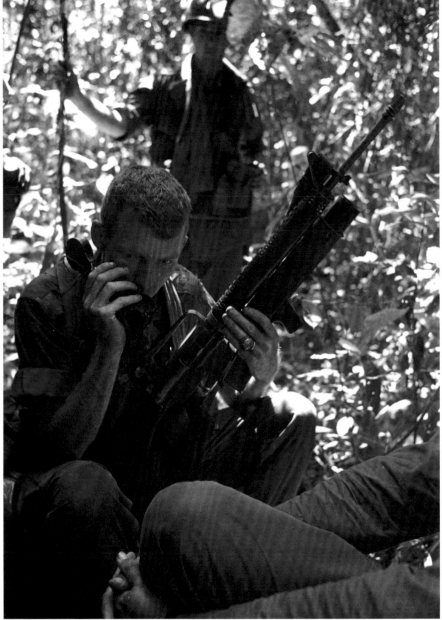

▲ **ANN BRYAN**
First Lieutenant Pete Runnels radios while
holding an M16 rifle equipped with an
M148 grenade launcher.
July 26, 1966 | South Vietnam

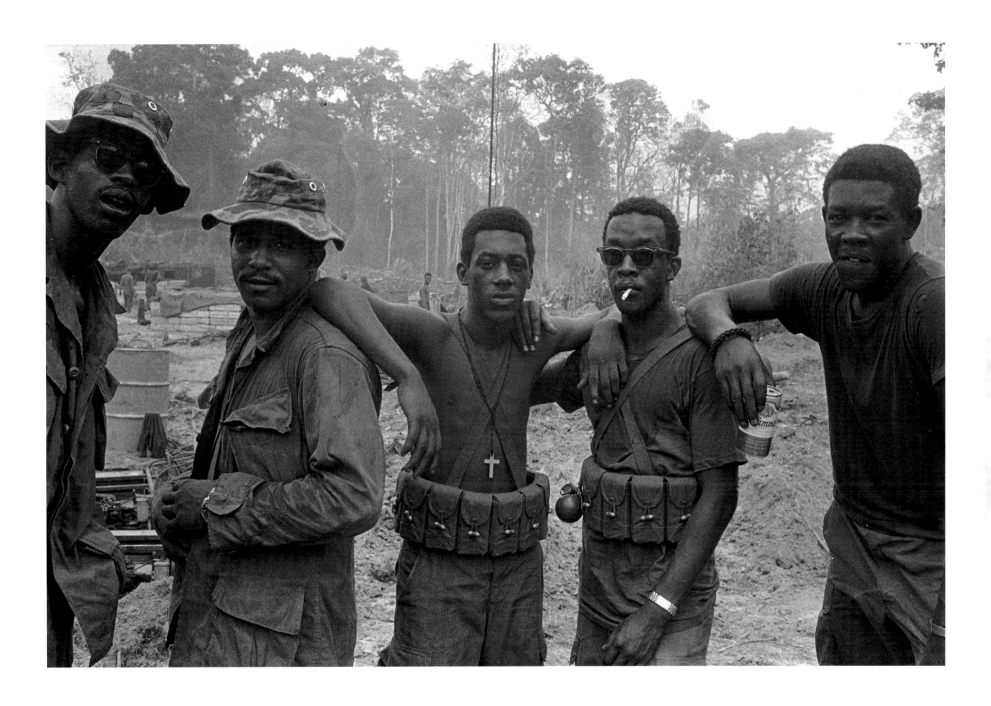

▲ **BRENT PROCTER**
A captured ox cart and a cyclo in front of a sign that reads, "Welcome to Shakey's Hill."
June 11, 1970 | Cambodia

▶ **BRENT PROCTER**
Two soldiers drink milk at Shakey's Hill, Cambodia.
June 11, 1970 | Cambodia

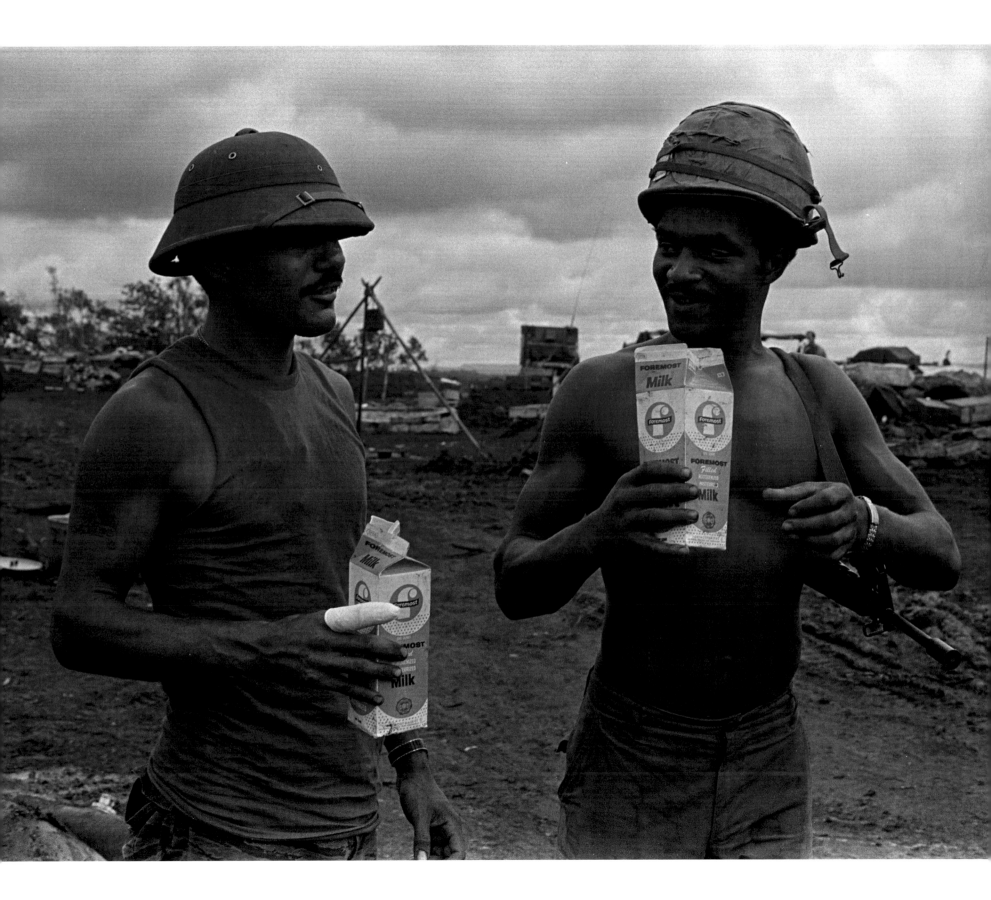

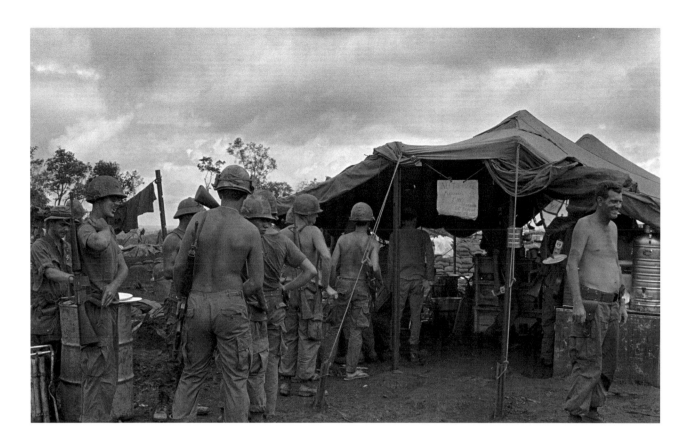

BRENT PROCTER

Troopers line up for chow at Fire Support Base Shakey's Hill.

July 11, 1970 | Cambodia

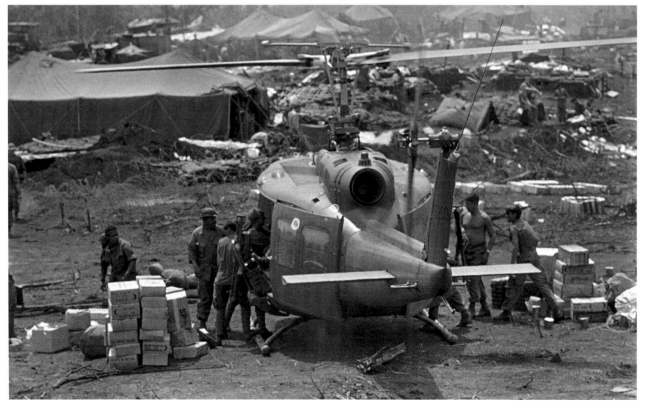

BRENT PROCTER

Unloading a log bird (supply helicopter) at Fire Support Base Shakey's Hill.

July 11, 1970 | Cambodia

▶ BRENT PROCTER

A crew prepares to fire a 105mm Howitzer.

July 11, 1970 | Cambodia

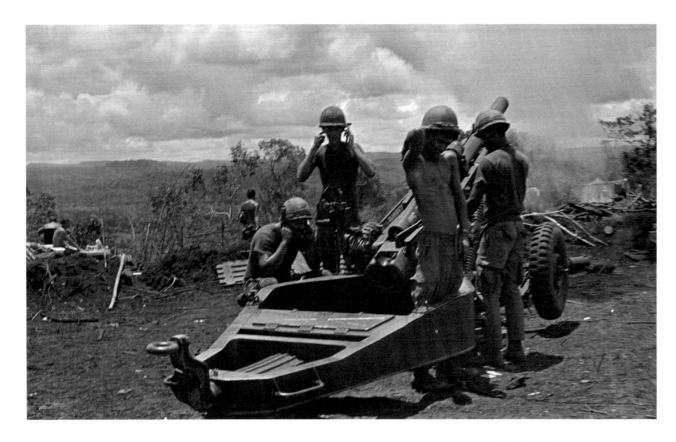

▶ BRENT PROCTER

Soldiers from B Company, 5th Battalion, 9th Infantry, 1st Air Cavalry Division return wearily to Fire Support Base Shakey's Hill after two days of fighting.

July 11, 1970 | Cambodia

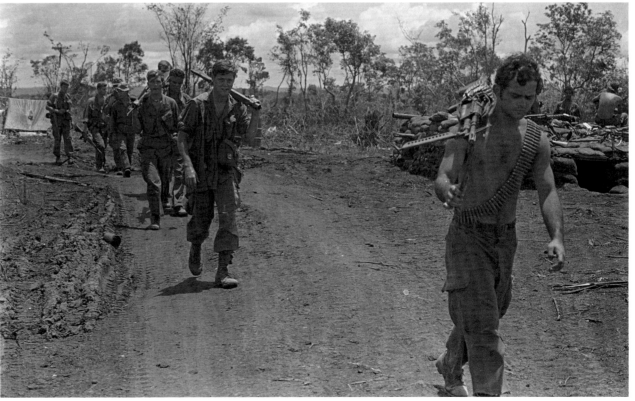

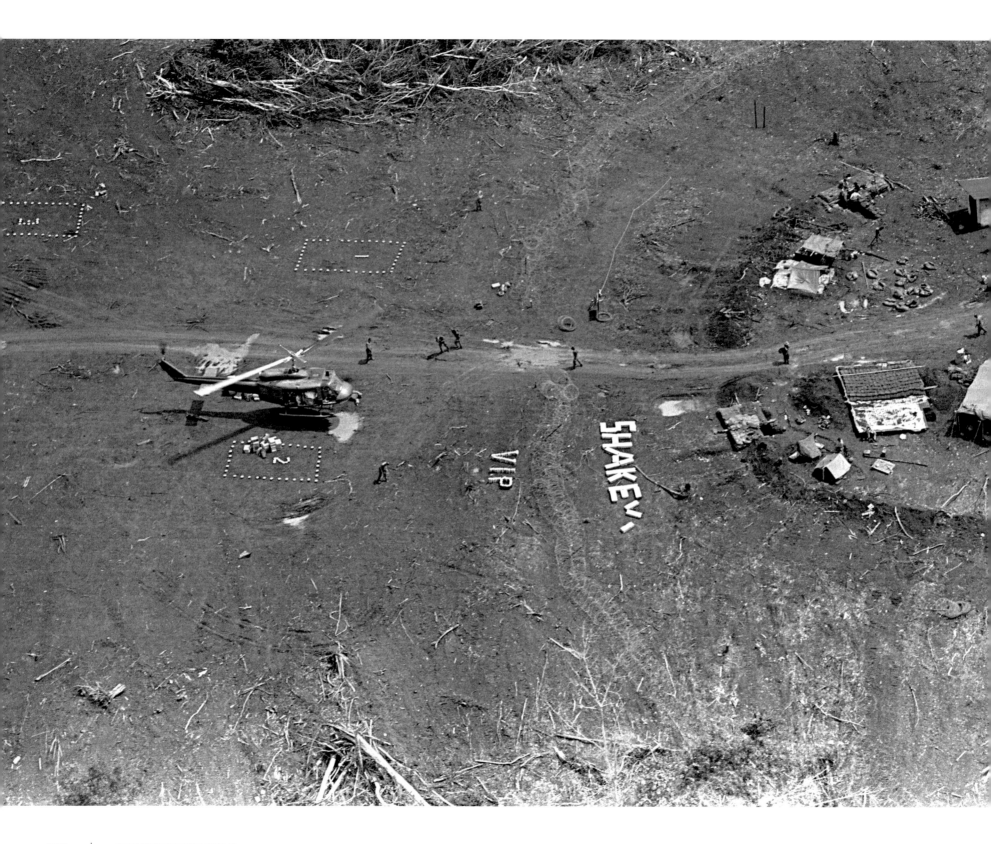

BRENT PROCTER

Bird's-eye view of Fire Support Base Shakey's Hill taken during an aerial circuit of the companies aboard a Command and Control helicopter.

July 11, 1970 | Cambodia

▶ **BRENT PROCTER**

A soldier with captured NLF claymore mines.

July 11, 1970 | Cambodia

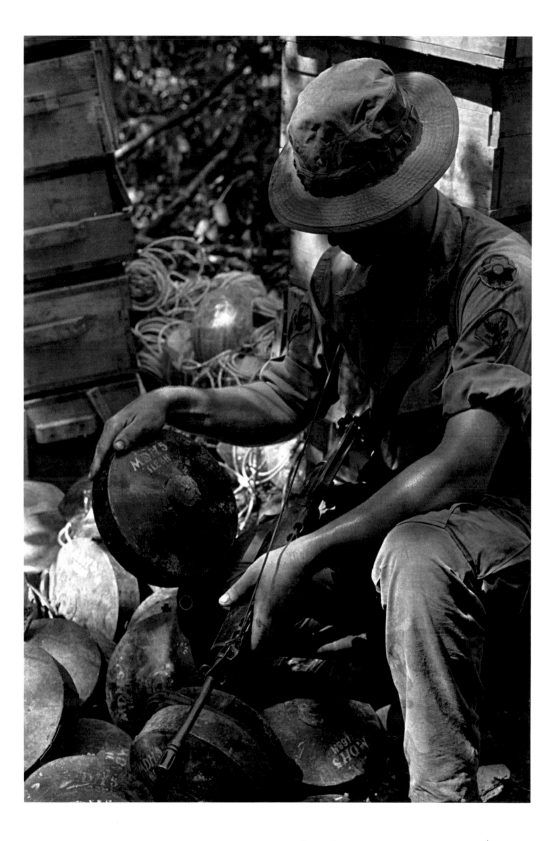

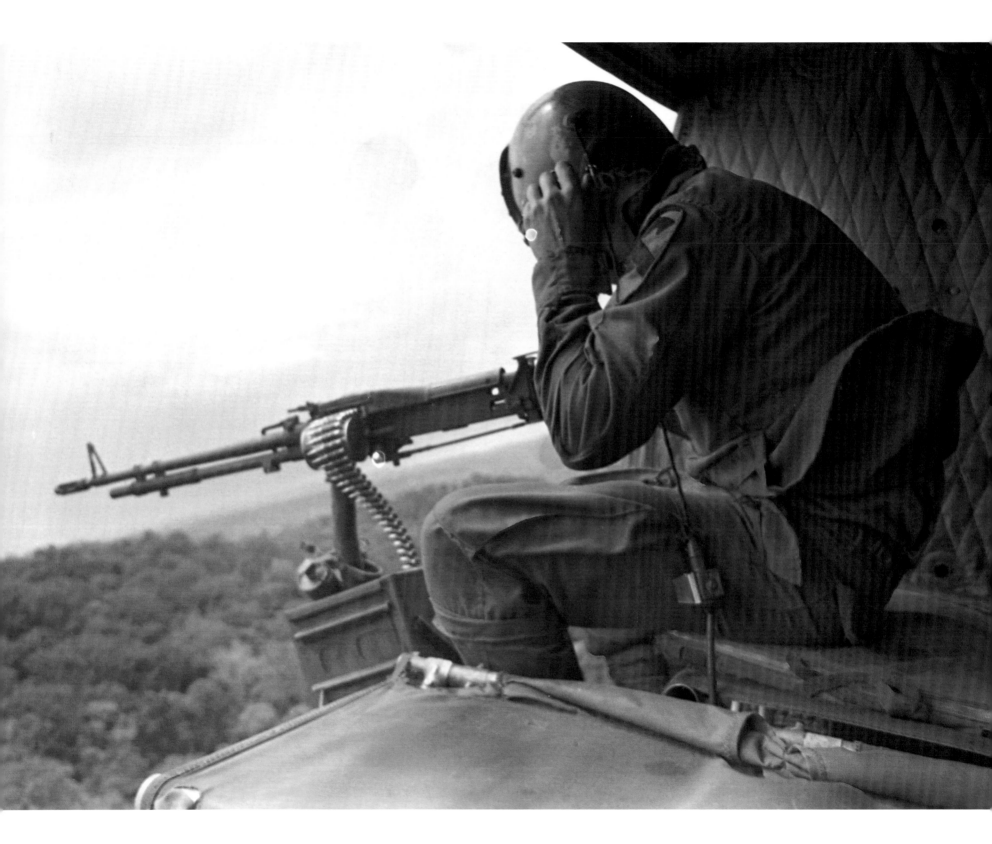

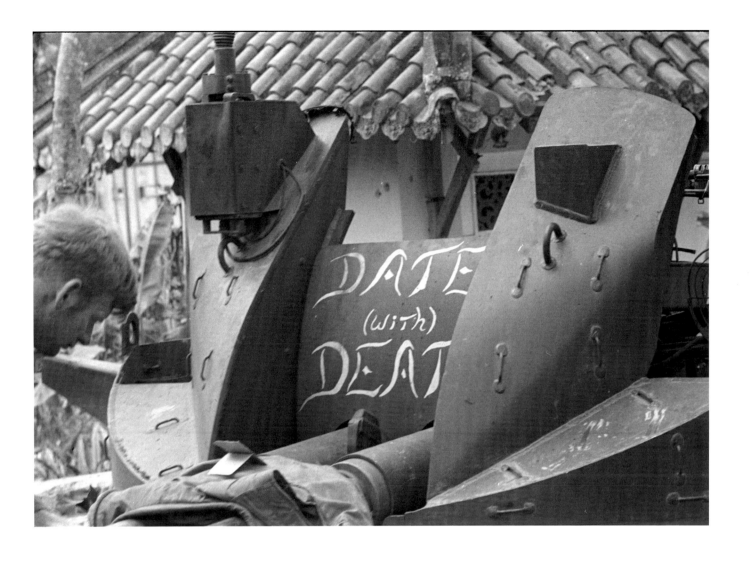

◀ **BRENT PROCTER**
Chopper gunner keeps a lookout for the enemy.
July 11, 1970 | Cambodia

▲ *OW* **STAFFER**
Tank dubbed "Date with Death" in Đà Nẵng.
1968 | Đà Nẵng

▶ **CYNTHIA COPPLE** - IMAGES ON PP. 132–33
Medic track designed by Food Machinery Corporation at Quảng Trị used to carry nearly thirteen men or four patients.
July 28, 1969 | Quảng Trị

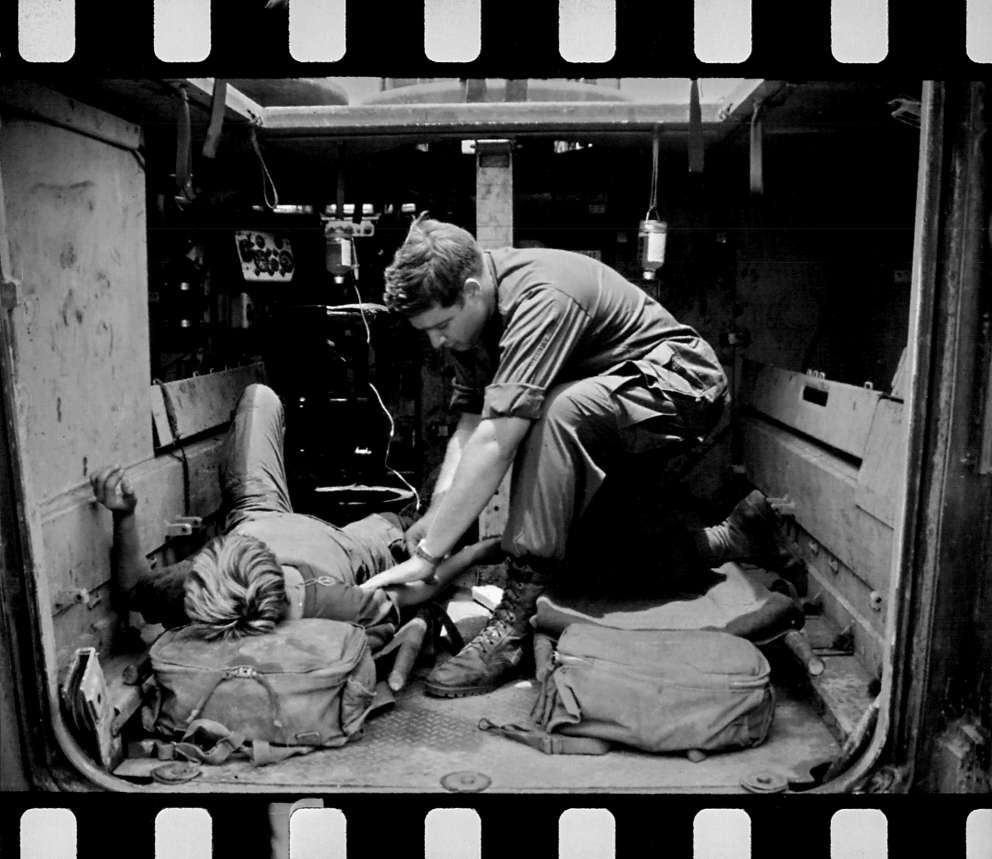

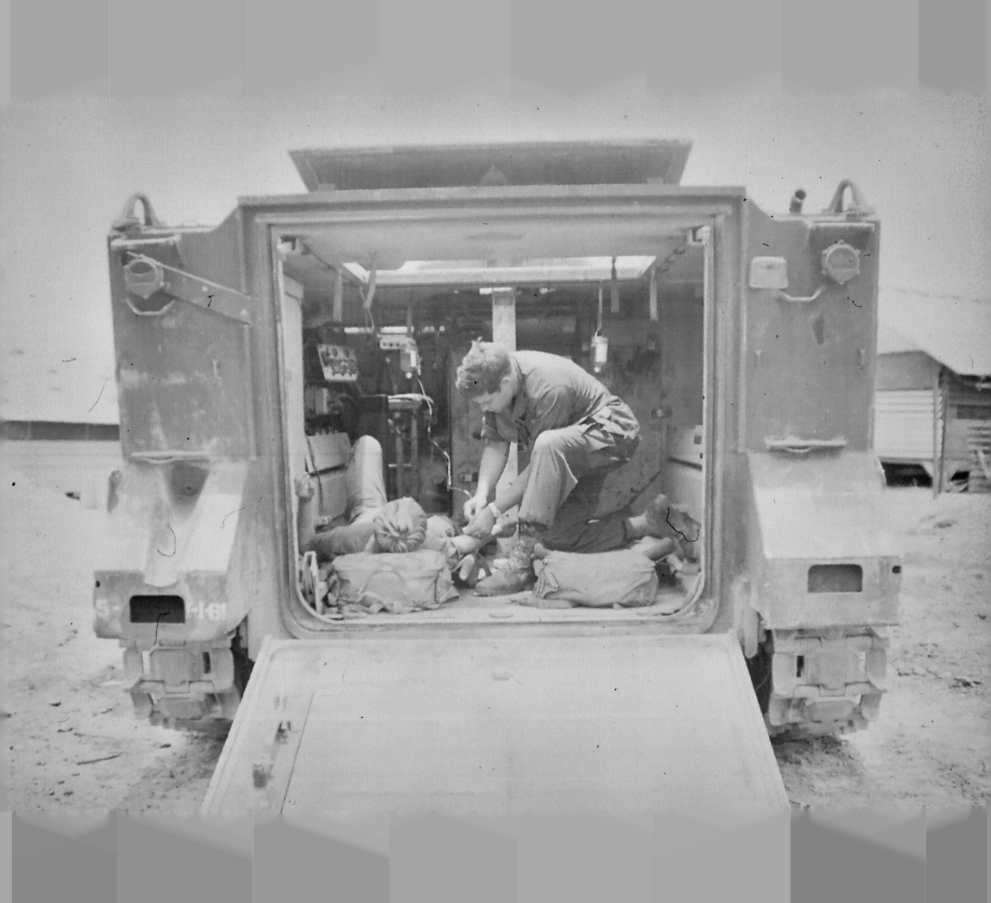

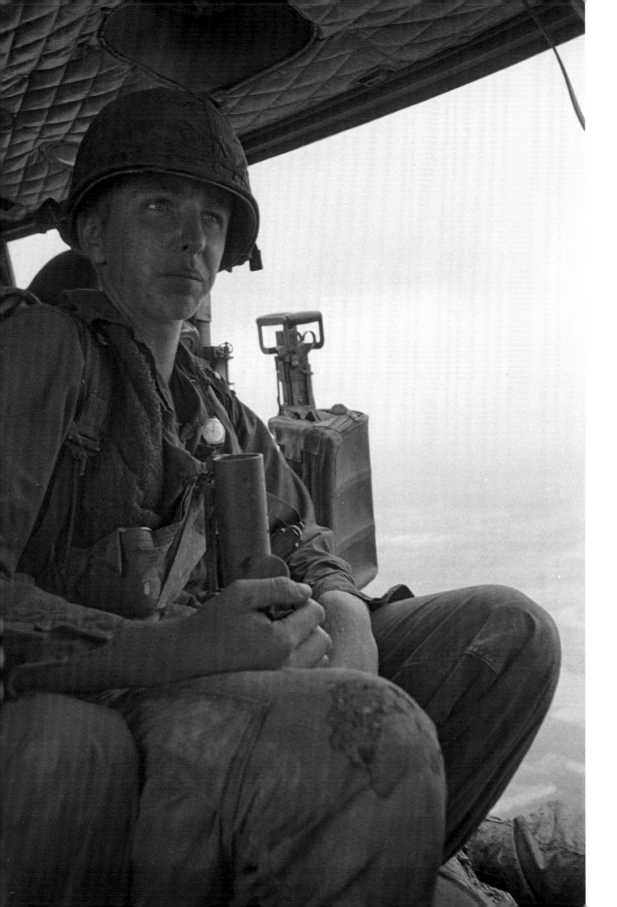

ART GREENSPON
C Company's M79 grenadier leaves Black Leach Hill on a US Army Air Ambulance unit.
February 1968 | Quế Sơn

ART GREENSPON
Helicopters on Fire Support Base West near Quế Sơn Valley.
1968 | Quế Sơn

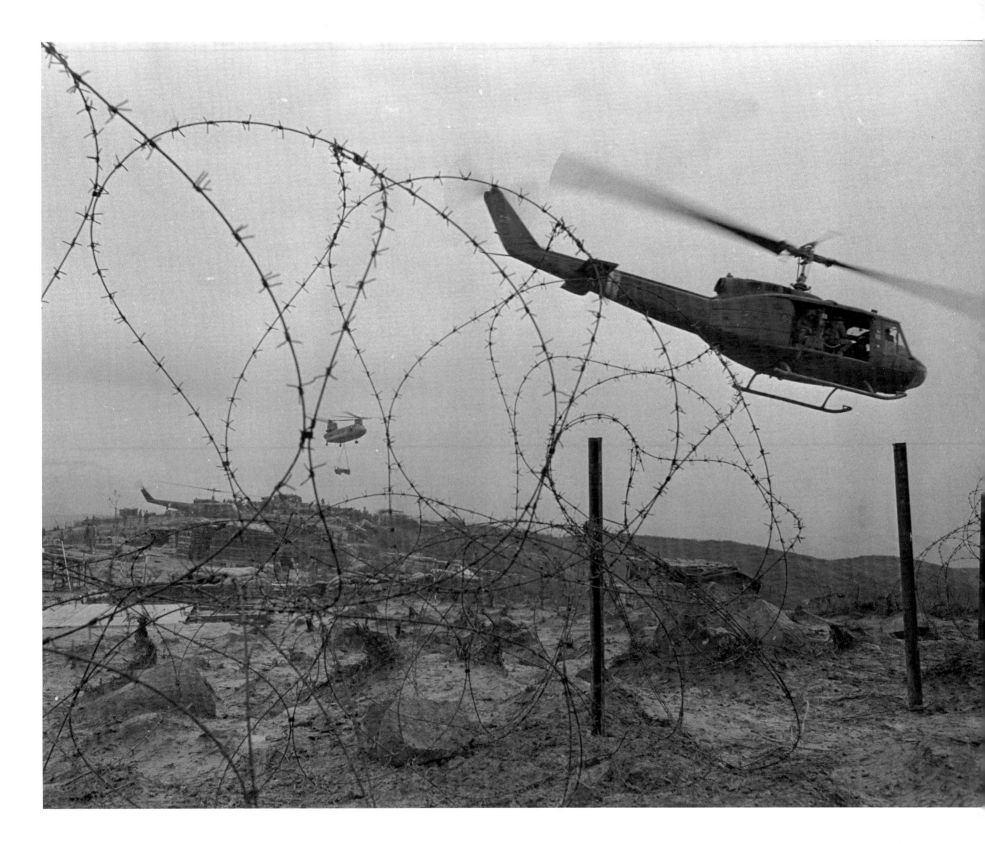

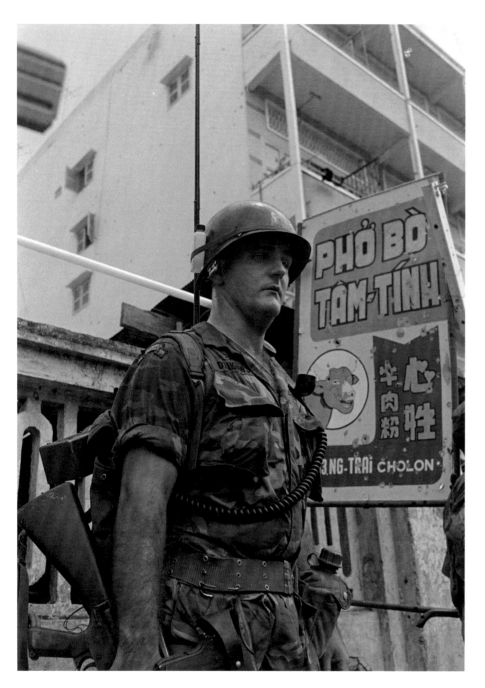

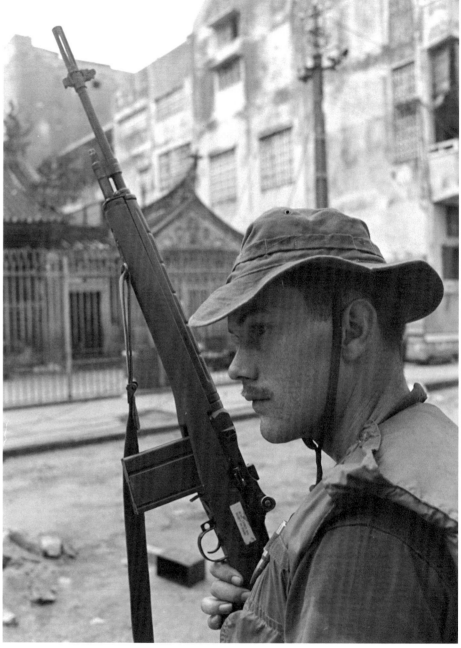

▲ **JOHN ROEMER**
Specialist Fourth Class Gene Dzikowski.
1968 | South Vietnam

▲ **JOHN ROEMER**
Specialist Fourth Class Anthony Kosakowski.
1968 | South Vietnam

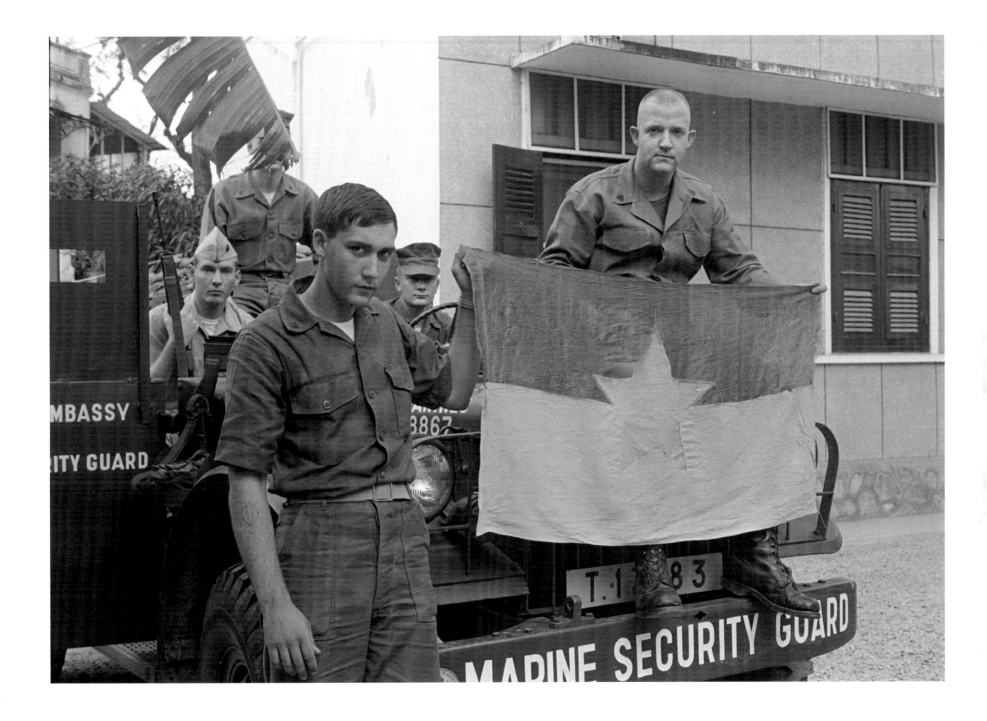

▲ **_OW_ STAFFER**
Sergeant Royal G. "Ozzie" Osborn with a
captured flag of the NLF.
1968 | South Vietnam

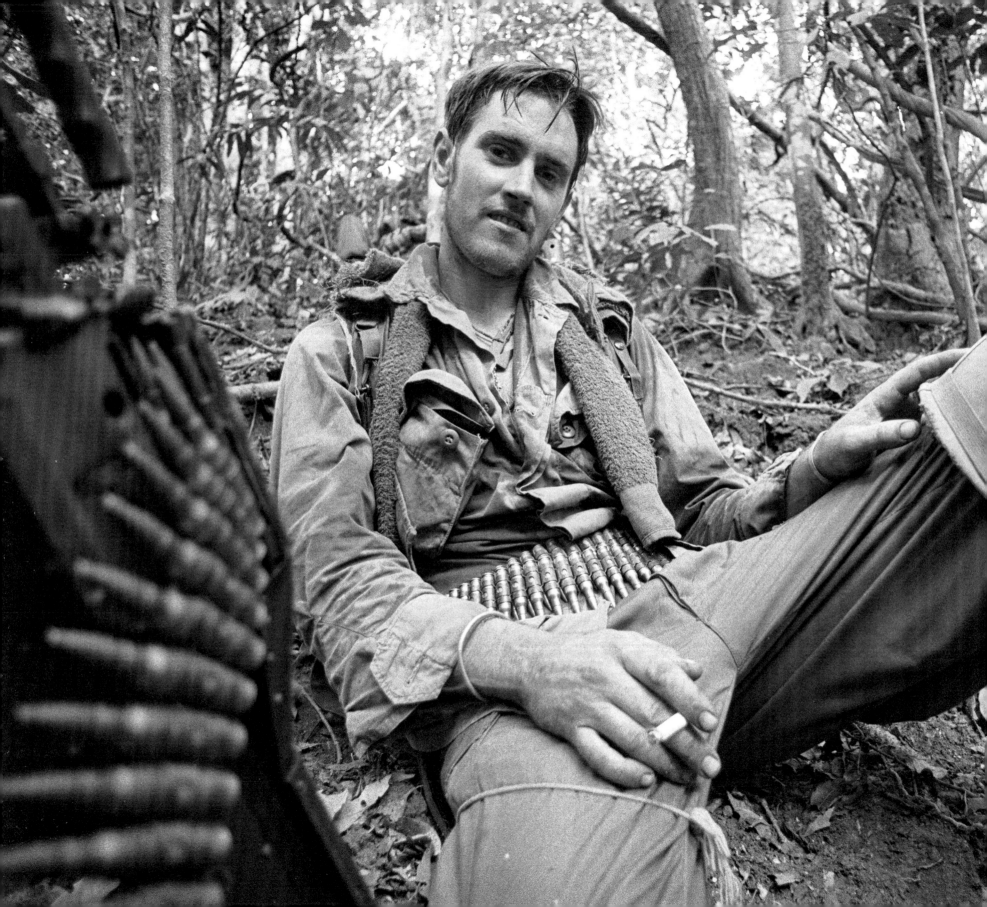

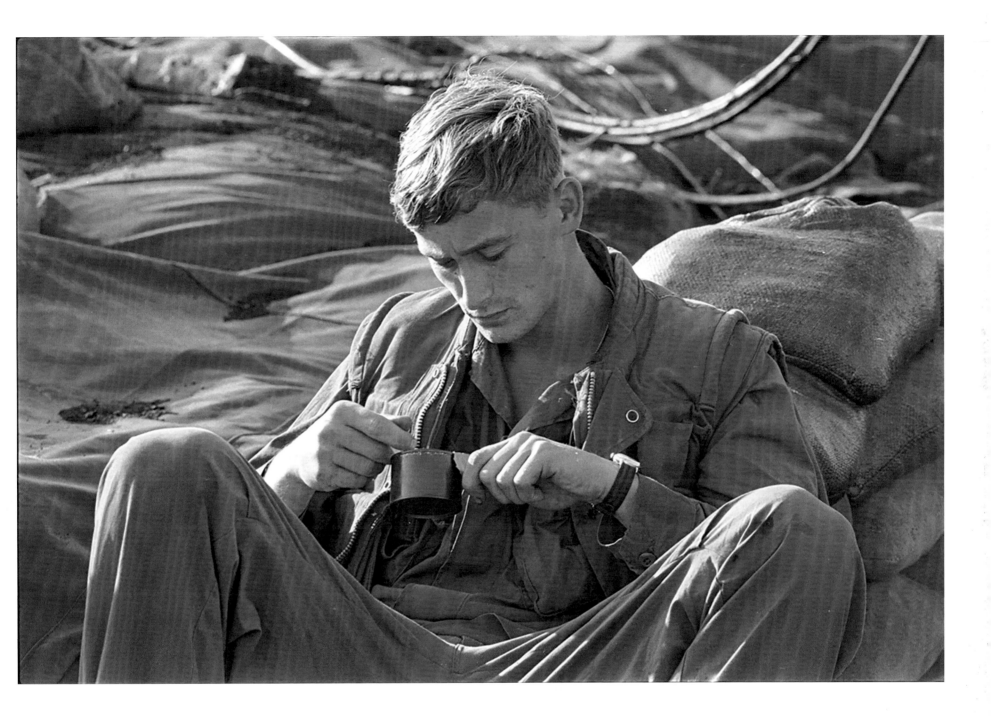

◀ *OW* STAFFER
An unidentified soldier from the 3rd Battalion, 1st Infantry takes a break in the mountainous jungles east of An Khê.
1969 | Near Pleiku

▲ *OW* STAFFER
An unidentified soldier examines his C ration meal.
May 3, 1969 | South Vietnam

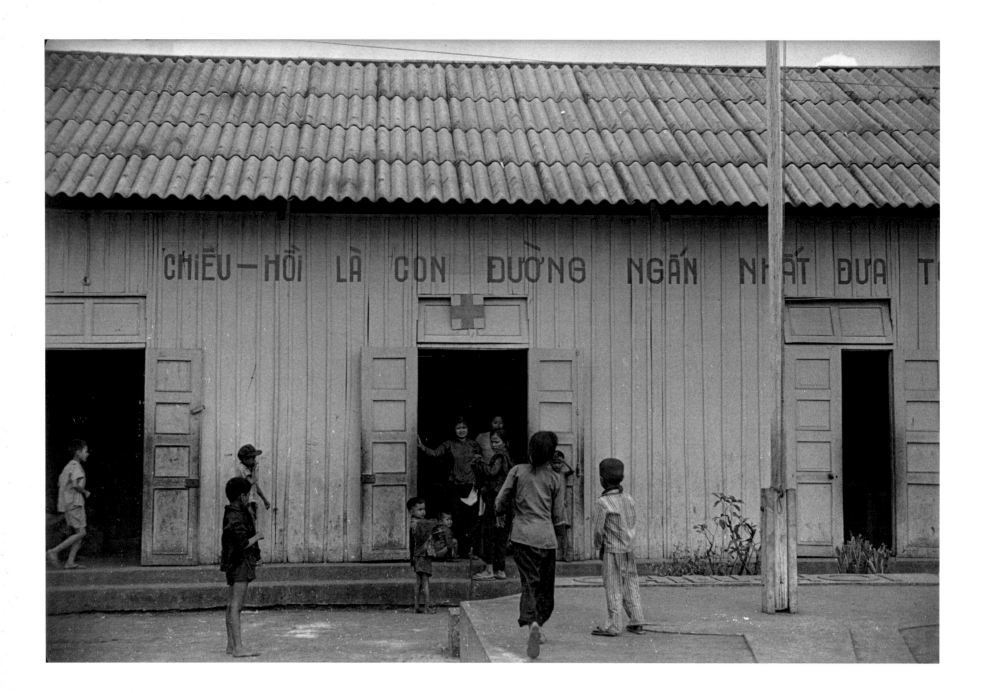

▲ **TOM MARLOWE**
The facade of a Chiêu Hồi Center building.
October 20, 1969 | Sông Bé

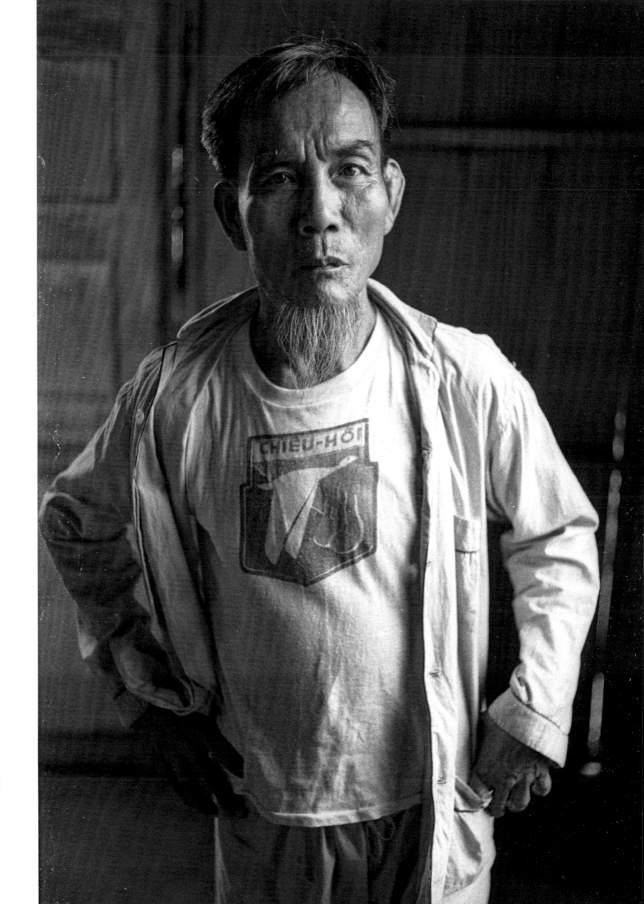

▶ TOM MARLOWE
A former NLF farmer wearing a Chiêu Hồi
T-shirt.
October 20, 1969 | South Vietnam

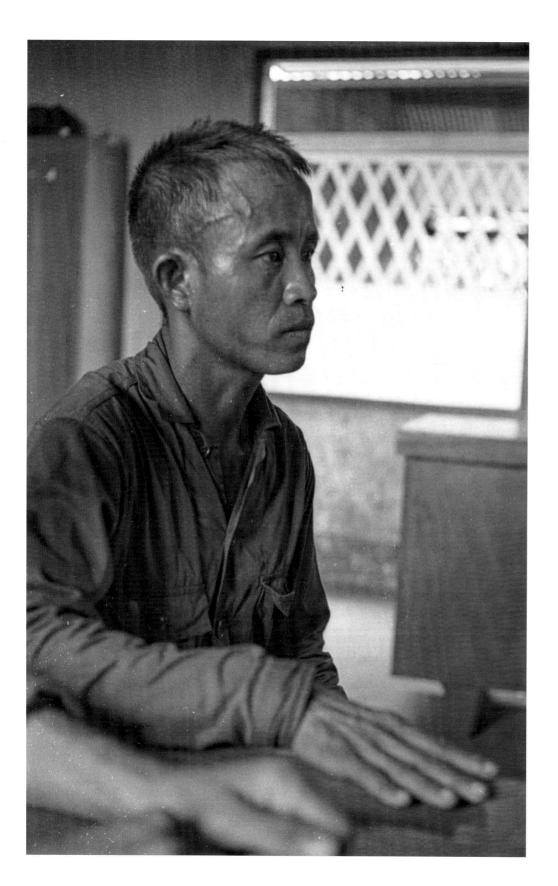

TOM MARLOWE
Nguyễn Cần, a NLF defector.
October 20, 1969 | South Vietnam

TOM MARLOWE
Refugees inside a Chiêu Hồi Center where
South Vietnamese encouraged NLF
supporters to defect.
October 20, 1969 | Sông Bé

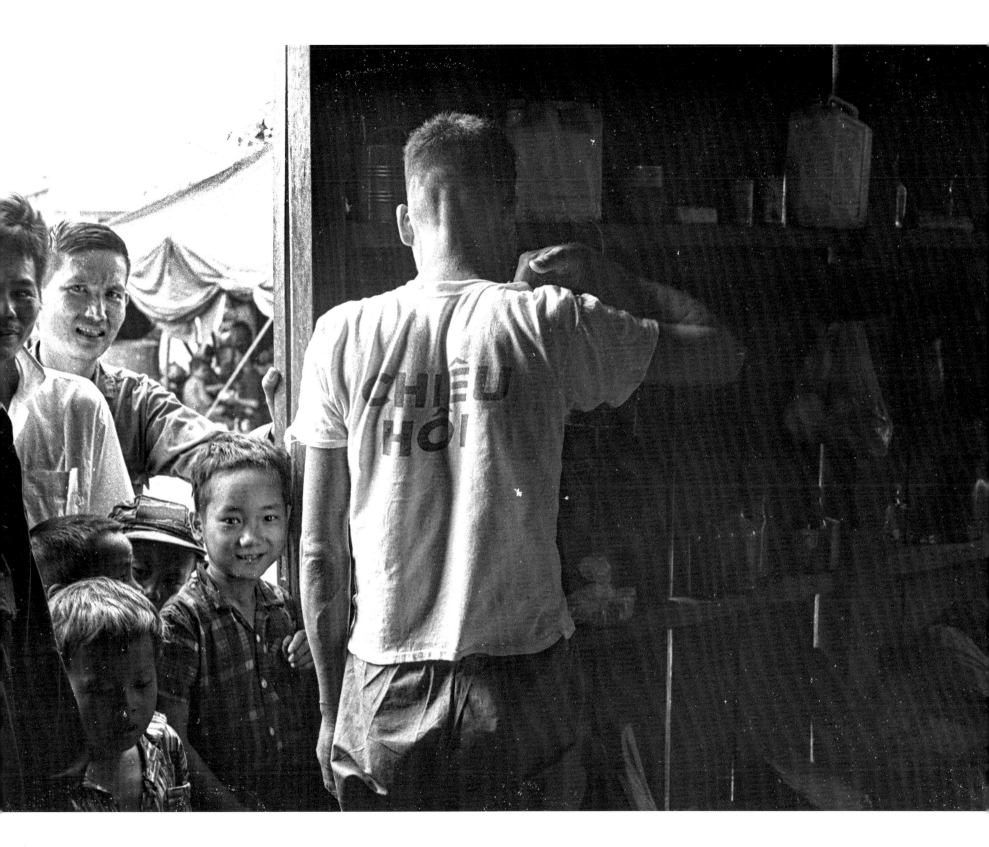

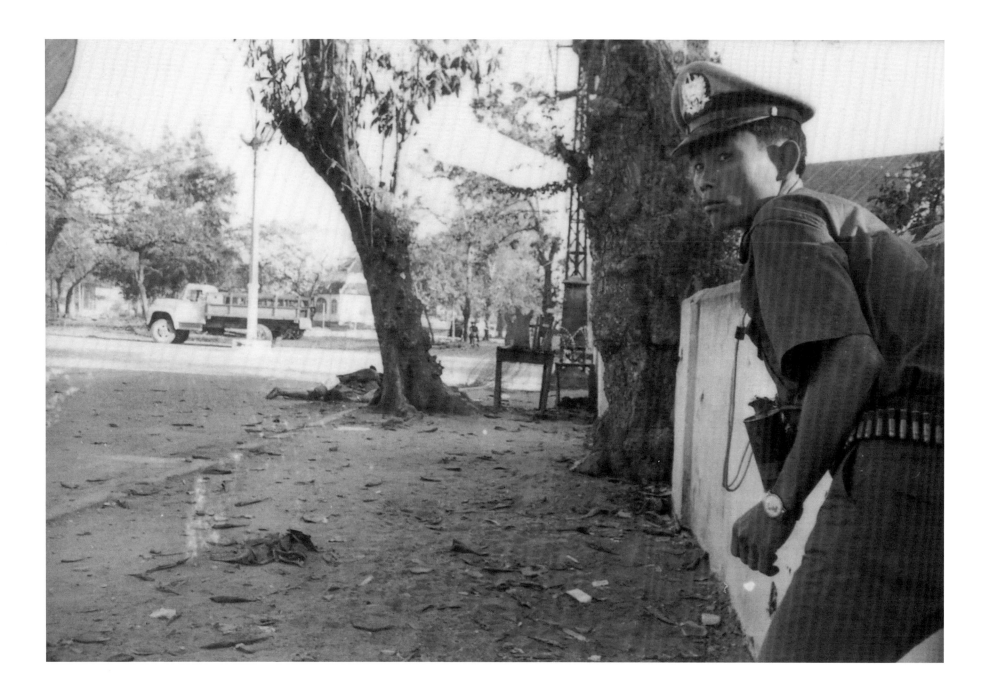

▲ *OW* STAFFER

An unidentified South Vietnamese police officer with a band of bullets around his waist nervously glances backwards while keeping guard.

1968 | Nha Trang

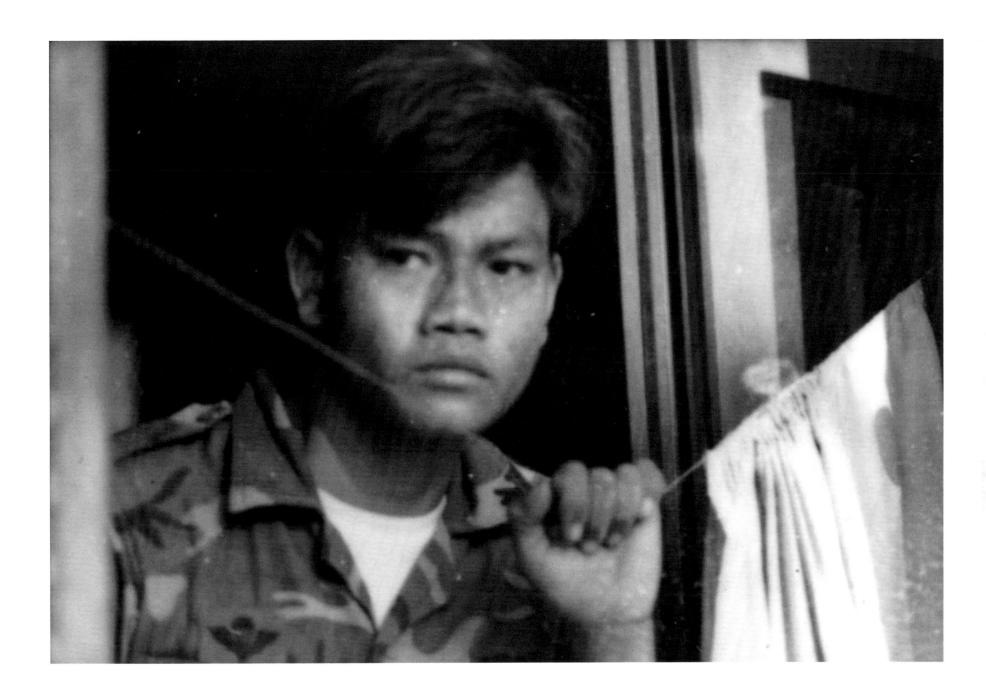

▲ **OW** *STAFFER*
An unidentified ARVN soldier peers
anxiously into the streets of Nha Trang.
1967 | Nha Trang

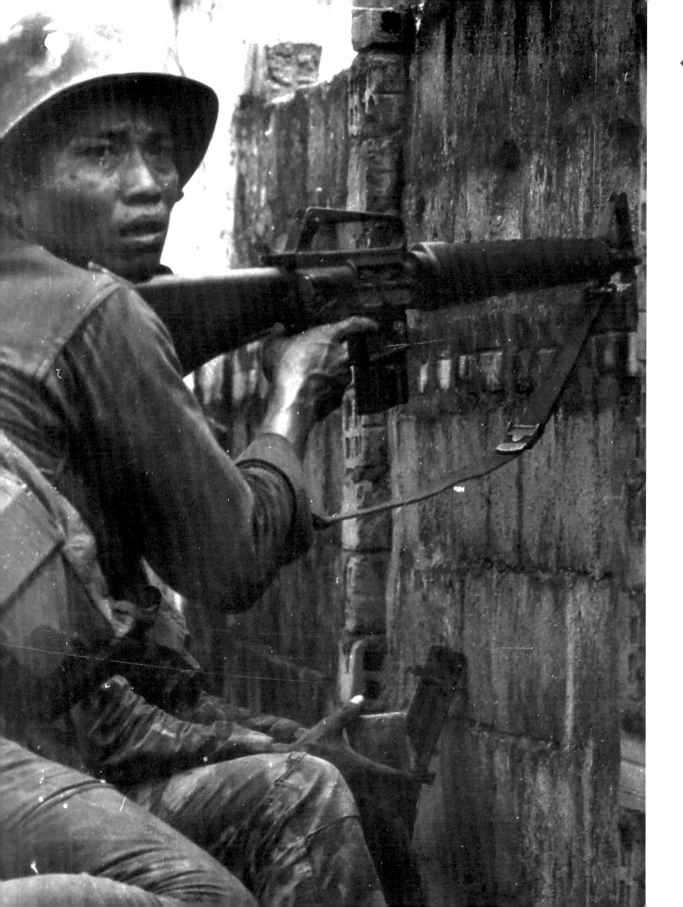

OW STAFFER
Attentive ARVN soldier clenches his rifle.
1967 | Nha Trang

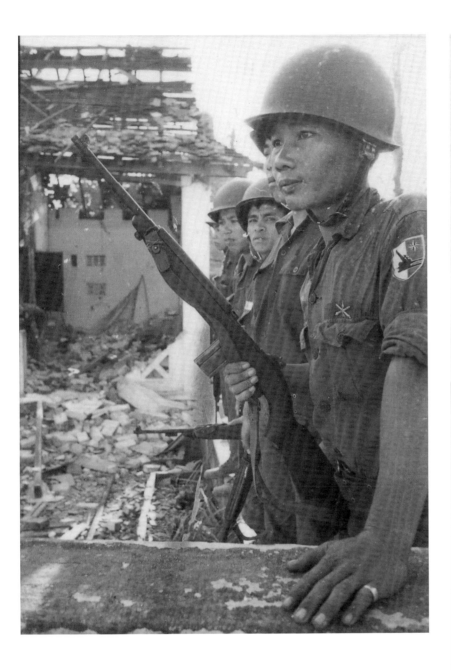

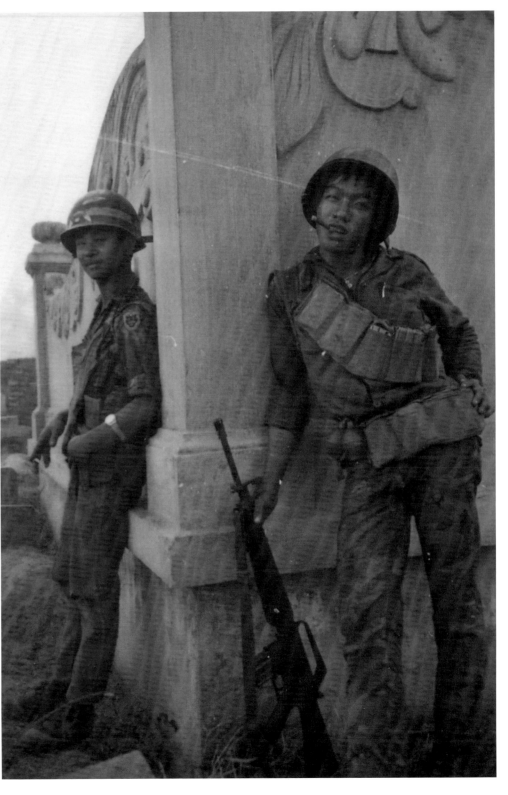

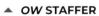 **OW STAFFER**
ARVN Artillery Battalion soldiers stand guard in the rubble of a graveyard destroyed by recent fighting.
1967 | Nha Trang

▶ *OW* **STAFFER**
ARVN soldiers take a momentary break from the melee.
1968 | Nha Trang

◀ *OW* STAFFER
An ARVN soldier suffers head wounds during a street battle.
1967 | Nha Trang

▶ *OW* STAFFER
Vietnamese Marine inserts prepare to be airlifted into combat zones where they will spend several days calling artillery fire and air strikes.
1967 | Đà Nẵng

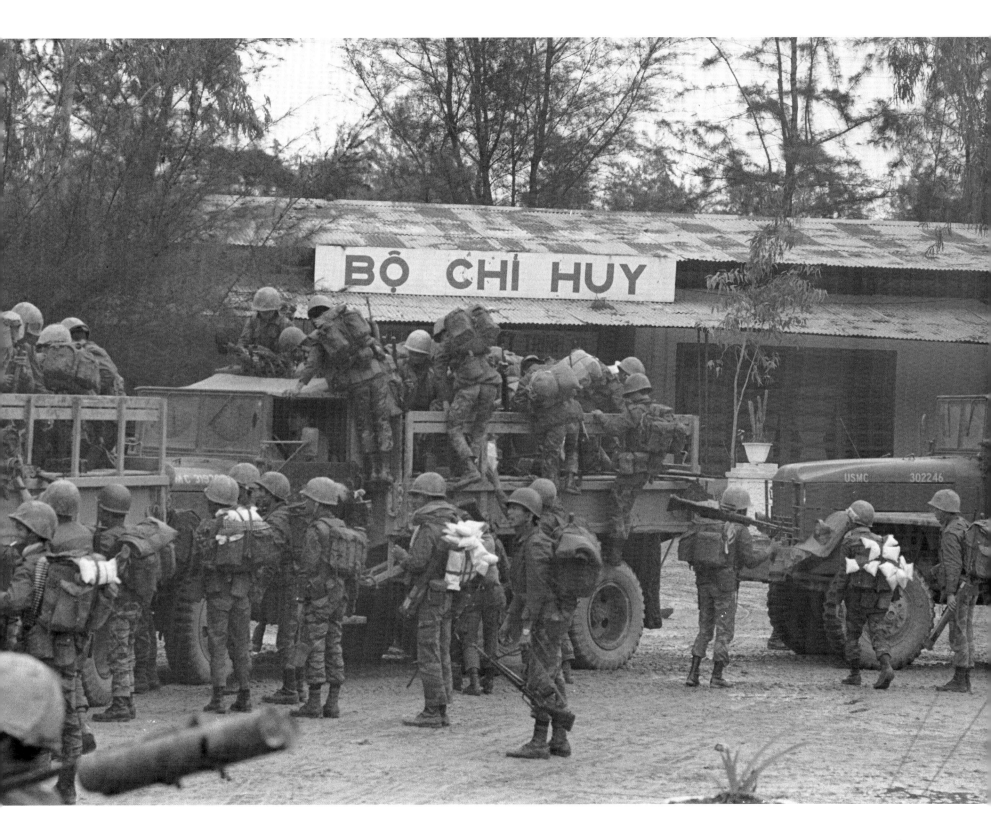

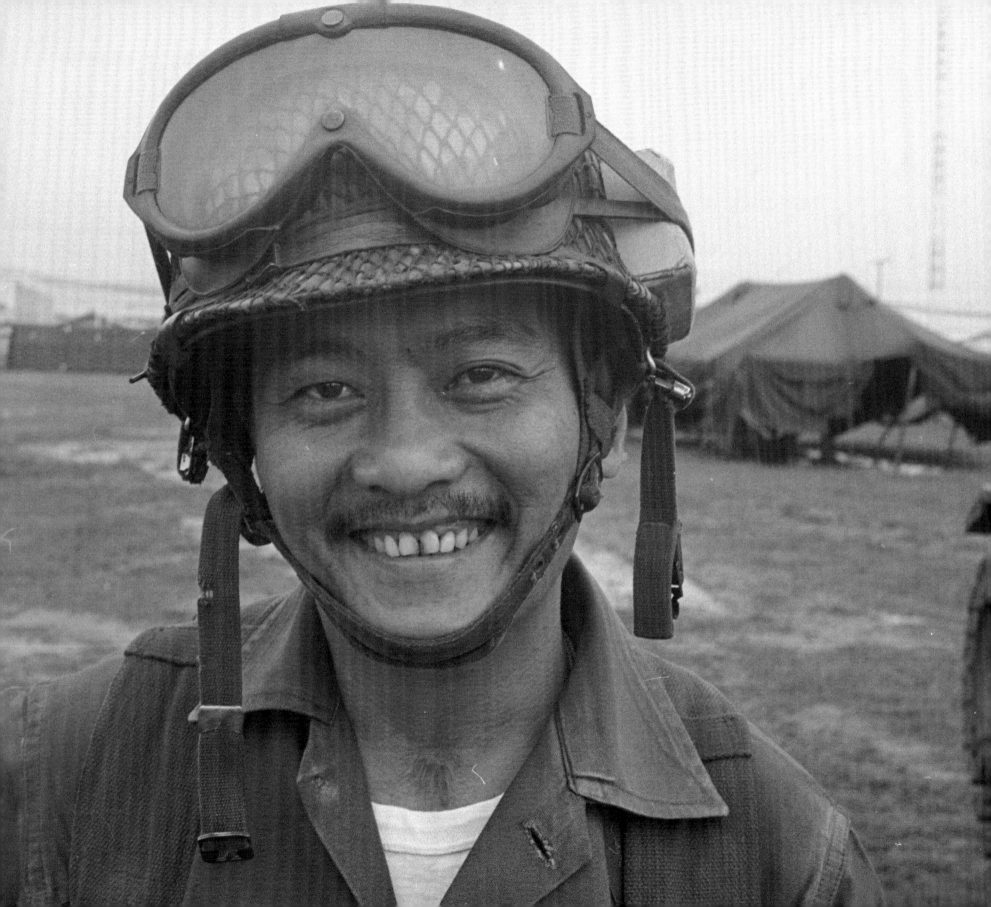

OW STAFFER
Sergeant Major Phan Thanh Thiết.
June 15, 1968 | South Vietnam

OW STAFFER
Vietnamese Green Berets.
March 1, 1968 | South Vietnam

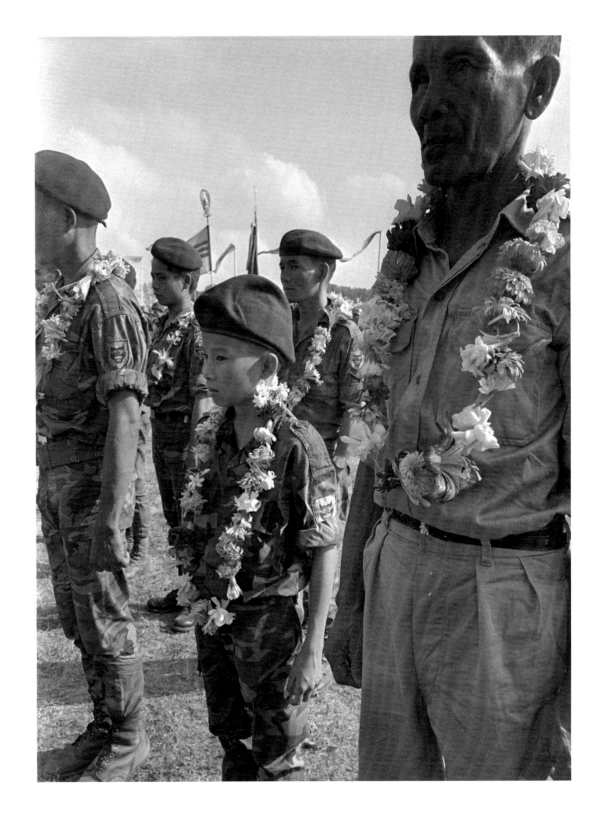

OW STAFFER

Green Beret Sergeant First Class John Jakovenko and seven others stand at rigid attention as the Plateau GI Special Forces camp is officially turned over to the Vietnamese Special Forces team A-111 Lực Lượng Đặc Biệt (LLDB) under the camp commander, Captain Nguyễn Ngọc Toàn.

February 2, 1970 | South Vietnam

▶ **RICHARD BOYLE**

Trần Văn Hai (*far left*), a NLF defector, chats with a translator and two Australian soldiers.

September 6, 1969 | South Vietnam

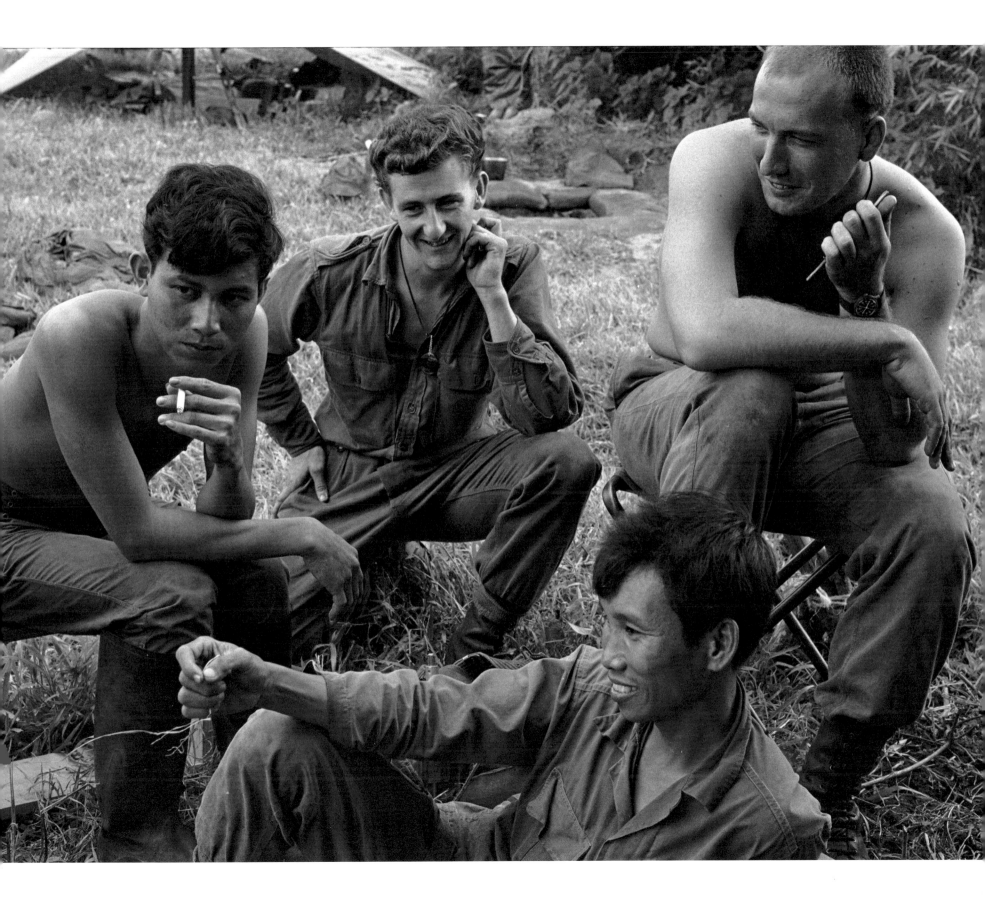

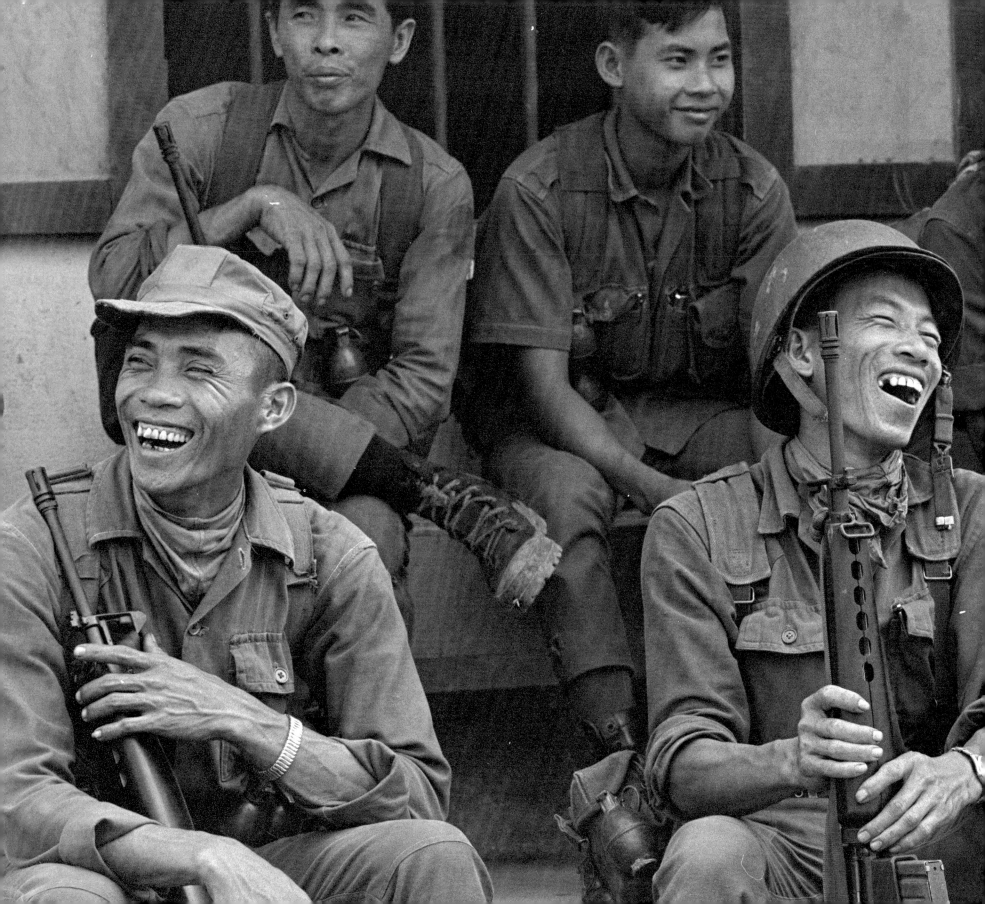

◀ *OW* STAFFER

▶ Military training for South Vietnamese
Popular Forces upgrade team.
November 25, 1969 | South Vietnam

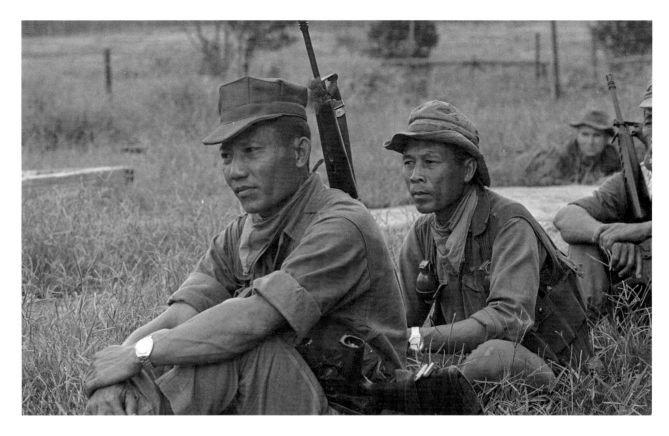

▶ *OW* STAFFER

Sergeant Lewis and a Vietnamese
interpreter give instructions on claymores
and ambush to South Vietnamese
Popular Forces.
November 25, 1969 | Biên Hòa

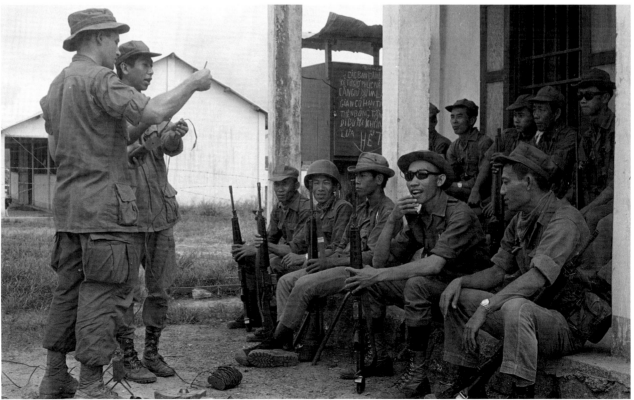

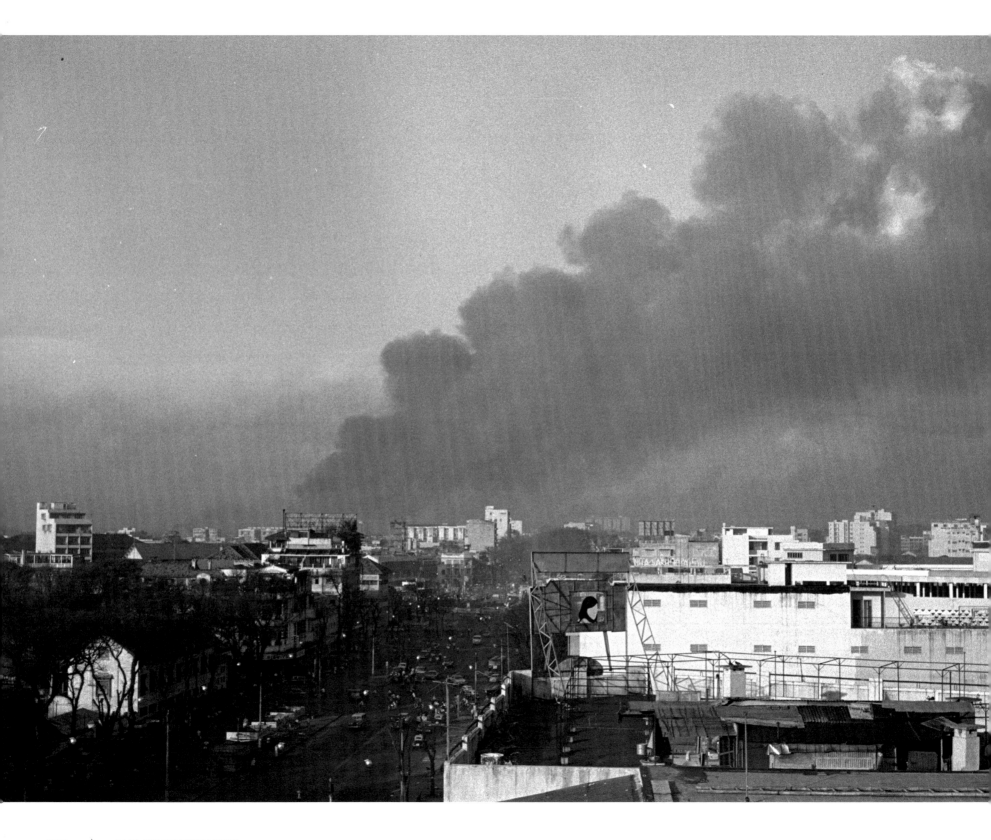

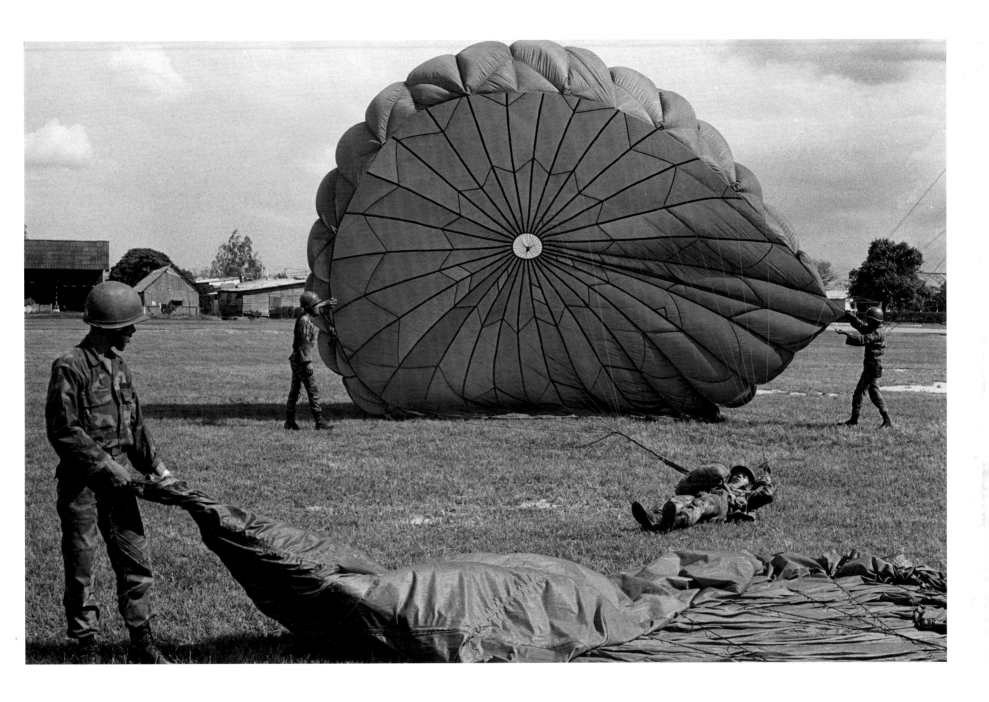

◀ *OW* STAFFER
Smoke pours into the air over Chợ Lớn during fighting.
June 15, 1968 | Saigon

▲ BRENT PROCTER
Dragging practice with a "wind machine" in the background at an ARVN airborne school.
January 10, 1970 | South Vietnam

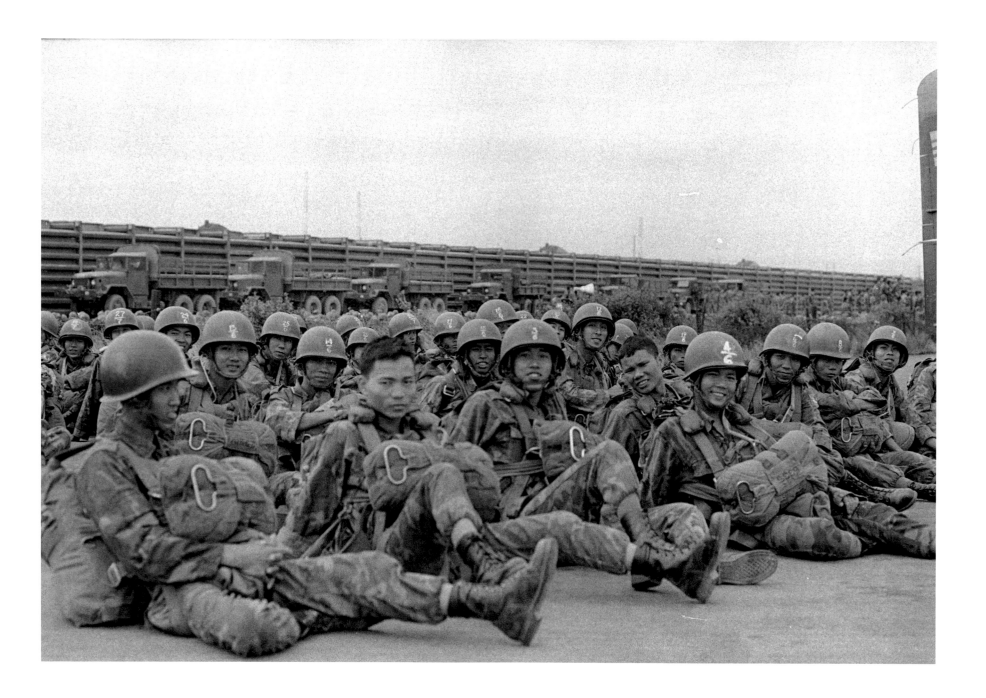

▲ BRENT PROCTER
Class 176 of nearly two hundred classes of fledgling
Vietnamese paratroopers waits nervously on the Tân Sơn
Nhứt tarmac, their backpacks and reserve chutes bulging.
January 10, 1970 | South Vietnam

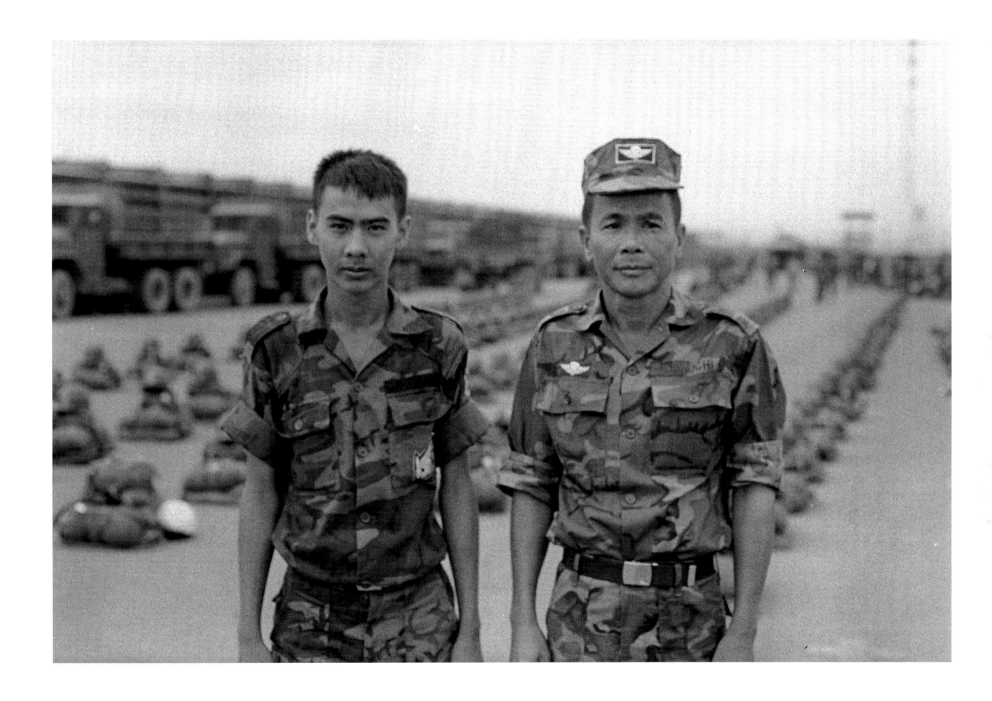

BRENT PROCTER
Vietnamese paratroopers featured in the *Overseas Weekly* news story, "Vietnamization Proceeds as Viets Hit the Silk at Jump School."
January 10, 1970 | South Vietnam

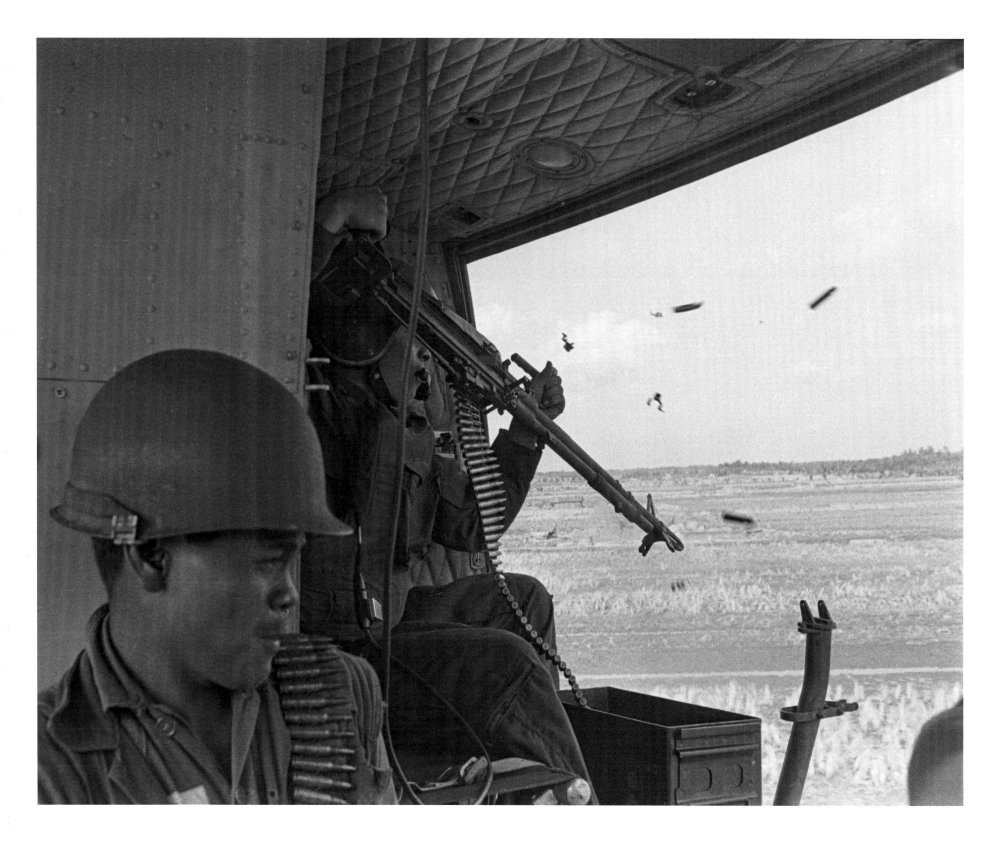

A door gunner fires while approaching a landing zone, and an ARVN soldier winces at the deafening noise.

1970 | Vĩnh Bình

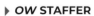 *OW* STAFFER

ARVN 9th Division gunners aboard helicopter during an air assault operation in the Mekong Delta.

1970 | Vĩnh Bình

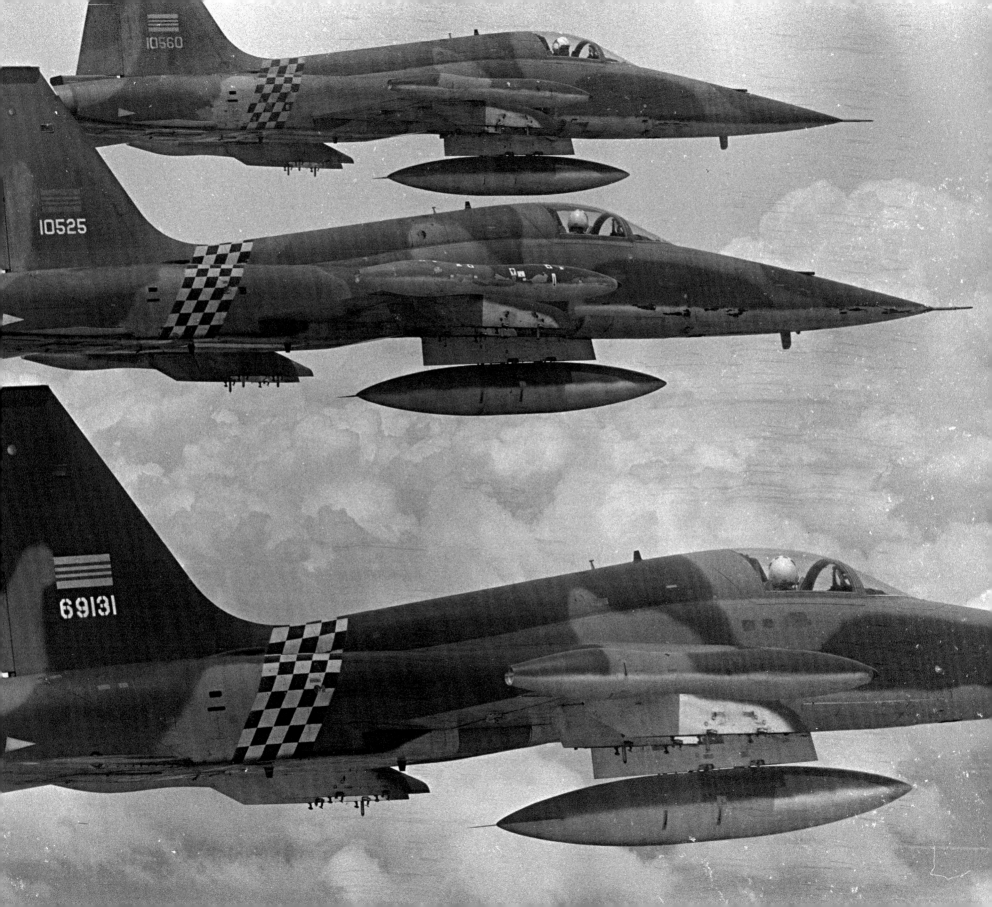

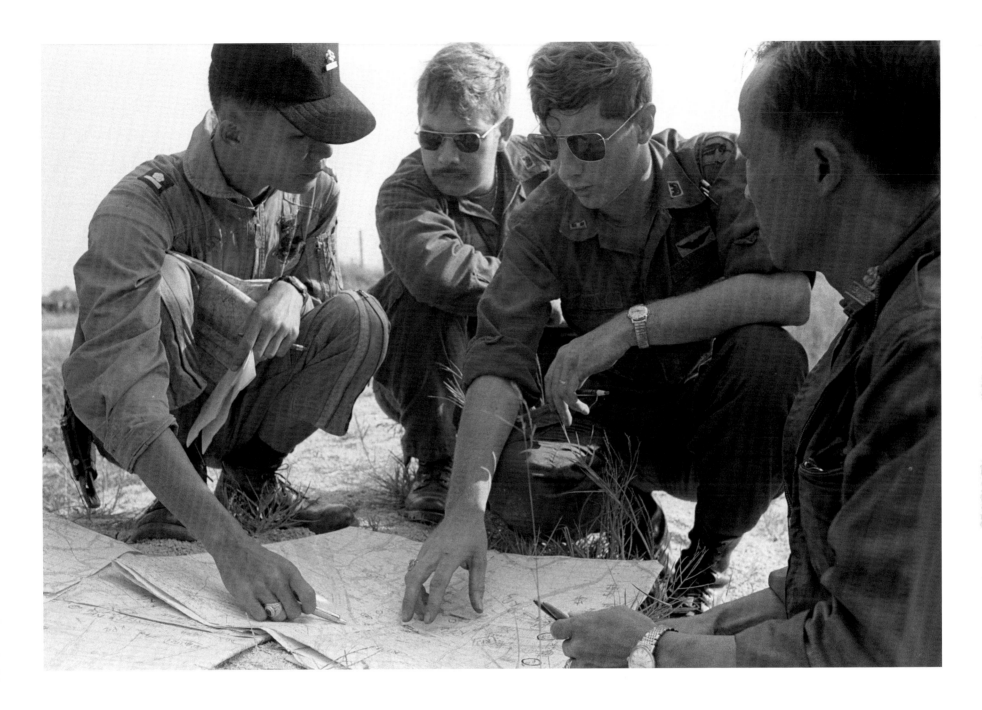

DON HIRST
South Vietnamese F-5 fighter planes.
April 4, 1970 | South Vietnam

▲ **OW STAFFER**
ARVN 9th Division ops in Vĩnh Bình province and pilots
of the US 175th Assault Helicopter Company liaise on
troop movements and landing zones with pilots from the
Vietnamese Helicopter Squadron.
1970 | South Vietnam

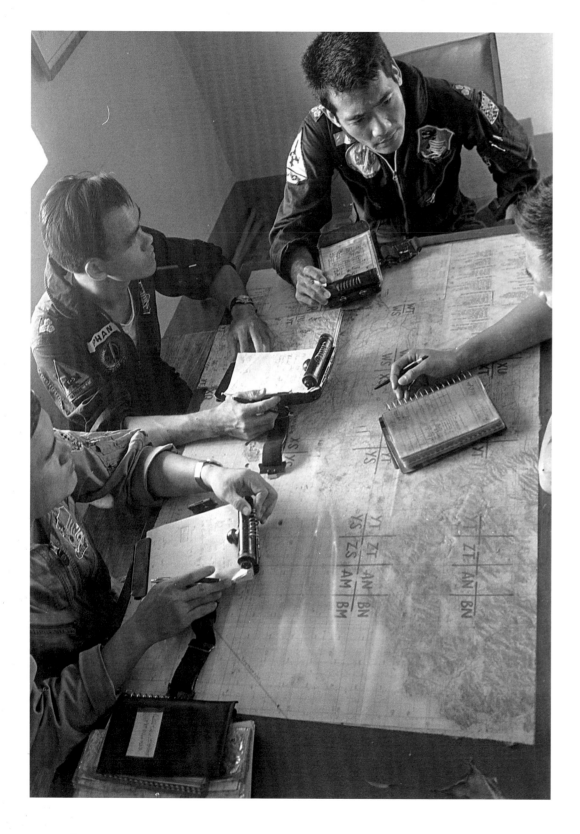

▶ **DON HIRST**
VNAF 522nd Fighter Squadron pilots review mission plans led by Captain Lê Minh Mỹ.

June 9, 1970 | Biên Hòa

▶ **DON HIRST**
VNAF 522nd Fighter Squadron Captain Trương Chánh prepares to board an F-5 fighter aircraft.

June 9, 1970 | Biên Hòa

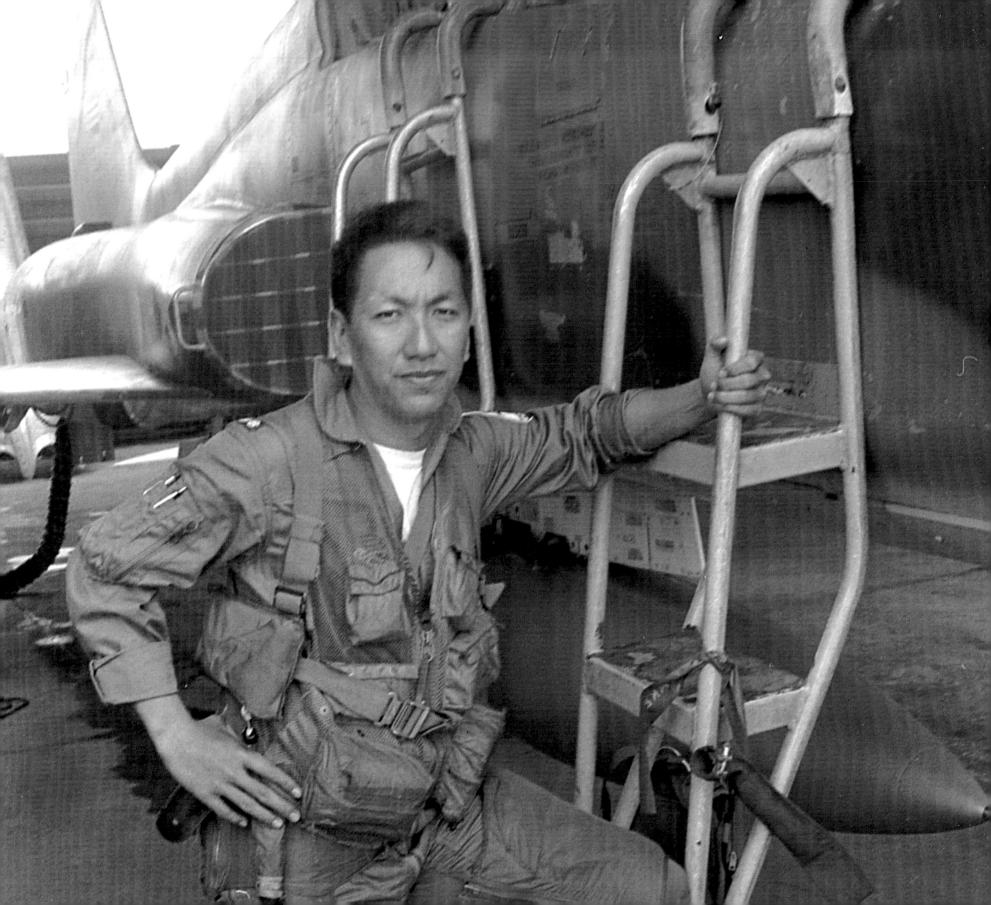

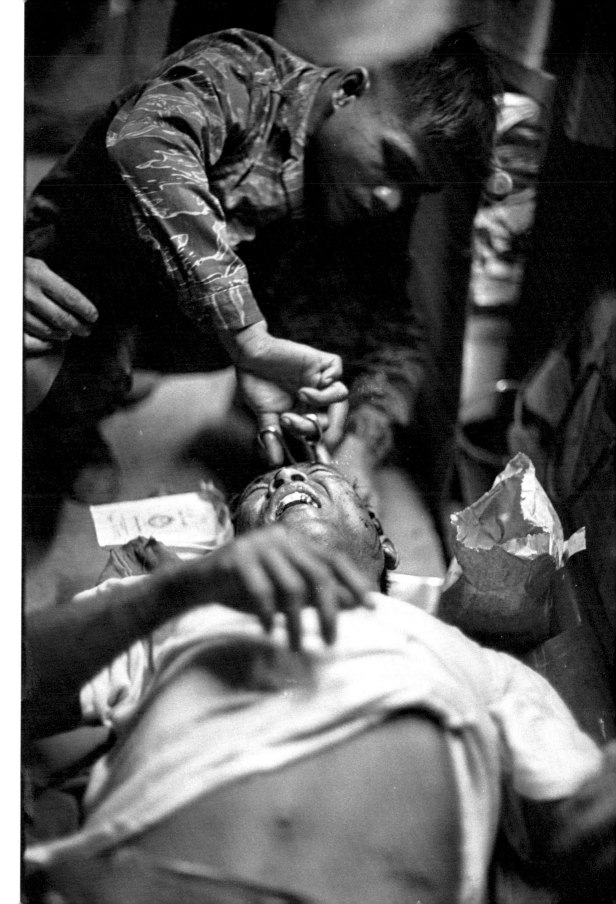

US Vice President Spiro Agnew (*left*), South Vietnamese Vice President Nguyễn Cao Kỳ (*center*), and an unidentified ARVN officer.
September 3, 1970 | South Vietnam

 OW STAFFER
A medic attends to a wounded man who winces in pain.
July 26, 1969 | Biên Hòa

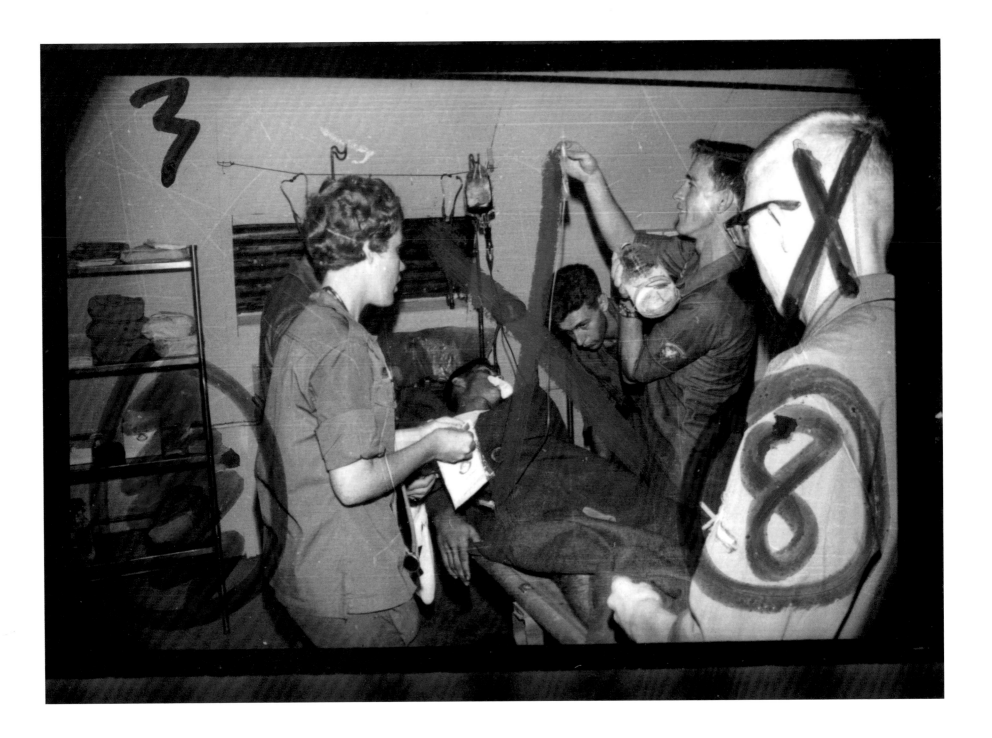

▲ **SAUL LOCKHART**
Doctors prepare to operate on a 1st Air Cavalry
soldier with a bad shrapnel wound.
May 1967 | South Vietnam

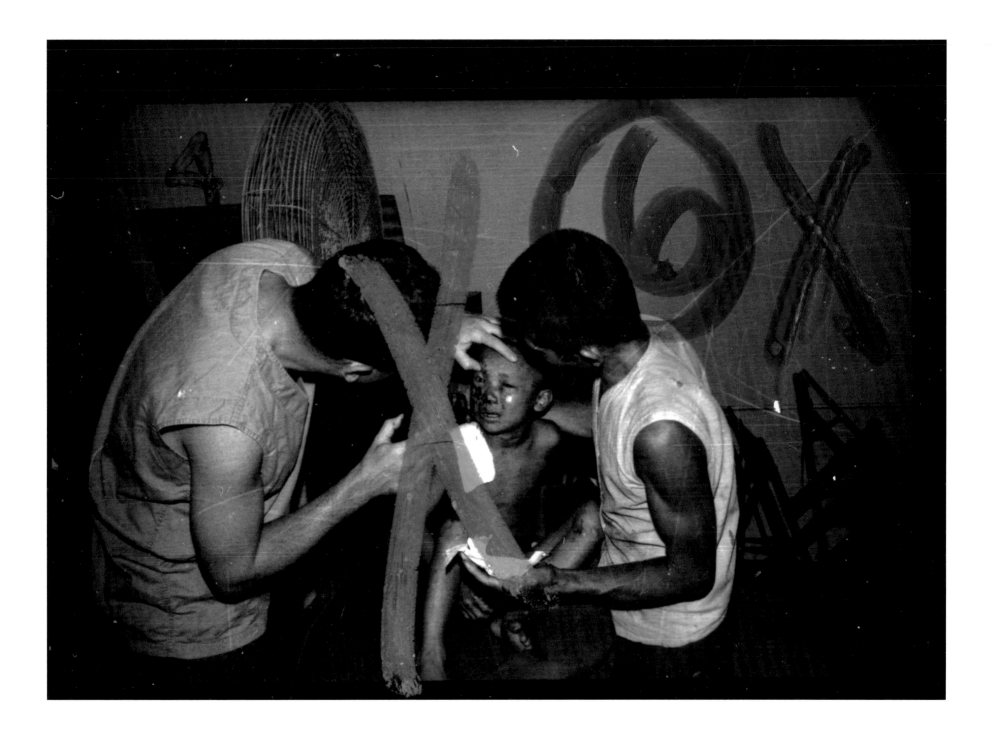

▲ **SAUL LOCKHART**
A medic treats a Vietnamese child caught
in the crossfire of battle.
May 1967 | South Vietnam

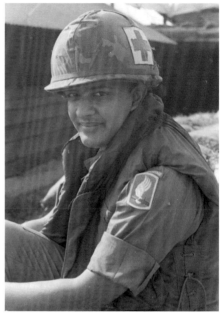

Major Narayanan Kasturirangan (a.k.a. Norman Katz), the 173rd Airborne's "Top Swinger" medic, receives a Medal of Honor.
March 14, 1970 | South Vietnam

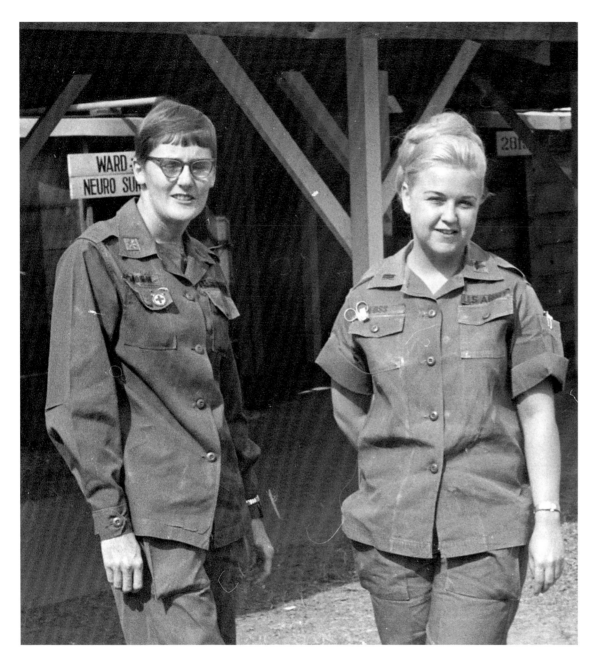

▲ **OW** STAFFER
Nurses Major Maryrose Troniar and First Lieutenant Jody Foss.
March 7, 1970 | Long Bình

▶ **DON HIRST**
Wounded soldiers are medevaced.
May 11, 1970 | Cambodia

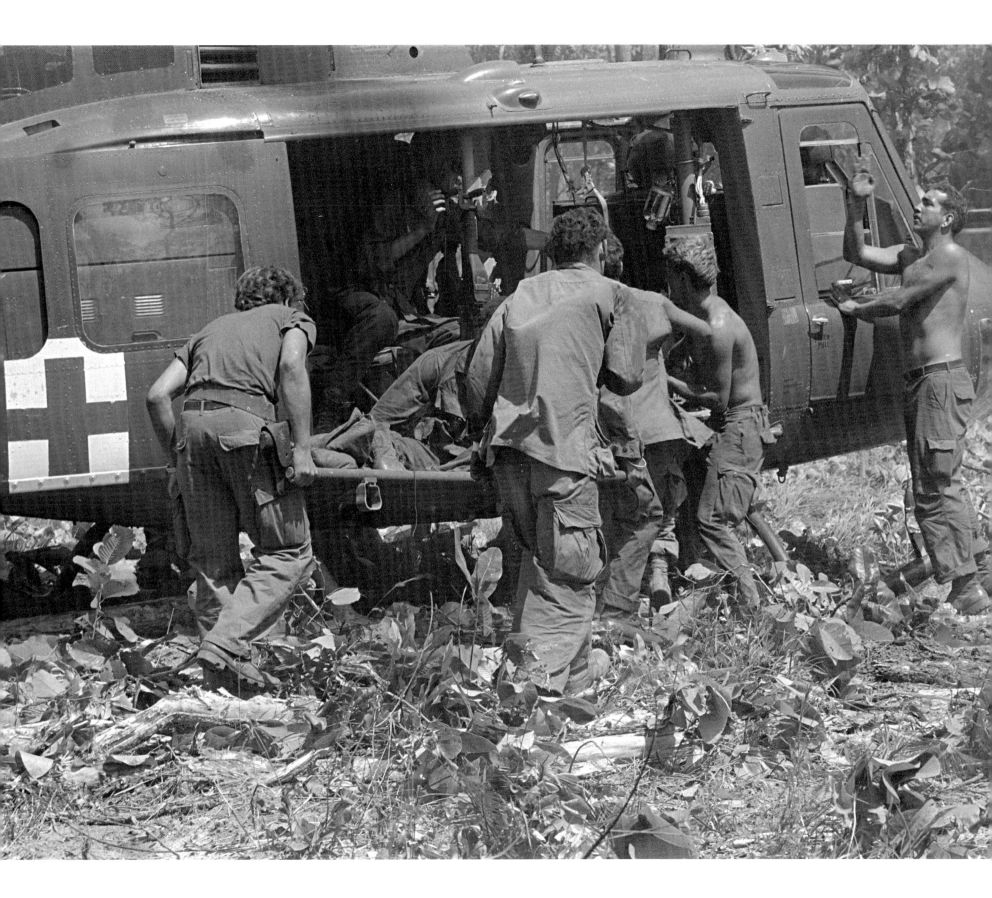

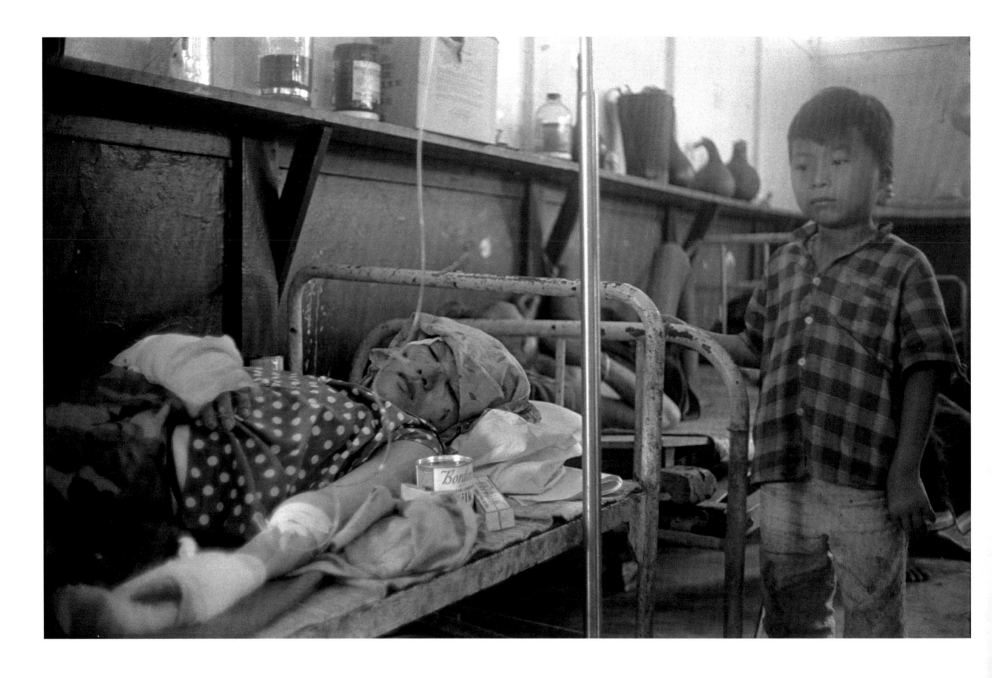

▲ DON HIRST

Võ Thị Phương rests in a hospital with one of her children standing by the bed. Her manicured nails peek out from the yards of bandages that cover her arms, a fiery red mess of cuts, bruises, and barely warded off infection. A glucose bottle slowly drips life-giving nourishment into her left arm. Two rockets landed near her house, killing her youngest daughter and severely wounding her husband. She doesn't remember too much because the hunks of red-hot shrapnel that ripped into her body mercifully drove her into unconciousness. "I didn't know my child was dead until after I woke up in the hospital," she said as she fought back tears. "I cried two days for my child."

April 20, 1970 | Pleiku

▶ *OW* STAFFER

Soldiers await medics and tend to injured Vietnamese peasants.

1970 | South Vietnam

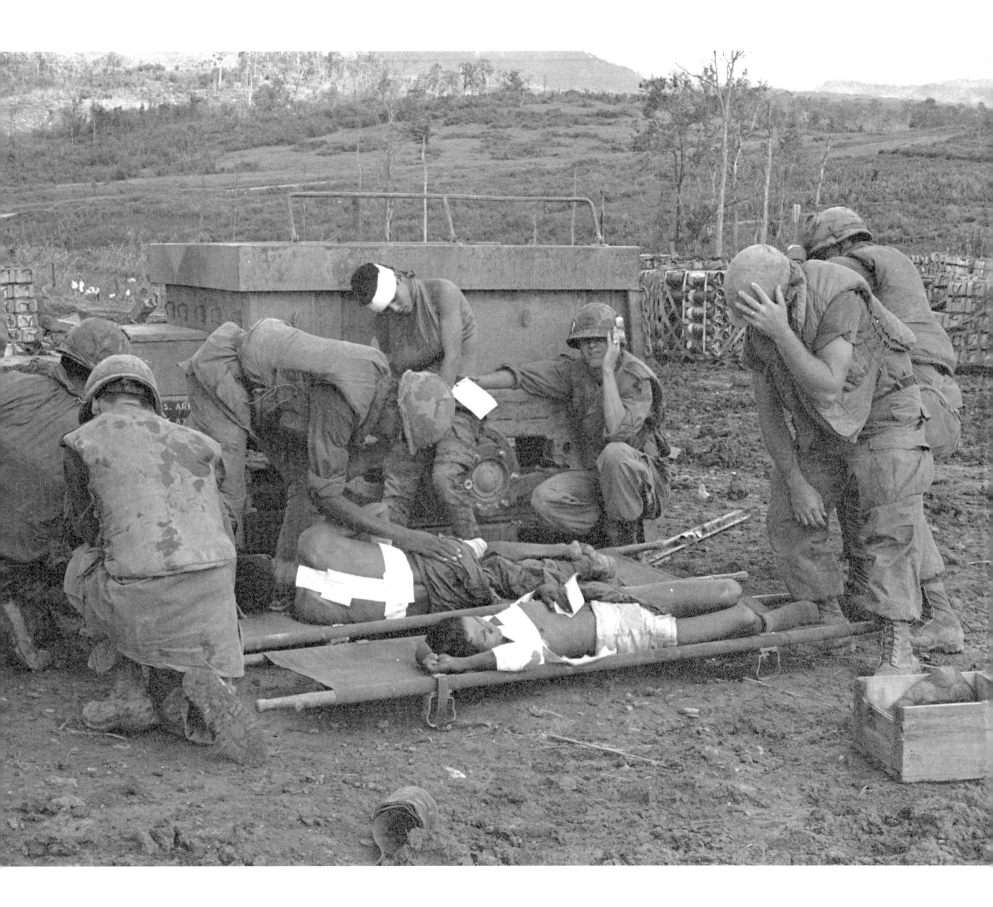

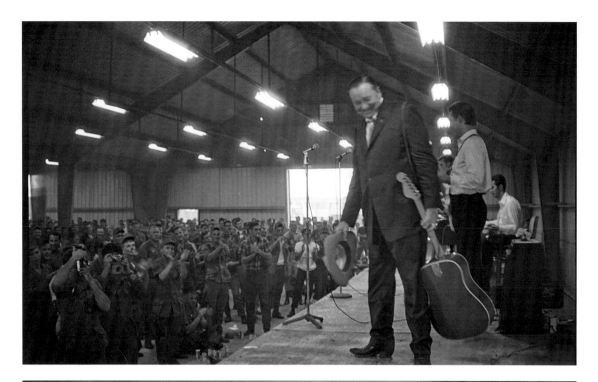

Country-and-western singer Tex Ritter entertains servicemen with "Boll Weevil Song."

December 7, 1968 | South Vietnam

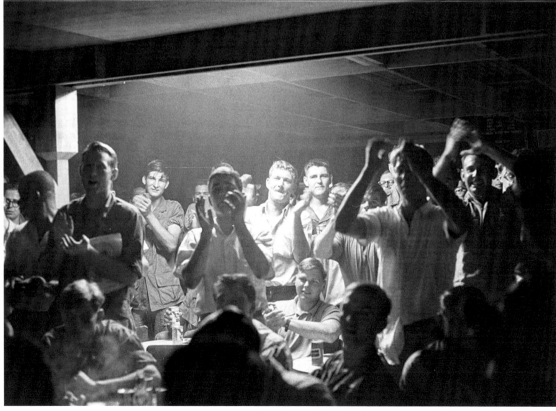

◀ **DON HIRST**
Troops clap, holler, whistle, and stomp on the ground as Johnny Cash performs "Folsom Prison Blues."

March 1, 1969 | Long Bình

▶ *OW* **STAFFER**
Commedienne Martha Raye
entertains US 1st Division Marines
at Hill 65 near Đà Nẵng.
1968 | South Vietnam

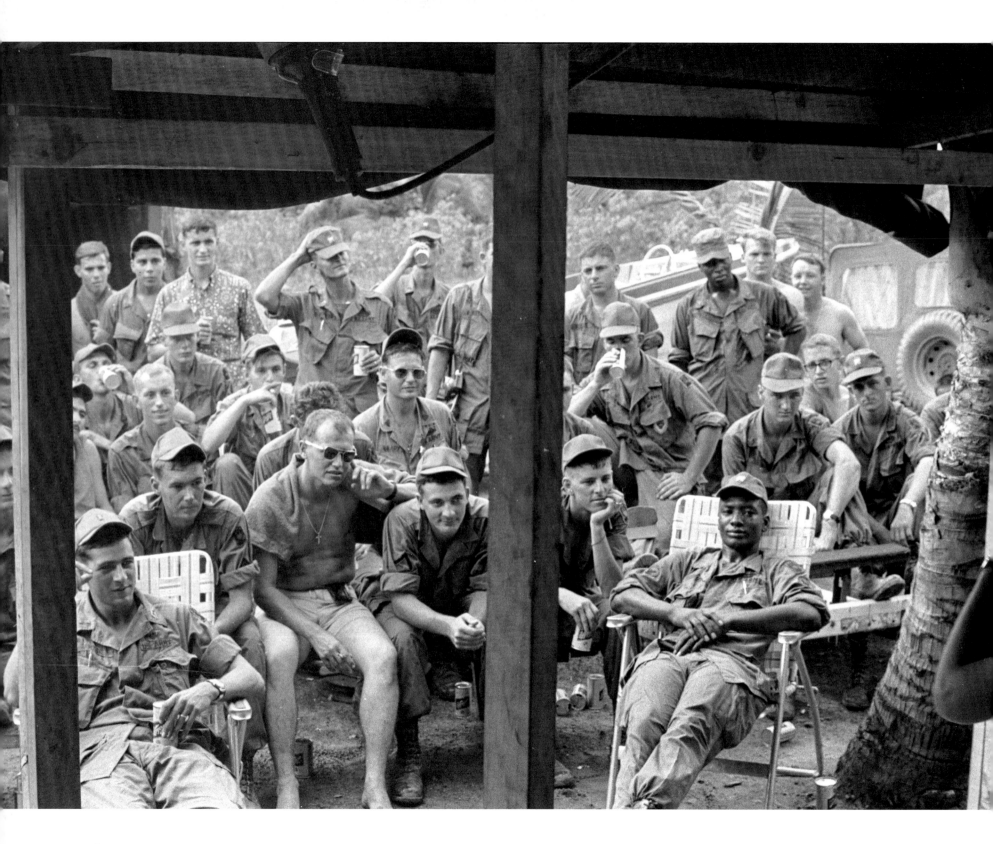

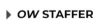

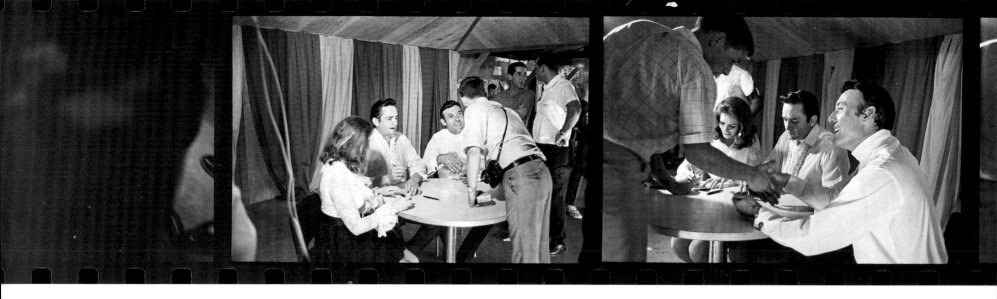

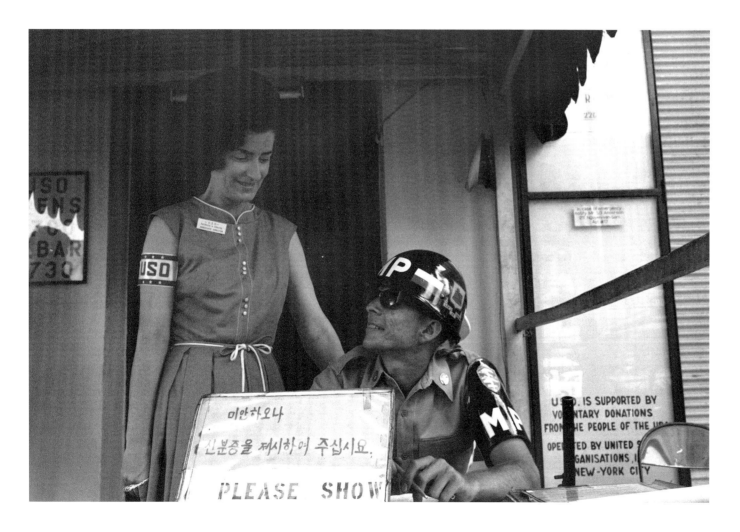

◄ ANN BRYAN

Patty Krause, assistant director of the Saigon United Service Organizations (USO) Center, with Private First Class Bill Ambler. Krause often traveled to remote locations to deliver care packages of food and toiletries to service members.

April 8, 1966 | South Vietnam

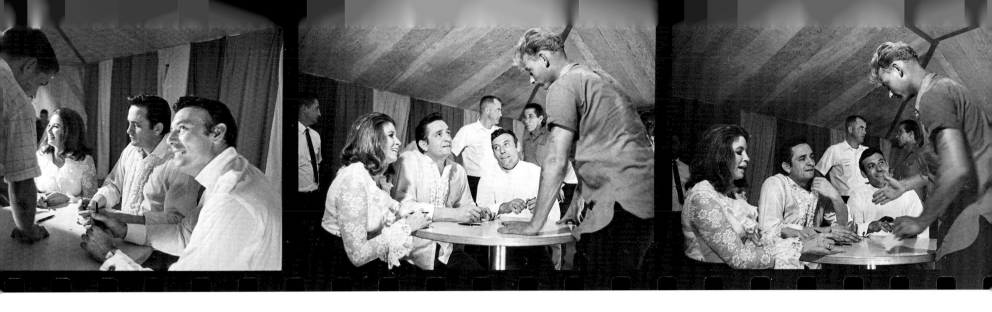

ANN BRYAN

▶ Singers Johnny Cash, June Carter, and Carl Perkins sign autographs for servicemen at the Enlisted Men's (EM) Club.

March 1, 1969 | Long Bình

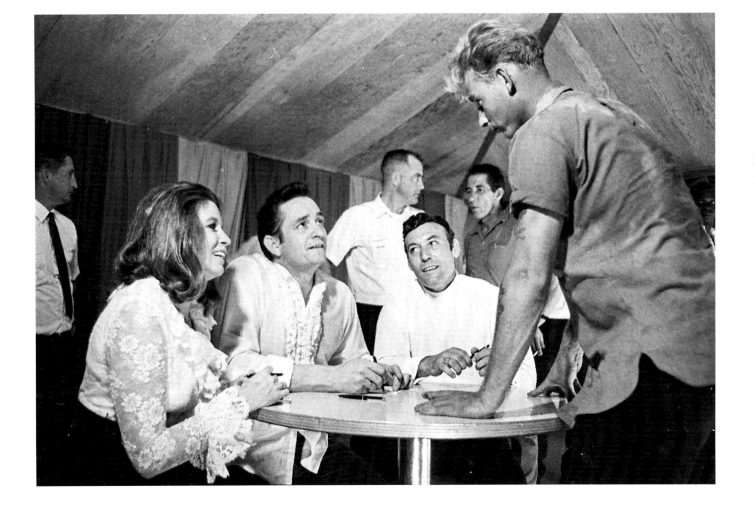

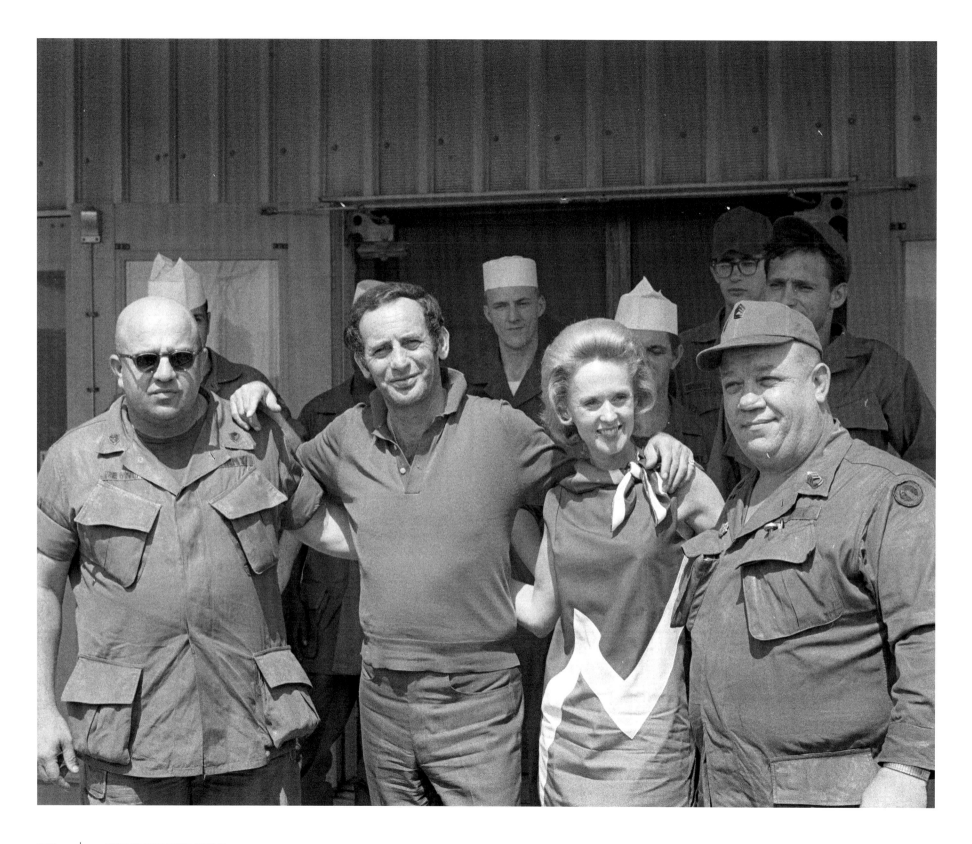

DON HIRST

Country singer Carl Perkins sings "Blue Suede
Shoes" for servicemen at EM Club in Long Bình.
After his first show at Long Bình, Perkins admitted,
"I'm a grown man, and I don't like to have other
men see me cry, but out there just now I sure
did feel like crying. These boys are willing to give
it all for a great country, and I'm doing very little
for them."

March 1, 1969 | Long Bình

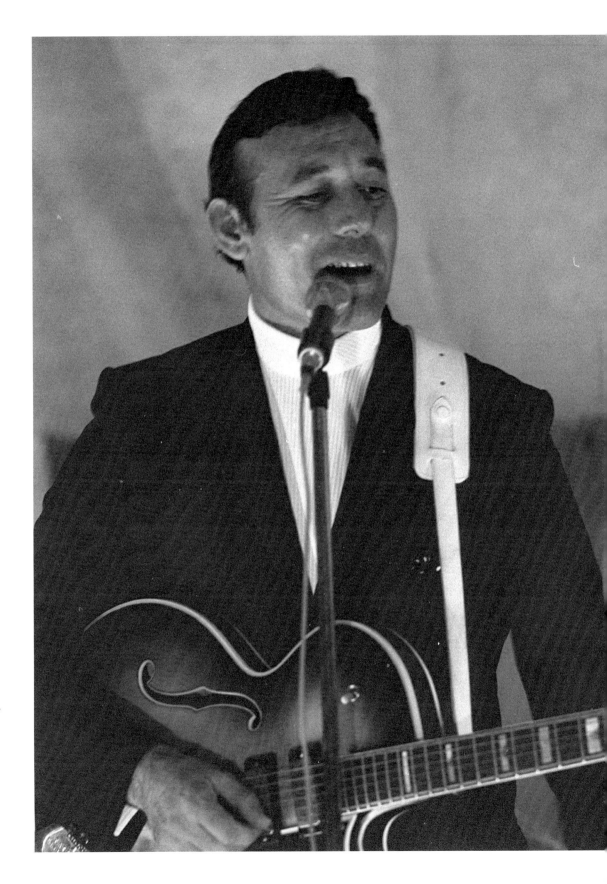

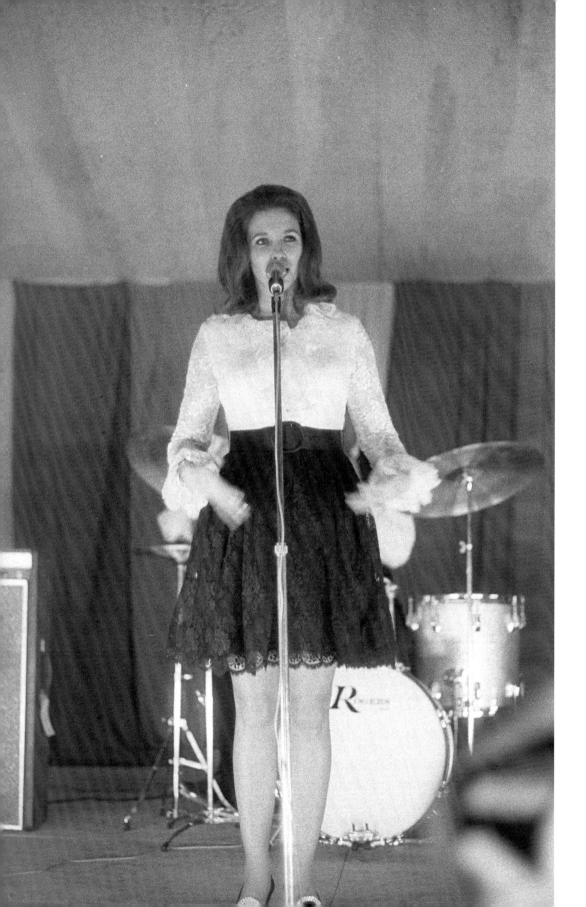

◄ DON HIRST

June Carter bows to a captive audience at the EM Club in Long Bình. She expressed "mixed emotions" about her first time being in a combat zone. "I'm scared to death in another way for the same reason everybody else is scared. You hear that boom in the distance, and you think, oh my goodness. But I really am glad to be here. It gives you a nice feeling if you know you can entertain somebody."

March 1, 1969 | Long Bình

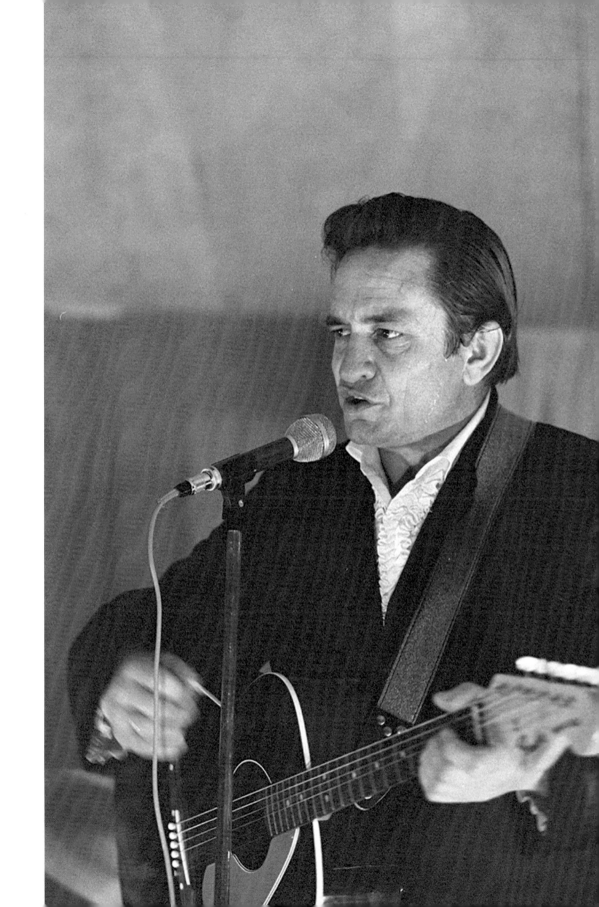

DON HIRST
Country singer Johnny Cash delights
800 servicemen at the EM Club.

March 1, 1969 | Long Bình

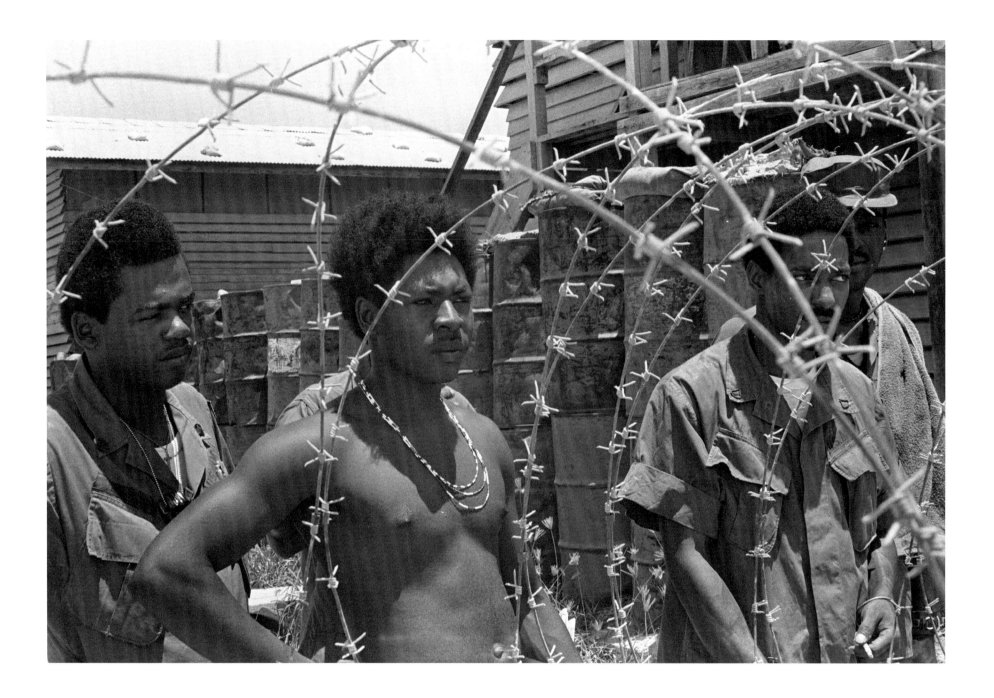

▲ **BRENT PROCTER**
Black soldiers at Camp McDermott are angered by a hastily
constructed barbed-wire fence. The fence was intended to
segregate the living quarters of black and white soldiers
following unsettling incidents of racial violence.
October 10, 1970 | Nha Trang

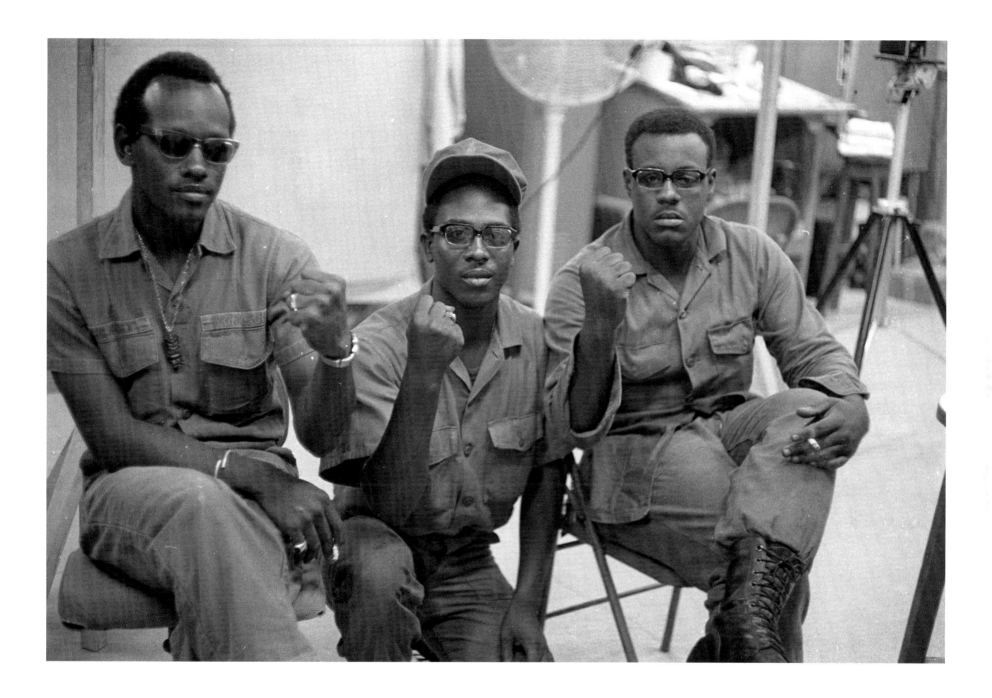

▲ **DON HIRST**
Navy sailors Hayes W. Skinner, Ronald
Washington, and Seaman Milton
Binion Jr. give a sign for black power.
November 18, 1968 | Đà Nẵng

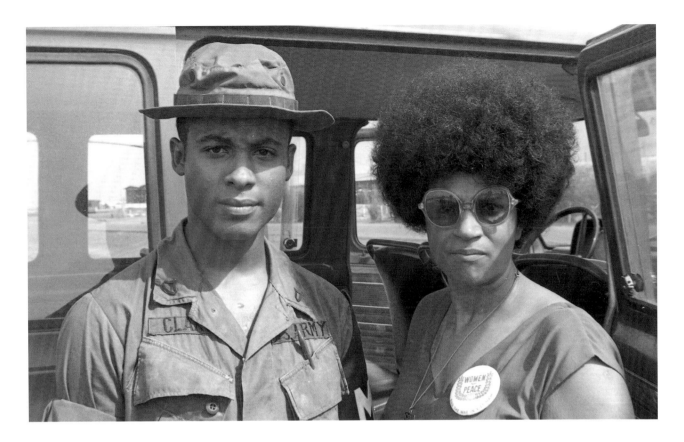

OW STAFFER
Private First Class Jeffrey Clark of the 25th Military Police Company and Eugenia Willette attend the court-martial of Bernardo Rodriguez Jr., accused murderer of her son Private Asa Martin Jr.
April, 1969 | Củ Chi

◀ **CATHY DOMKE**
Ann Fabos of USAID leads a protest against the Army ban on women's pants after an incident in which she was denied entrance into the Rex Hotel in Saigon for an Overseas Weekly story, "Chicks Blast 'Nam Pants Ban."
January 10, 1970 | South Vietnam

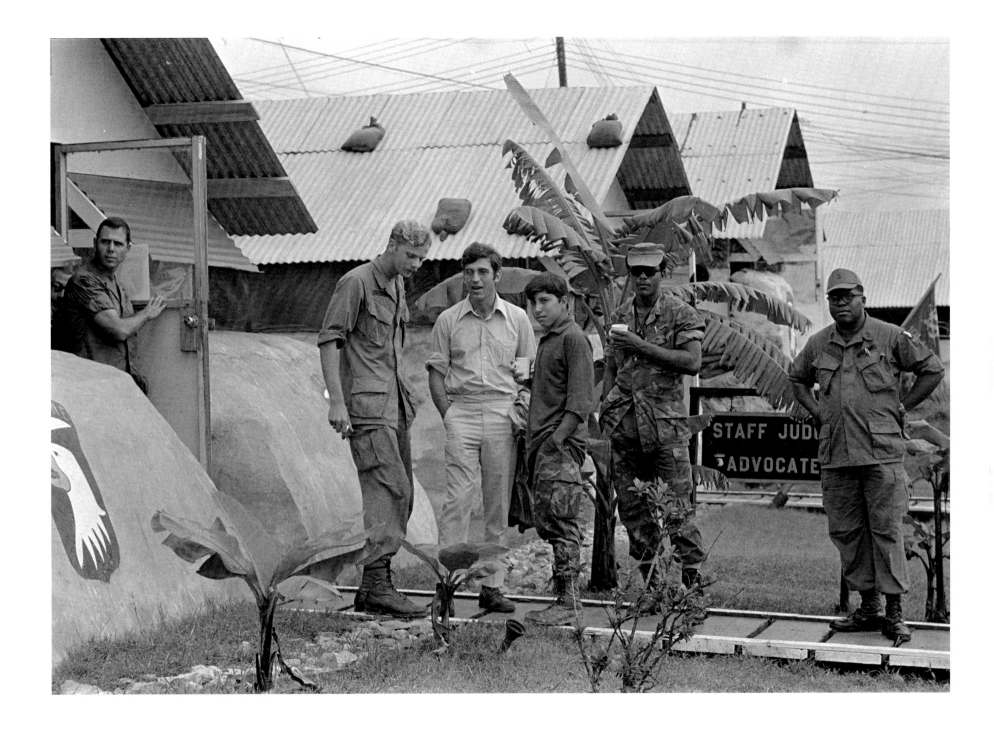

▲ *OW* STAFFER
Conscientious objectors Captain Stephen Daniel, Private
Adolf R. Flores, Private Frank Moore, and Specialist Fourth
Class Frederick H. Miller with attorney Henry Aronson.
1972 | South Vietnam

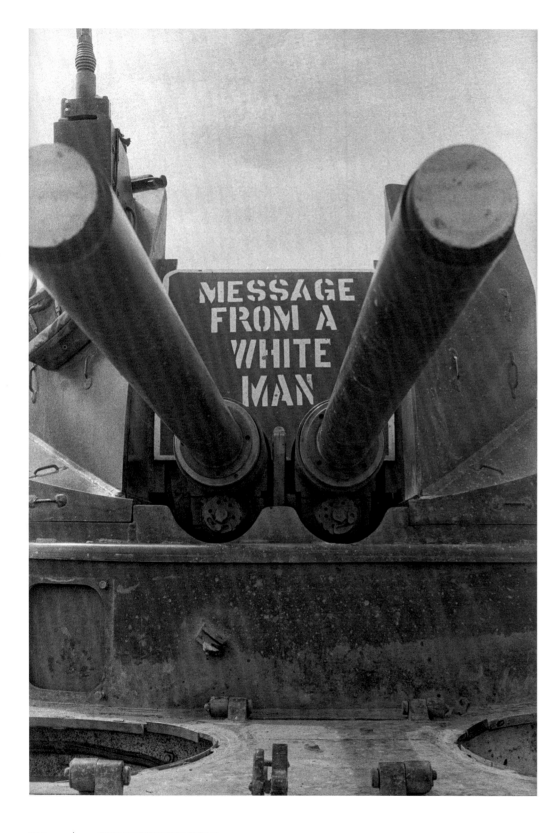

BRENT PROCTER

"Message from a White Man," Firebase Tennessee.

October 16, 1970 | South Vietnam

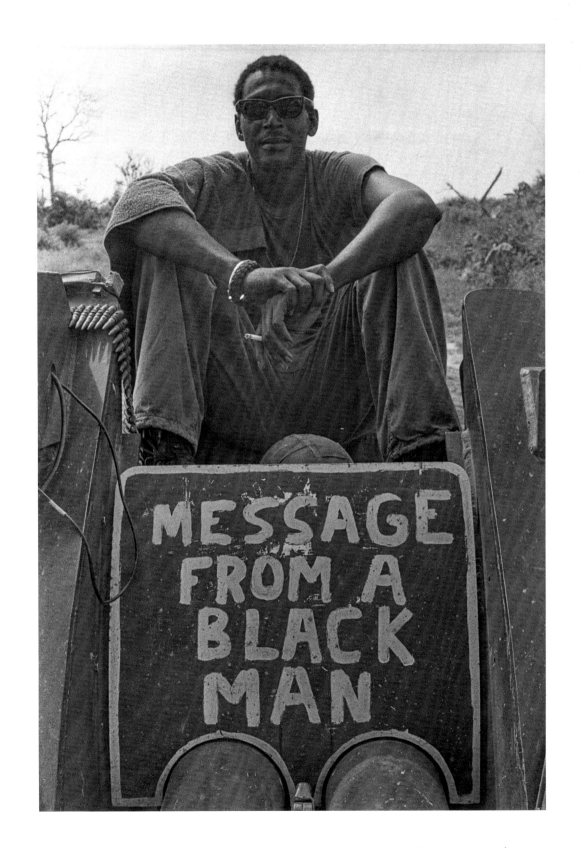

▶ **BRENT PROCTER**
"Message from a Black Man," Firebase Tennessee.
November 7, 1970 | South Vietnam

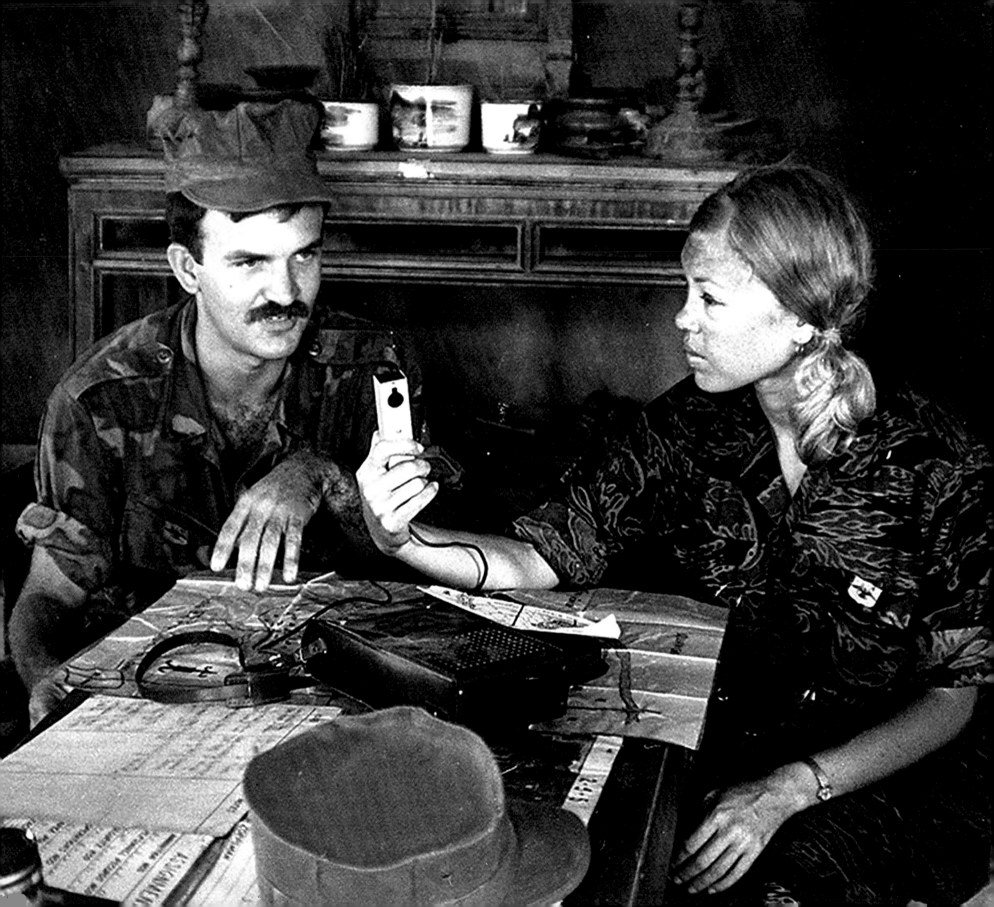

MAN ON THE STREET

WHAT DO YOU THINK . . . ?

Paris Peace Talks Bring Withdrawal?

PROSPECTS for peace in Vietnam advanced one more step when Vietnamese President Nguyen Van Thieu called for a withdrawal of 20,000 or more U.S. troops from Vietnam in the next few months.

President Thieu, Ambassador Ellsworth Bunker and Gen Creighton Abrams met recently to discuss the possibility of withdrawing American troops as soon as possible.

Thieu feels the Vietnamese armed forces are strong enough to take over a greater burden of fighting so that GIs can start going home this year.

Abrams will meet with the ARVN chief of staff to hammer out plans for the gradual phaseout of American combat troops. How much this will affect GIs in the near future remains to be seen.

Many troopers are skeptical about a troop withdrawal from 'Nam. But the strongest feeling among GIs is a desire to get the mess over with as soon as possible. Let's just hope the brass can live up to their word!

Are days like this numbered for GIs in Vietnam?

How's Withdrawal Grab Ya, GI?

WHAT DO YOU THINK ABOUT THE PLANNED TROOP WITHDRAWAL?

● **Sgt Tony Franken, 366th Security Police Sqdn, Da Nang:** It's great if they'll do it. I doubt we will, because everything they've said they'd do they haven't. Ever since I've been over here, I've learned not to trust anybody. When I first heard about the proposal, I was happy about it.

● **Sp4 Oscar Bazemore, Hq Co, 11th Trans Bn, Cat Lai:** Is it worth it? I guess it might be worth a try to release a division or so if we don't need them. I think it might work, but I'm not 100 percent sure. I sure wish one of the outfits to go home would be mine.

Franken Bazemore

● **1st Lt Warren David, Hq Co, 1st Bn, 8th Inf, 1st Brig, 1st Air Cav Div, Tay Ninh:** Well, I don't really know what to say about it. It's a good idea—I sure hope to hell something comes of it. When I heard about it, my hopes were sure built up.

● **CW2 John Esslinger, Co C, 227th Avn Co, Phuoc Vinh:** I'm too short to worry about our division moving homeward. Anything that they can do to help build a peace here is good. I personally think that a troop withdrawal is premature. It looks as if they haven't really done anything to really promote peace. I just hope it will all work out. I'm too short to worry — 83 and a wakeup!

● **Pfc Ondray Cleveland, CMD Advisory Team 100, Saigon:** That's a great idea! Send us all back home where we belong. I don't think a withdrawal will work, but it's a nice idea. I don't think that 20,000 troops is enough. Take 'em all out of Vietnam as far as I'm concerned.

● **S Sgt Robert Ehnerd, 90th MP Det, 716th MP Bn, Saigon:** First of all, I think it's a lot of crap. We'll never do it — hell, we'll be here another two years.

I don't see how how the U.S. could lower the troop commitment. As far as I'm concerned, we're fighting a war here in 'Nam and we need all the people we can get.

● **Sp4 Fernando Hidalgo, Co C, 1st Bn, 508th Inf, 82d Abn Div, LZ Hardcore:** I feel real good about it and I think I'll be one of the first ones home. Why not? I've got over nine months' service in 'Nam. I doubt a withdrawal will work, though. It's just to boost the morale of the troops, that's why they did it. They're going to talk for months about it and not do anything.

● **Sp5 Andrew Simar, 5th Maint Bn, Qui Nhon:** I don't think we'll withdraw 20,000 troops or any other number. We have too much tied up over here to take that many GIs out. I feel that it'll be quite awhile before we pull anybody out of Vietnam. Sam has too much invested over here to quit now.

● **Sfc Culbert Thomas, AFVN, Det 3, Da Nang:** Troop withdrawal? I don't think so because we've got too much invested over here for it to work. In a couple of years, possibly.

● **Sgt Kenneth McDonald, Det**

1500, USAF Pacific TCR, Cholon: It's President Thieu's country—he runs it. General Abrams says that it's possible, but not right now. I haven't been here long enough to get the full scope of this conflict, as they call it, so I really can't say if a troop withdrawal will work or not.

● **S Sgt Robert Boyd, 633d Supply Sqdn, Pleiku:** I think it would be a good idea. It would have some effect, one way or another, on the talks that are going on in Paris now. It would affect both sides, the South Vietnamese and Hanoi. It would give Hanoi a little more confidence in what the United States is trying to do in the war and it would benefit both. It would give Hanoi confidence that the U.S. means what they are saying, that they want the war over. Maybe Hanoi will settle down and not demand so much.

● **Sfc Samuel B. McGloflin, Installation Engineers, Pleiku:** Really, I honestly think they should reduce U.S. troop strength and turn more of it over to the South Vietnamese. Let them have more of the responsibility of their own country. They know what they have, we know what they have, and they will be better satisfied in knowing that they have the opportunity of protecting their country.

● **S Sgt Clyde Kintigh, Hq Trp, 3d Sqdn, 5th Cav, 9th Inf Div:** I think it would be a good thing providing that the South Vietnamese government could take care of its own part in this war. If they can't, then I don't think we should move out.

● **Capt Charles L. Martin, 377th Combat Support Gp, Tan Son Nhut AB:** If the report is in fact correct, I think it's a real good sign, especially if it's the South Vietnamese government in part making these proposals. If in fact the people that know our capability over here feel that we can send back troops in the near future, I think it's a real good sign.

Kintigh Martin

David Esslinger Cleveland Ehnerd Hidalgo Simar Thomas McDonald Boyd McGloflin

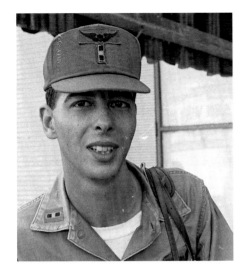

I'm too short to worry about our division moving homeward. Anything that they can do to help building peace here is good. I personally think that a troop withdrawal is premature. It looks as if they haven't really done anything to really promote peace. I just hope it will all work out.

——————

Chief Warrant 2 John Esslinger, Company C, 227th Aviation Company, Phước Vĩnh

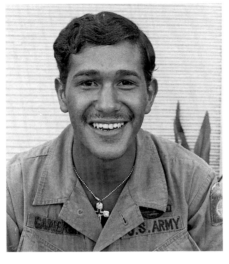

I feel real good about it and I think I'll be one of the first ones home. Why not? I've got over nine months' service in 'Nam. I doubt a withdrawal will work, though. It's just to boost the morale of the troops; that's why they did it. They're going to talk for months about it and not do anything.

——————

Specialist Grade 4 Fernando Hidalgo [sic], Company C, 1st Battalion, 508th Infantry, 82nd Airborne Division, LZ Hardcore

Really, I honestly think they should reduce US troop strength and turn more of it over to the South Vietnamese. Let them have more of the responsibility of their own country. They know what they have, we know what they have, and they will be better satisfied in knowing that they have the opportunity of protecting their country.

——————

Sergeant First Class Samuel B. McGloflin, Installation Engineers, Pleiku

If the report is in fact correct, I think it's a real good sign, especially if it's the South Vietnamese government in part making these proposals. If in fact the people that know our capability over here feel that we can send back troops in the near future, I think it's a real good sign.

——————

Captain Charles L. Martin, 377th Combat Support Group, Tân Sơn Nhứt

Body Counts — Do They Matter?

VIETNAM is a war of statistics. Every day radio, TV and newspapers bombard the American public with accounts of how many tons of bombs were dropped, how many air strikes were flown, how many cities were shelled and how many enemy were killed.

Ever since the U.S. got involved in the Vietnam War, the powers-that-be have measured progress by stacks of VC and NVA dead in relation to allied losses. Each week the total number of kills on both sides are tallied and a kill ratio for the week computed. The results sound something like a baseball scoreboard.

When the kills and kill ratio are high, commanders all the way up the line crow that we're almost to the end of the tunnel and the enemy just can't take these kind of losses much longer. After almost four years of full-scale American involvement, this optimistic argument begins to wear thin.

Critics say that you really can't measure the progress of a guerilla war by the number of ex-enemy you find (or claim to find). They point out it's really hard to tell just who was the enemy and who was the poor civilian who happened to get caught in a cross-fire. Cynical GIs say that if it's dead, then it's a VC.

Many people question the accuracy of the counts in the first place because in the past gung-ho commanders have been known to fudge on their count just a little bit. Said one GI, "They're not actually counting how many people are getting killed. They just fly over in a chopper and estimate how many people are dead and how many the VC dragged away."

IS BODY count a good way to measure who's winning the war?

► **Sgt Fred McMillian, 384th Qm Det, 34th S&S Bn, Da Nang:** Counting bodies is not a good policy for the simple reason that it doesn't show the actual war effort. We're doing a good job over here, doing things like pacifying areas and stopping enemy supply routes. The enemy has reinforced routes that were previously destroyed. The enemy is better equipped than ever before. The way to deter-mine the war effort is to gauge the slackening of enemy terrorist attacks and to note that less regular Vietnamese forces are coming down from the North to threaten military installations. This shows that we are doing a lot of work to keep them out of this country and eliminate their threat. The body count shows that we can't keep them out and we should be making more efforts to drive them out.

► **S Sgt Vittorio Sacco, 377th Security Police, Tan Son Nhut AB:** It's a pretty poor way of telling how the war is going. There are a lot of bodies that you can't identify, so how are you going to count them? If they could count all of the bodies, this might be a good method. The only way to really know how the war is going is the body count. I don't know how else they could do it.

► **S Sgt Levon Galloway, 147th LEM Co, Long Binh:** No. They're not actually counting how many people are getting killed. They just fly over in a chopper and estimate how many are dead and how many the VC have dragged away. When a battle occurs at night, they don't count the bodies until the next day. It's not accurate, but it's the only way to tell how the war is going.

► **Sp4 Randy Nelson, 59th Sig Co, Long Binh:** I'd say it isn't accurate. It's the most efficient way of determining the ration of American and VC dead. But all the body count reveals is deaths. It doesn't say anything about the psychological effect on the South Vietnamese and North Vietnamese. The number of people killed doesn't really tell who's winning the war. At the moment the war seems to be more a psychological war than a war of "I kill you, you kill me." There is no better way of saying who's winning the war, but the counting is rather one-sided. Still, it's the most efficient way we have.

► **Sp4 David Sodeman, 147th LEM Co, 185th Maint Bn, Long Binh:** I don't think it is. It's the logical way to find out how many people are killed, but it's not a very efficient way to determine what the outcome of the war will be. Someone will eventually find another way to determine this, but for now it's the only way we have. The body count doesn't say anything about our purpose here — it just concerns deaths and counting

them doesn't reveal much. The body count tells how many VC are killed, but doesn't say anything about the outcome or progress of the war.

► **Sgt John Wortham, 101st Abn Div, Bien Hoa:** I believe so. If you take the number of VC killed in a week or month and see if it increases or decreases, you can tell how the war is progressing. It depends on what part of the country you're in. I'm in Phu Bai. From February to June 1968 we killed an average of 150 to 200 VC and NVA per week. In June the body count decreased and we killed 10 or 15 per week. That proves the war is decreasing. In my opinion the war is just about over. When they start using 15-year-old kids and women to fight the war, it's not looking too good for them. The body count therefore does indicate the progress of the war.

► **Sgt Robert Thursby, 716th MP Bn, Saigon:** I don't believe it tells the overall effect of what is going on. It doesn't tell whether you have control over provinces and villages. A lot of times in the central highlands you get a big body count but you can't regain or maintain control of the area. The NVA or VC may still be in the area to influence or scare the people in spite of the big body count. I think the best way to determine the progress of the war would be found by combining body counts, number of Hoi Chanh, and the general progress of the people in rebuilding their villages. At least in the Pleiku area, where I'm from.

► **Sgt Daniel W. Boone, 505th TCM Sqdn, 505th TCM Groups Bien Hoa:** That's not the only reason we're over here, to kill VC. I think the opinion of the Vietnamese people, who they're for, determines how the war is going. The body count is not a good way to determine the progress of the war. If all of the South Vietnamese people were for us, the war would be easily won.

► **Sp5 Charles Shoudel, Hq Aviation Material Management Center, Data Processing Center, MacV, Saigon:** Who wants to go out and count bodies? We're letting Ho Chi Minh get away with too much. It's like a big cake, divided in half and he's eating our half and his too. If we go across the DMZ, he'll lose something — right now every-thing's going for him. The body

count dosen't prove a thing. The enemy is saying they killed more of us, and we're saying we killed more of them. But I can think of no better way to keep track of the progress of the war.

► **WO1 Gerald Kunishige, 187th Assault Helicopter Co, 269th Bn, 1st Avn Brig, Tay Ninh:** The body count is the only thing we have to determine how the war is going, but it's not accurate. The VC haul off their dead and wounded in much the same way as we do. Many times we found blood trails leading into the jungle from LZs — no bodies were found, but we know some were killed or else wounded. But the number of dead enemy, even if incorrect, doesn't tell the whole story about the war.

► **WO1 J. Emerson, 187th Assault Helicopter Co, 269th Bn, 1st Avn Brig, Tay Ninh:** The body count is not a true report of the number of enemy killed. Sometimes we find VC graves — they bury their dead in unmarked graves. In some units they find numerous unmarked graves and these dead enemy are not counted at all. The real way to find out where the war stands is to ask the South Vietnamese people themselves.

► **WO1 Dick Loos, 187th Assault Helicopter Co, 269th Bn, 1st Avn Brig, Tay Ninh:** The body counts are not only incorrect but misleading. If there was some way they could get a poll from all over the country, from the common people in the villages and hamlets, and ask them how the war is coming along, we'd have a better idea of how things stood in this war. You can have all kinds of body counts, but you can't tell that way if the Vietnamese people are being won over.

► **WO1 Bill Hadfield, 187th Assault Helicopter Co, 269th Bn, 1st Avn Brig, Tay Ninh:** The

body count is not a good indication of who is winning the war or how it is progressing, but it's the only guideline we have. It is very difficult to get an accurate count. In a mass attack, you get a general idea of how many enemy died because the bodies are usually left on the battlefield. Then you can almost make a good guess at how many were carried away by retreating enemy soldiers. The number killed is some indication of how the war is going, but not a totally accurate one. It's the only way we have because the evidence is right in front of us. The progress of the war would best be determined by the attitudes of the Vietnamese themselves. But this is a very hard thing to determine.

► **Sp4 George Hardick, 716th MP Bn, Saigon:** Actually, the body counts are not accurate. I spent 21 months out there and the intelligence reports we received were either less than or more than the right amount. The infantry men call an air strike and they can't determine how many people were killed. After a bombing there is usually no-body left—you can't tell how many bodies are in the rubble. The body count has some bearing on the progress of the war.

► **Sgt Gary Norton, 716th MP Bn, Saigon:** They drag a lot of their bodies away. Lots of them you never find. If you're fighting near a river, lots of the bodies float away on the water or sink. The counting of bodies is not accurate. Here, all of us know what is going on, but in the States they just read the body counts with the wrong figures and get the wrong idea about the war. Over here morale is one of the most important things. If you kill lots of NVA it doesn't mean you're winning. You can go over a month with no body count, but it doesn't prove anything about the progress of the war. The Vietnamese people don't really want to end the war—they're prolonging it because they're making money off of it. The ARVN troops seem to all be in the cities. They should go to the field. Our unit spent one year on the line. Now we're in Saigon—as a reward, I guess—and the Vietnamese are making money off us.

McMillian

Sacco

Galloway

Nelson

Sodeman

Wortham

Thursby

Boone

Shoudel

Kunishige

Emerson

Loos

Hadfield

Hardick

Norton

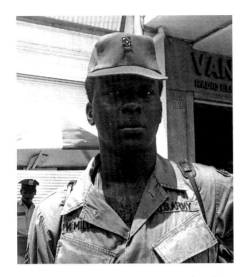

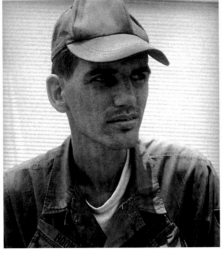

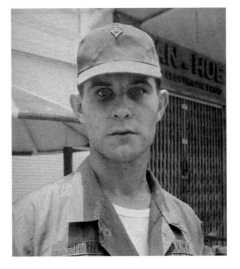

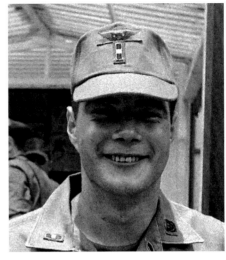

Counting bodies is not a good policy for the simple reason that it doesn't show the actual war effort. . . .The way to determine the war effort is to gauge the slackening of enemy terrorist attacks and to note that less regular Vietnamese forces are coming down from the north to threaten military installations. This shows that we are doing a lot of work to keep them out of this country and eliminate their threat. The body count shows that we can't keep them out, and we should be making more efforts to drive them out.

———————

Sergeant Fred McMillian, 334th Quartermaster Detachment, 34th Supply & Services Battalion, Đà Nẵng

That's not the only reason we're over here, to kill VC. I think the opinion of the Vietnamese people—who they're for—determines how the war is going. The body count is not a good way to determine the progress of the war. If all of the South Vietnamese people were for us, the war would be easily won.

———————

Sergeant Daniel W. Boone, 505th Tactical Control Maintenance Squadron, 565th Tactical Control Maintenance Group, Biên Hòa

Who wants to go out and count bodies? . . . The body count doesn't prove a thing. The enemy is saying they killed more of us, and we're saying we killed more of them. But I can think of no better way to keep track of the progress of the war.

———————

Specialist Grade E4 Charles Shoudel, Headquarters, Aviation Material Management Center, Data Processing Center, Military Assistance Command, Vietnam, Saigon

The body count is the only thing we have to determine how the war is going, but it's not accurate. The VC haul off their dead and wounded in much the same way as we do. Many times we found blood trails leading into the jungle from LZs [landing zones]—no bodies were found, but we know some were killed or else wounded. But the number of dead enemy, even if incorrect, doesn't tell the whole story about the war.

———————

Warrant Officer Gerald Kunishige, 187th Assault Helicopter Company, 269th Battalion, 1st Aviation Brigade, Tây Ninh

Birnbaum Heyman Williams Boyea Demings Austell Pair Davis Hoyle Jones Johnson Smith Augburn Maniero Sang

Prejudice in the Service?

Never in Combat, Say GIs

The medic is black. He grew up in Dothan, Ala.

But now, in a small jungle clearing in 'Nam, he kneels over a wounded buddy, pinching his nose and forcing his own life-giving breath into the victim's mouth. Life, in spite of the effort, slips away, and the medic sobs bitterly in remorse and frustration. The lifeless face beneath him is white.

Is there prejudice among servicemen in Vietnam?

GIs say yes and no, but never, never in combat.

● **Sp4 Mark Birnbaum, 10th Psyop Bn, 4th Psyop Gp, Can Tho:** From my experience, I think you can read a lot of things in the Army publications, like the Army Times. I remember reading one article which said that there are more and more Negro Lieutenant Colonels now. They're getting more promotions. Before, a black officer could only aim for Major — that was as high as he could go. But now they're getting Lieutenant Colonels and full Colonels, and there might eventually be many black Generals. In the enlisted ranks, I don't think there is any prejudice at all. In my experience, I've seen no prejudice involved with promotions, awards, or in any way. Our First Sergeant used to do a lot of yelling about prejudice, but I think it was basically an excuse and had little or nothing to do with prejudice. I have seen and experienced a definite sort of group prejudice within my own environment against — for lack of a better word — a hippie or head type of individual. I've seen that in a well organized persecution, getting down on these particular people and giving them a hard time. It has not been at a command level, but on a higher NCO level. The commander is more often an intelligent person, a person of responsibility, and realizes these people are probably making the great-

est contribution to the unit, that they are usually the best educated and the best informed, the best trained in the jobs they are doing and cause the least trouble. Since I'm not black, I can't really comment on racial prejudice — I can't feel, I can only observe. Being Jewish, I've never found any religious prejudice in the Army, never once. But I can look around my unit and say there is no prejudice against blacks. But I may be wrong. I may not even see it.

● **Sp4 Duane Heyman, 10th Psyop Bn, 4th Psyop Gp, Can Tho:** One thing you would not see immediately, as far as promotions go, is what goes on in the boards — the subtle factors involved in the selection. You can't tell from the outside. I think the most active prejudice that I've seen was in basic training. Some of the Southern cadres were really against the educated people. They resented many of the educated people who were going through basic training. As far as racial prejudice goes, I have seen individual incidents of personal antagonism. I know that a lot of individuals do hold prejudicial feelings, but they're kept off the job very well. This expression of prejudice has been outside the system, on a personal level. The worst prejudice is among different educational and social groups, not racial groups. Edu-

cation is sort of inversely proportional to rank among the EM because of the college draftees and the lifer NCOs. There's definitely a conflict between lifers and draftees or short term enlistees.

● **1st Sgt Ernest Williams, HHC, 1st Engr Bn, 1st Inf Div, Lai Khe:** I definitely feel that this is a problem in the States— among the Negroes and the whites. But over here they work together beautifully and the prejudice that is exhibited is more between the Vietnamese and the Americans. It's more outward toward the Vietnamese here. But otherwise, I don't see any racial prejudice in the Army in Vietnam. In the States the job is more one of a play around type, it's not as serious a job as it is here. Here you're fighting or you're doing something that really has meaning. People are more interested in working together and getting the job done than they seem to be in the States. In the States you have more time to play around—you don't have time to think about it here.

● **Sp5 Weslie Boyea, HHC, 1st Engr Bn, 1st Inf Div, Lai Khe:** I haven't seen any evidence of prejudice in Vietnam. The black man hangs around with black men, and the white man hangs around with white men around here, but when you go out into

Black medic helps dying white trooper: *death is not prejudiced.*

the field there's none of it. I mean, you just can't do it, I wouldn't do it anyway. You don't even think about it out there. You might find some around the big base camps, I don't know.

● **Pfc Gerald Demings, D Co, 1st/508th Inf, 82d Abn Div, Phu Loi:** So far I haven't encountered any. I'm not racially prejudiced, so it doesn't bother me at all.

● **Sp4 Almon Austell, 588th Maint Co, Chu Lai:** Since I've been in 'Nam, I've encountered a little bit of it. In Germany, when I was stationed there, sometimes it would come out and sometimes it wouldn't, but it was there. You could see it. That's the reason I volunteered to come to Vietnam, because it was getting too tight over there. Since I've been over here, I really haven't encountered it. Because most of the guys I run around with, they're all right. And the guys I work with are pretty nice too, so I really don't have anything to say about prejudice. Except when I was in Germany. The German people were really nice but the American people there were something else.

● **Pfc Hillery Pair, Jr., D Co, 1st/508th Inf, 82d Abn Div, Tan Son Nhut:** If there is any prejudice here now, it's so little that it doesn't make much difference. For myself, I haven't run into any. I think that everybody is everybody. It's a one-way thing and we all go.

● **Pfc Rubin Davis Jr., D Co, 1st/508th, 82d Abn Div, Tan Son Nhut:** I think there is prejudice in the Army. Over here in Vietnam, I don't think there's too much, because we are fighting, together, living together. Back in the States, I think there is a lot, because there they are not fighting together. Back in America, there is prejudice in the Army. Everybody wants to be on their own, there are guys who are below, guys who are higher. To the guys in the regular Army, the Negroes in the service are below. The white man will push him. If he's high rank as a black man, he'll try to push the white man. Over here in Vietnam, everybody is working together. But after this war is over, you can forget it, because they're going to start the same jazz. Over here, the white man and the black man work together, live together. We can't lose them and they can't lose us, because we're fighting for everybody. We want to live and they want to live. I think soon, in America, you can say we grew up together in Vietnam, we grew up together because we lived and died together. But back in America, you can't say that because there isn't a war there. The black man over there hasn't got anything. He's trying now to come up, but the white man's trying to keep him down. The black man will get up there, though it might take time. As for me, I don't like the Army. But as long as I'm in the Army,

I'll abide by the rules. I'm a black man, but since I'm in the Army, I have to follow the man above me, no matter what color, race, creed. In the Army, they treat you like kids, not men. A man of 22 should be treated as a man, not a 2-year-old kid. It hurts a man's feelings to be treated as a kid.

● **Sp4 David Hoyle, D Co, 1st/508th, 82d Abn Div, Tan Son Nhut:** I think there is very little prejudice over here in Vietnam. Some people don't like the black folks, but I don't really care whether he's black, white, brown or Italian. As long as I get out of this place I can live with all of them and I hope that all of them can live with me. I don't try to hinder anybody over here in Vietnam. I'm just over here for a year and I want to get back to my wife in the States. There's very little prejudice over here, but it depends on the person over here.

● **Sgt James Cotton, 154th Transportation Co, Camp Davies, Saigon:** Yes, I do think there is prejudice in the Army. There will always be prejudice. They are trying to stop it, but it will be a little while yet. In promotions, some of the Negro troops are being passed over. I personally have not experienced discrimination but some of my friends have told me about it.

● **Sp4 James Jones, 536th Heavy Equipment Maintenance Co, Camp Davies, Saigon:** I

(Continued on Page 14)

'In combat, if a guy had only one smoke he would share it with five guys, no matter what color. A support soldier would smoke it himself.'

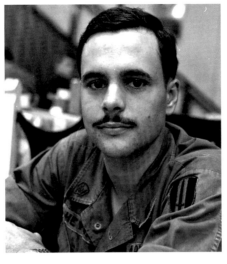

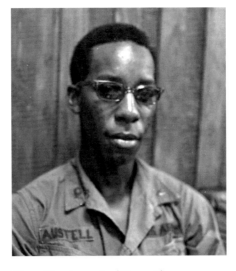

. . . I have seen and experienced a definite sort of group prejudice within my own environment against—for lack of a better word—a hippie or head type of individual. . . .Since I'm not black, I can't really comment on racial prejudice—I can't feel, I can only observe. Being Jewish, I've never found any religious prejudice in the Army, never once. But I can look around my unit and say there is no prejudice against blacks. But I may be wrong. I may not even see it.

Specialist Grade E4 Mark Birnbaum, 10th Psychological Operations Battalion, 4th Psychological Operations Group, Cần Thơ

. . . As far as racial prejudice goes, I have seen individual incidents of personal antagonism. . . .The worst prejudice is among different educational and social groups, not racial groups. Education is sort of inversely proportional to rank among the EM [enlisted men] because of the college draftees and the lifer NCOs. There's definitely a conflict between lifers and draftees or short-term enlistees.

Specialist Grade E4 Duane Heyman, 10th Psychological Operations Battalion, 4th Psychological Operations Group, Cần Thơ

Since I've been in 'Nam, I've encountered a bit of it. In Germany, when I was stationed there, sometimes it would come out and sometimes it wouldn't, but it was there. You could see it. That's the reason I volunteered to come to Vietnam because it was getting too tight over there. Since I've been over here, I really haven't encountered it. Because most of the guys I run around with, they're all right. And the guys I work with are pretty nice too, so I really don't have anything to say about prejudice. Except when I was in Germany. The German people were really nice, but the American people there are something else.

Specialist Grade E4 Almon Austell, 588th Maintenance Company, Chu Lai

I think there is prejudice in the Army. Over here in Vietnam, I don't think there's too much, because we are fighting together, living together. . . .Back in America, there is prejudice in the Army. . . .As for me, I don't like the Army. . . .I'm a black man, but since I'm in the Army, I have to follow the man above me, no matter what color, race, creed. In the Army, they treat you like kids, not men. A man of twenty-two should be treated as a man, not a two-year-old kid. It hurts a man's feelings to be treated as a kid.

Private First Class Rubin Davis Jr., D Company, 1st Battalion, 508th Infantry, 82nd Airborne Division, Tân Sơn Nhứt

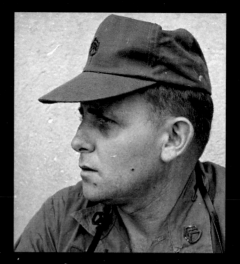
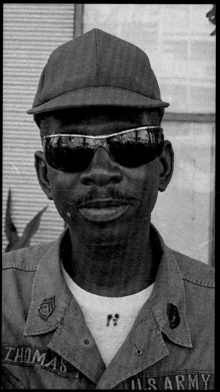
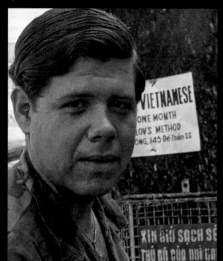
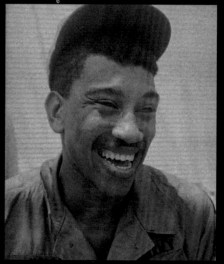

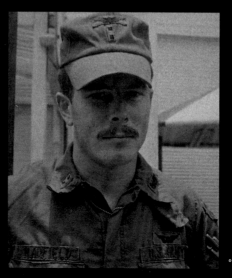

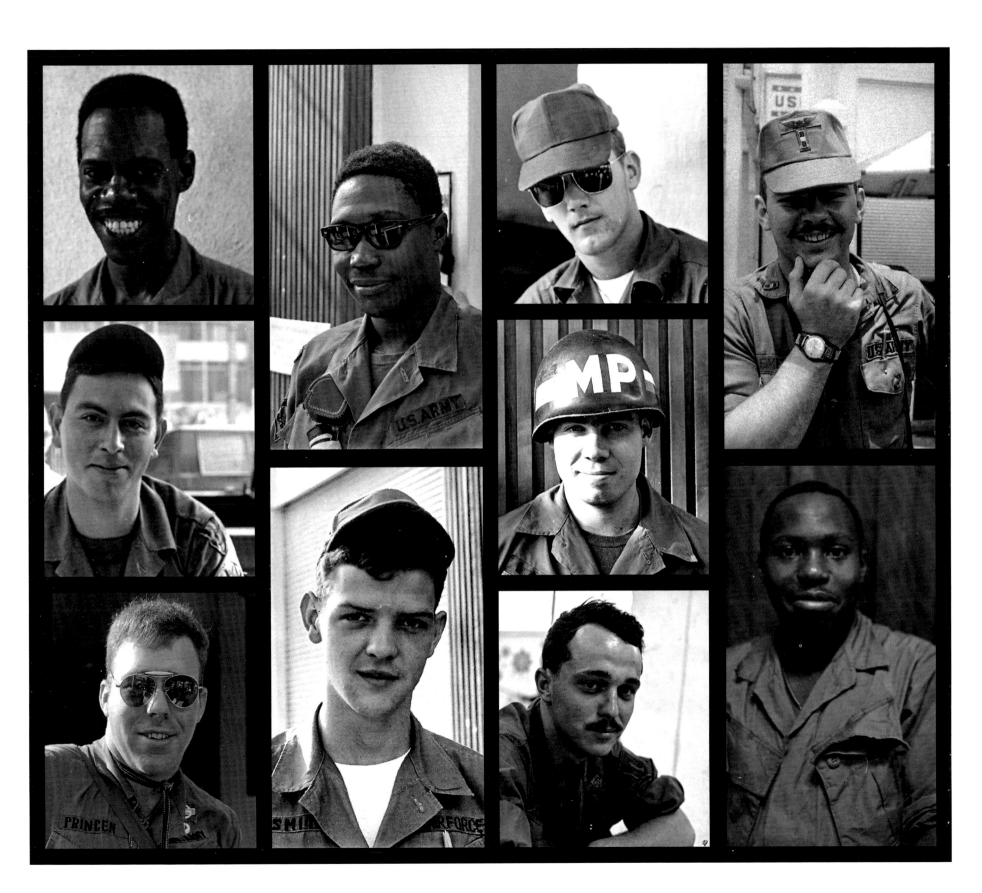

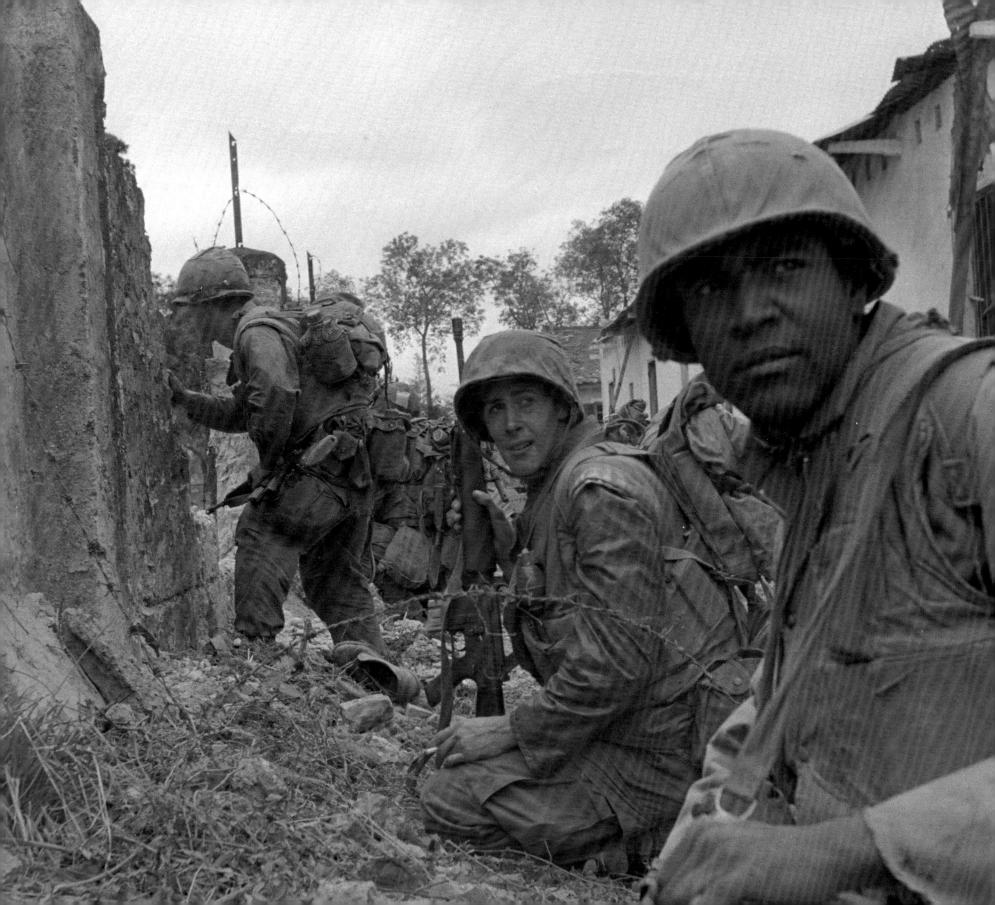

ABOUT THE CONTRIBUTORS

CYNTHIA COPPLE, a graduate of UC Berkeley in 1966, was a war correspondent in South Vietnam in 1969. Stationed in Saigon, she traveled throughout the country covering the war for the *Overseas Weekly*. In the 1970s she was a publicist for Bay Area rock bands Grateful Dead and Van Morrison. Since 1982, she has been Director of Lotus Holistic Health Institute in Santa Cruz, CA. She cofounded and is past-president of the National Ayurvedic Medical Association. She also cofounded and is former dean of the Mount Madonna Institute College of Ayurveda, which granted her an honorary MA degree in Ayurveda in 2009. She is the author of *Know Your Blueprint: The Ayurvedic Secret to Restoring Your Vitality and Passion in 30 Days* (2016).

ART GREENSPON has had a long and diverse career as a television reporter and producer, freelance war photographer, newspaper photojournalist, documentary filmmaker, and portfolio manager. He began his journalism career at suburban Connecticut radio stations in the 1960s and quickly progressed on to WCBS-TV in New York as a daily assignments reporter. He transitioned to photography and traveled to Vietnam where his war photography was widely recognized. His iconic photograph "Help from Above" was nominated for a Pulitzer Prize and won two national awards. During the 1970s he worked as a staff photographer for the *New York Times* and produced documentary films for CBS News and public television station WNET/13. He lives in New Canaan, Connecticut with his wife Nancy and their cat Oliver. His two children are freshmen in college.

DON HIRST served in Vietnam as a US Army enlisted man in 1964–65 and 1967–68. From 1968 to 1972, he performed extensive coverage of American troops at war for the *Overseas Weekly*, Saigon bureau and was later promoted to Pacific Bureau Chief in 1972. From 1974 to 1985, he served as associate editor at *Army Times* in Washington DC. In 1979, he was nominated for the Pulitzer Prize for National Reporting for breaking a story about North Korea's secret troop buildup that posed a major threat to the planned pullout of American ground troops from South Korea. In 1985 he launched *Salute* and was its executive editor for twenty years. He retired in June 2011 due to lymphoma caused by herbicide exposure in Vietnam.

LISA NGUYỄN is the curator for Digital Scholarship and Asian Initiatives at the Hoover Institution Library & Archives at Stanford University where she works with private donors and organizations to collect historical documentation on political and socioeconomic change in Asia. She is a member of the Society of American Archivists (SAA) and has served on the Cultural Property Working Group and on the Mosaic Program Fellowship selection committee. In 2011, she curated the exhibition *China: A Century of Change*, which received the Katherine Keyes Leab and Daniel J. Leab American Book Prices Current Exhibition Catalogue Award. Her primary research interests include scholarly practices in digital resource management, deep learning, and data curation.

BRENT PROCTER began his journalism career in his native New Zealand in 1963 in provincial and metro newspapers. He first joined the *Overseas Weekly*, Pacific Edition in 1969 as a freelancer. Upon Ann Bryan's departure from the *Overseas Weekly*, Procter served as the paper's Saigon bureau chief from 1970 to 1971. Over the course of his 40-year career in journalism in the United States, he covered topics spanning Watergate to Oprah Winfrey. Procter returned to New Zealand where he is active in the hospitality industry.

ERIC WAKIN is the deputy director of the Hoover Institution, a research fellow, and the Robert H. Malott Director of the Institution's Library & Archives. Wakin is the author of *Anthropology Goes to War: Professional Ethics and Counterinsurgency in Thailand*. Before coming to Hoover, he was the Herbert H. Lehman Curator for American History and the Curator of Manuscripts at the Rare Book & Manuscript Library at Columbia University and an adjunct professor in its History Department. Wakin received a BA in English literature from Columbia University; an MA in Southeast Asian studies and an MA in political science from the University of Michigan–Ann Arbor; and a PhD in United States history from Columbia.

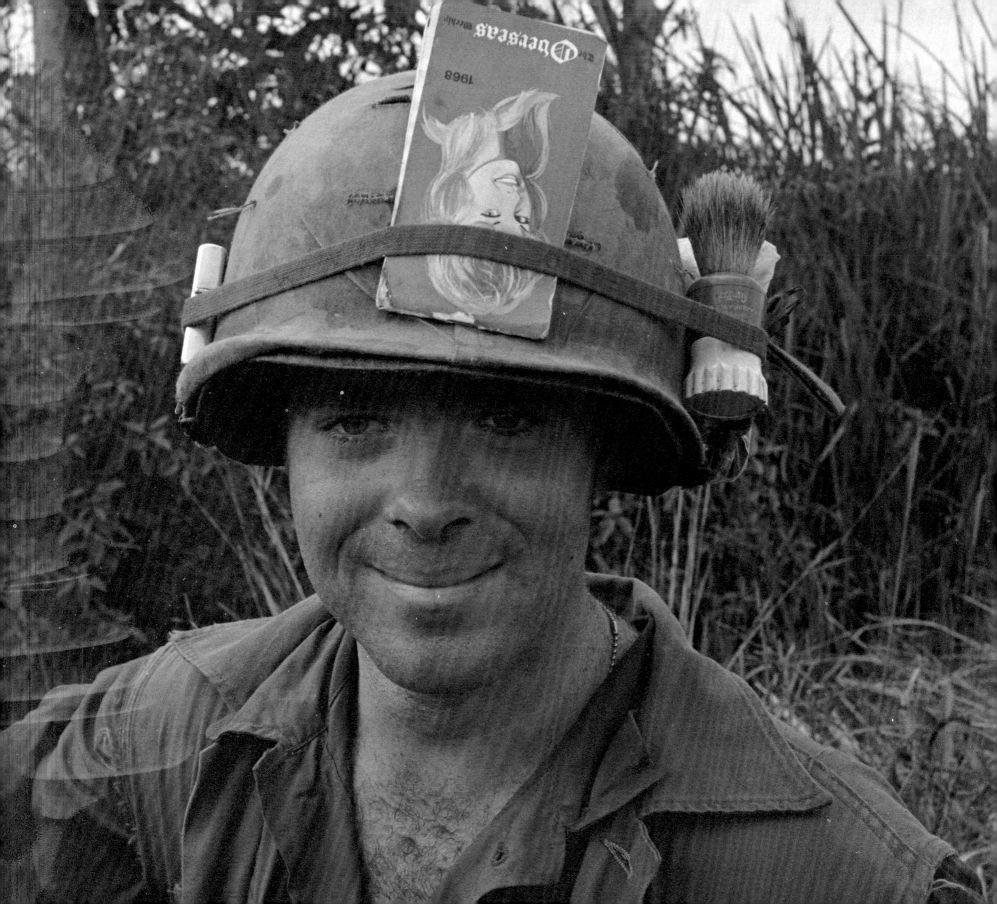

FURTHER READING

Readers interested in learning more about the Overseas Weekly *will find related sources listed below.*

Ann Bryan Mariano McKay Papers, C4009, State Historical Society of Missouri, Manuscript Collection.

Bartimus, Tad, Denby Fawcett, Jurate Kazickas, Edith Lederer, Ann Bryan Mariano, Anne Morrissy Merick, Laura Palmer, Kate Webb, and Tracy Wood. *War Torn: The Personal Experiences of Women Reporters in the Vietnam War.* New York: Random House, 2002.

Boyle, Richard, and Paul Norton MacCloskey. *The Flower of the Dragon: The Breakdown of the US Army in Vietnam.* San Francisco, Ramparts Press, 1972.

GI Press Collection Online. Wisconsin Historical Society. http://content.wisconsinhistory.org/cdm /landingpage/collection/p15932coll8.

Hoffmann, Joyce. *On Their Own: Women Journalists and the American Experience in Vietnam.* Cambridge, MA: Da Capo Press, 2008.

Linn, Brian MacAllister. *Elvis's Army: Cold War GIs and the Atomic Battlefield.* Cambridge, MA: Harvard University Press, 2017.

Overseas Weekly photographs. Hoover Institution Library & Archives. https://digitalcollections.hoover.org /objects/59153.

Roberts, Archibald E. *Victory Denied.* Fort Collins, CO: Committee to Restore the Constitution, 1972.

Stewart, Bhob, Bill Pearson, Roger Hill, Greg Sadowski, and Wallace Wood. *Against the Grain: Mad Artist Wallace Wood.* Raleigh, NC: Two Morrows Publication, 2003.

Stur, Heather Marie. *Beyond Combat: Women and Gender in the Vietnam War Era.* New York: Cambridge University Press, 2011.

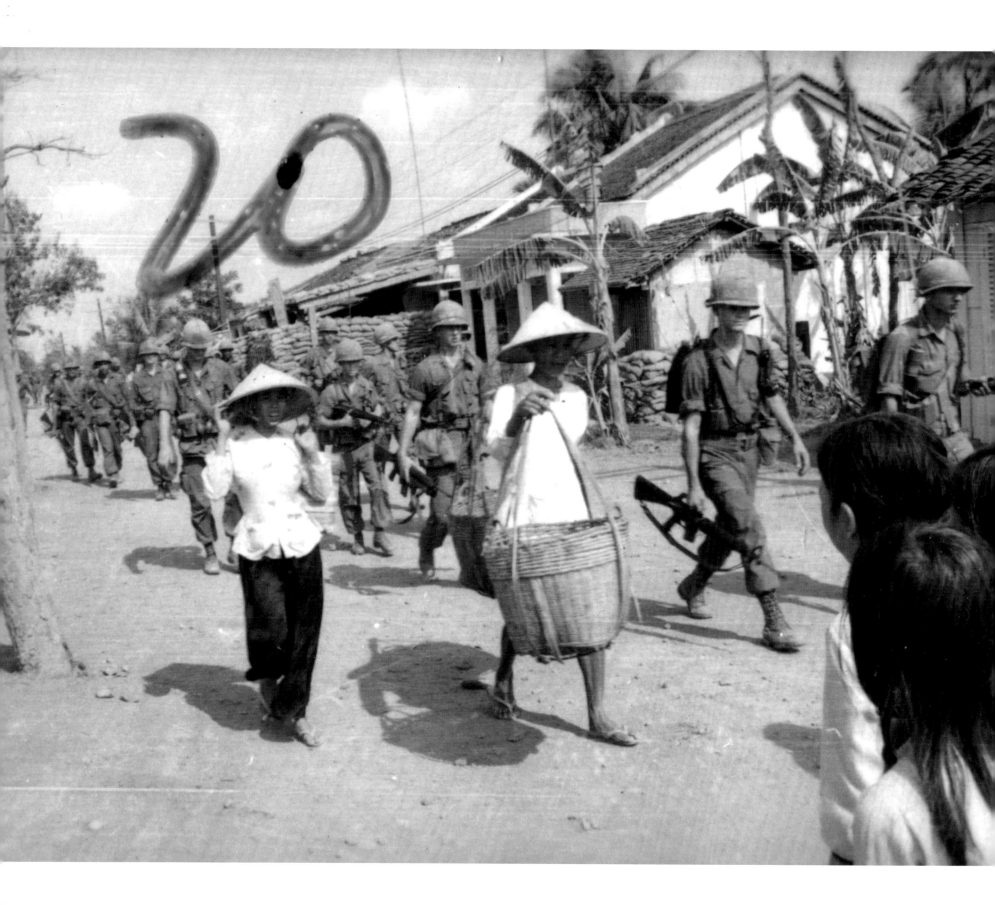

NOTES

1. Ann Bryan, "Look Who's Turning 18 Years Old," *Overseas Weekly* Pacific Edition, May 23, 1967, 4.

2. Staff Reporter, "The G.I.'s Friend," *Time*, June 9, 1961, 47.

3. Ann Bryan, "Look Who's Turning 18 Years Old," *Overseas Weekly* Pacific Edition, May 23, 1967, 4.

4. William Brinkley, "They All Say, 'Look At That American Signora!'" *Life*, December 23, 1957, 69–70.

5. Staff Reporter, "*The Overseas Weekly*, Gadfly to the Army, Seeks Entry into Asia," *Wall Street Journal*, February 25, 1966.

6. Staff Reporter, "The G.I.'s Friend," *Time*, June 9, 1961, 47.

7. General Walker allegedly responded to the charges against him with contempt: "We have Communists and we have the *Overseas Weekly*. . . . Immoral, unscrupulous, corrupt, and destructive are terms which could be applied to either." Charles C. Moskos Jr., *The American Enlisted Man* (New York: Russell Sage Foundation, 1970), 103.

8. Edward Behr, *Bearings: A Foreign Correspondent's Life behind the Lines* (New York: Viking Press, 1978), 241.

9. Staff Reporter, "Twitting the Brass," *Time*, October 20, 1967, 71.

10. Edward Behr, *Bearings: A Foreign Correspondent's Life behind the Lines* (New York: Viking Press, 1978), 241.

11. Ann Bryan Mariano, "Vietnam Is Where I Found My Family," in Tad Bartimus et al., *War Torn: The Personal Experiences of Women Reporters in the Vietnam War*.

12. Letter from Ann Bryan to Marion von Rospach, April 25, 1966, Ann Bryan Mariano McKay Papers, C4009, folder 440, State Historical Society of Missouri.

13. Letter from Ann Bryan to Marion Rospach, February 20, 1967, Ann Bryan Mariano McKay Papers, C4009, folder 445, State Historical Society of Missouri.

14. Of the 5,000 accredited journalists in Saigon, only a dozen women routinely reported about the war from mid-1960s to 1970s. Ann Bryan Mariano, "Vietnam Is Where I Found My Family," in Tad Bartimus et al., *War Torn: The Personal Experiences of Women Reporters in the Vietnam War* (New York: Random House, 2004), 38.

15. Ann Bryan Mariano, "Vietnam Is Where I Found My Family," in Tad Bartimus et al., *War Torn: The Personal Experiences of Women Reporters in the Vietnam War* (New York: Random House, 2004), 38.10. Edward Behr, *Bearings: A Foreign Correspondent's Life behind the Lines* (New York: Viking Press, 1978), 241.

16. Letter from Marion von Rospach to Ann Bryan, June 22, 1967. Ann Bryan Mariano McKay Papers, C4009, folder 447, State Historical Society of Missouri.

17. Ann Bryan, "Battle Rages But We're Starting," *Overseas Weekly* Pacific Edition, October 23, 1966, 4.

18. Staff Reporter, "Weekly for G.I.'s Plans Vietnam Edition Despite US Opposition," *New York Times*, August 9, 1966, 5.

19. Staff Reporter, "Stars and Stripes Forever," *Newsweek*, July 18, 1966, 63

20. Staff Reporter, "Twitting the Brass," *Time*, October 20, 1967, 71.

21. Ann Bryan Mariano, "Vietnam Is Where I Found My Family," in Tad Bartimus et al., *War Torn: The Personal Experiences of Women Reporters in the Vietnam War* (New York: Random House, 2004), 41.

22. Letter from Ann Bryan to Marion Rospach, February 20, 1967, Ann Bryan Mariano McKay Papers, C4009, folder 445, State Historical Society of Missouri.

23. Elizabeth Engel, "Ann Bryan Mariano McKay Papers Finding Aid," State Historical Society of Missouri, https://shsmo.org/manuscripts/columbia/c4009.pdf (last accessed February 24, 2018). Staff Reporter, "Stars and Stripes Forever," *Newsweek*, July 18, 1966, 63.

24. Staff Reporter, "Stars and Stripes Forever," *Newsweek*, July 18, 1966, 63.

PHOTO REFERENCES

Man on the Street

Overseas Weekly freelancer Cynthia Copple interviews an unidentified US soldier for the "Man on the Street" column. Photograph courtesy of Cynthia Copple.
1969 | South Vietnam

Image courtesy of the State Historical Society of Missouri.

Image courtesy of the State Historical Society of Missouri.

Image courtesy of the State Historical Society of Missouri.

About the Contributors

ART GREENSPON

Unidentified Marines attentively await their next move.
March 1968 | Huế

Further Reading

OW STAFFER

A combat patrol of B Company.
1968 | South Vietnam

Notes

ANN BRYAN

GIs share the dusty village road with basket-carrying farmwomen on their way to the market.
April 30, 1967 | Rạch Kiến

Photo References

OW STAFFER

Mai Lan, a Vietnamese language teacher on the American Forces Vietnam Network, points to a board that says in Vietnamese, "I am an American. I am an American soldier. We are friends."
September 7, 1968 | Saigon

Final Image

BRENT PROCTER

The US flag fluttering in the light breeze at Firebase Tennessee, located twenty-four miles northwest of Saigon near the Iron Triangle battlefield.
October 16, 1970 | South Vietnam